The Fundamentals of
DRAWING

The Fundamentals of
DRAWING

ARCTURUS

Dedication:
To all the teachers, colleagues and students I have had the
privilege of working with and learning from.

Arcturus Publishing Limited
26/27 Bickels Yard
151–153 Bermondsey Street
London SE1 3HA

Published in association with
foulsham
W. Foulsham & Co. Ltd,
The Publishing House, Bennetts Close, Cippenham,
Slough, Berkshire SL1 5AP, England

ISBN 0-572-02879-2

British Library Cataloguing-in-Publication Data:
a catalogue record for this book is available from the British Library

This edition printed in 2005
Copyright © 2003 Arcturus Publishing Limited/Barrington Barber

Jacket design by Alex Ingr

Printed in China

Contents

Introduction

Learning to draw is not difficult. Everybody learns to walk and talk, and read and write at an early age. Learning to draw is less difficult than all that. Drawing is merely making marks on paper which represent some visual experience. All it takes to draw effectively is the desire to do it, a little persistence, the ability to observe and a willingness to carefully correct any mistakes. This last point is very important. Mistakes are not in themselves bad. Regard them as opportunities for getting better, and always correct them.

Many of the exercises in this book incorporate the time-honoured methods practised by art students and professional artists. If these are followed diligently, they should bring about a marked improvement in drawing skills. After consistent practice and regular repetition of the exercises, you should be able to draw competently, if not like Leonardo da Vinci – that takes a little longer.

Finally, do not despair if your drawings are not masterpieces. If they were, you would not need this book or any other.

First Stages

Before you start you will need to equip yourself with pencils, pens, charcoal, graphite and various kinds of drawing paper. Soft paper with a tooth or smooth hard paper are equally good, depending on the effect you want.

You will need to find an effective grip for your pencil and also get used to handling a drawing board and possibly an easel. Don't rush any of this, just experiment until you discover what works best for you. Once you are comfortable with the paraphernalia, you can begin to think about the business of drawing.

Also in this section you will find a series of exercises designed to introduce you to the basics and give you a grounding in various types of drawing. As you progress you will have to call upon the techniques these exercises teach, so practise them regularly and diligently.

MATERIALS

You don't need sophisticated drawing implements to be effective. If you are drawing for the first time, a B, 2B, 3B or 4B pencil, well sharpened, should be adequate. Buy a range of these and try them out, experimenting with their individual softness or blackness.

Later on you might like to try drawing with a solid graphite stick. This costs more than a pencil but lasts longer, and it's also very good when you wish to vary your strokes. Charcoal is marvellous for larger drawings and can be smudged or softened very easily. It also enables you to keep a light touch and still get a black mark.

A pen (0.1 grade or higher) is good to try out when you have developed some confidence.

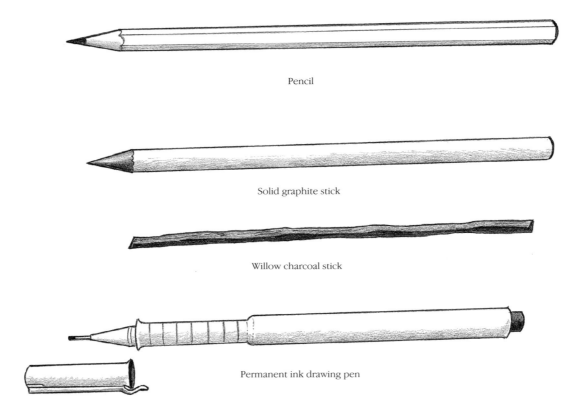

Pencil

Solid graphite stick

Willow charcoal stick

Permanent ink drawing pen

PAPER

All of the implements mentioned are used with standard cartridge paper. This comes in a variety of weights and textures and is available at art shops. Try out several different types so that you understand their respective merits. The advantage of smooth paper is that you can draw in greater detail and also draw smaller shapes. The advantage of a coarse paper is that the lines you draw on it look slightly broken, giving a textured effect and ensuring that you don't draw too small. Generally, the smaller the drawing the smoother and finer the drawing paper, or implement, should be. Larger drawings require a corresponding increase in the textural coarseness of the paper.

A sketch pad is useful in the beginning because you can carry it around and draw whenever and wherever you like.

HOLDING THE PENCIL

Your inclination will probably be to hold the pencil like a pen. Try holding it like a brush or a stick. Keep the grip loose. You will produce better marks on the paper if your grip is relaxed and there is no tension in your hand or arm.

WORKING AT A BOARD OR EASEL

If you don't have an easel and are sitting with the board propped up, the pencil should be at about shoulder height and you should have a clear view of the drawing area.

The best way to draw is standing up, but you will need an easel for this.

There should be plenty of distance between you and the drawing. This allows the arm, wrist and hand to move freely and gives you a clearer view of what you are doing. Step back every few minutes so you can see the drawing more objectively.

Keep your grip easy and don't be afraid to adjust it. Don't have a fixed way of drawing.

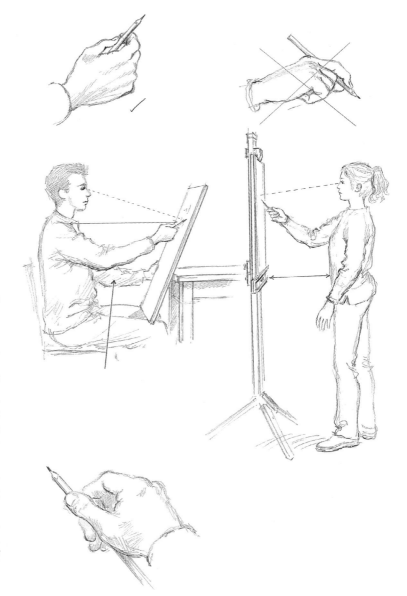

USING THE PAPER

Try to work as large as possible from the beginning. The larger you draw the easier it is to correct. Aim to gradually increase the size of your drawing until you are working on an A2 sheet of paper and can fill it with one drawing.

You will have to invest in an A2 drawing board for working with A2 paper. You can either buy one or make one out of quarter-inch thick MDF. Any surface will do, so long as it is smooth under the paper; masking tape, paper clips or blu-tak can be used to secure the paper to the board.

Also see pages 40–41 for more information.

LINES AND CIRCLES

In this first exercise you will learn the most fundamental cornerstone of good drawing: precision of hand and eye. Start by drawing the following geometrical shapes.

As you practise, concentrate on the point of the pencil exactly where the graphite comes off the pencil onto the paper. Don't be concerned if your attention wanders at first – just practise coming back to the point of the pencil. You will notice wobbles and blips creeping into the drawing whenever your attention strays. When you can keep your attention on the point of the pencil and no other thoughts and expectations intrude, you will find that your drawing will go smoothly. When the eye follows the hand exactly, the hand will perform exactly. Keep practising. Always start drawing sessions with five to ten minutes of practice.

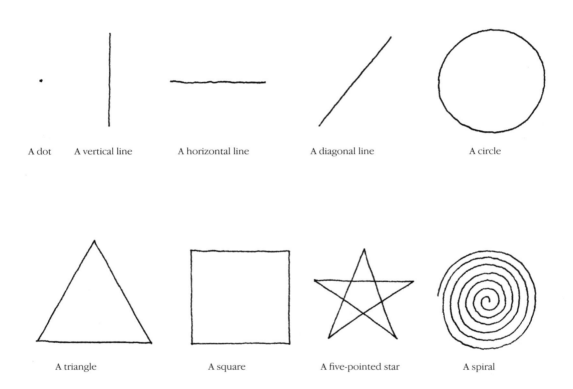

A dot A vertical line A horizontal line A diagonal line A circle

A triangle A square A five-pointed star A spiral

Control of the hand is a basic technique you must learn if you are to draw well. The more you practise the following exercise, the surer your line will be and the greater the accuracy of your eye in judging space and form.

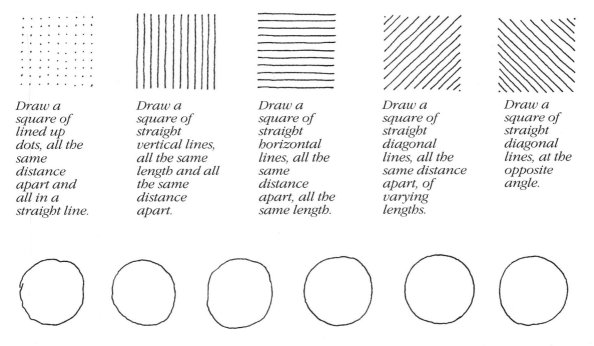

Draw a square of lined up dots, all the same distance apart and all in a straight line.

Draw a square of straight vertical lines, all the same length and all the same distance apart.

Draw a square of straight horizontal lines, all the same distance apart, all the same length.

Draw a square of straight diagonal lines, all the same distance apart, of varying lengths.

Draw a square of straight diagonal lines, at the opposite angle.

Now draw a circle. Continue drawing circles, trying each time to improve on the one you have drawn before. Keep practising until the circle begins to look how you think it should. When it looks fairly good, practise drawing it more quickly.

Don't rush these exercises. The value of them lies in concentrating your attention on the movement of the pencil on the paper. Repeat them until you feel sure and relaxed. If you feel tense, try consciously to relax.

3D SHAPES
To give the impression of depth and solidity in drawing, you have to use perspective or shading or both.

A basic illusion of three dimension and depth can easily be produced. Now try this next series of shapes.

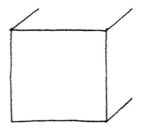

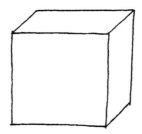

1. Draw a square.

2. Add three more parallel lines.

3. Join the ends ... and you have a cube. If your lines are accurate enough it is impossible not to see a cube.

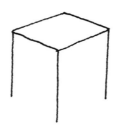

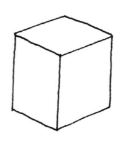

4. Draw a diamond or parallelogram.

5. Add three lines of the same length and in parallel.

6. Join the ends – again, you have a cube!

As you can see, shading or tone helps to create an illusion of three dimensions or solidity.

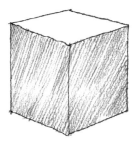
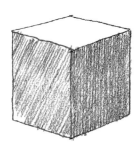
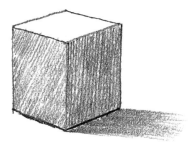

7. Shade the two lower sections of the cube lightly.

8. Shade one of the lower sections more heavily.

9. Add a cast shadow – this fades off from the darkest section in line with the floor or surface on which the cube is standing.

Now see what effect you can get by adding tone to a circle.

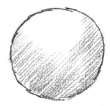
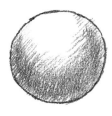
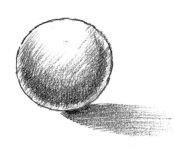

10. Draw a circle ...

11. Shade lightly just over half the area in a crescent shape.

12. Shade more heavily a smaller area nearer the edge.

13. Shade the outer edge of this area more heavily still. Add a fading off cast shadow. Now your circle should look like a sphere.

ELLIPSES

Drawing ellipses is another of those necessities that the aspiring artist has to learn to do. Unfortunately, there is no foolproof way of drawing them mechanically. You just have to practise until you become proficient.

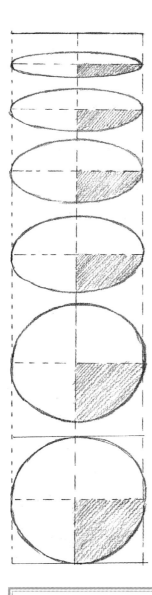

Ellipses are continuous curves and at no time do they become straight edged or create angles. Look at the three elliptical shapes below. Compare the two incorrect versions, which have almost straight edges or angles, with the correct version, which has neither.

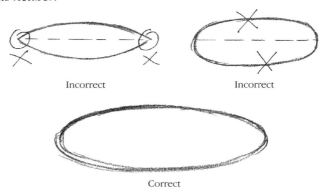

Incorrect Incorrect

Correct

The column of ellipses shows what happens when a circular shaped object is viewed at various levels. At eye level a circle appears as just a horizontal line. When the object is lowered, the ellipse increases in depth while maintaining its width. Lower it further still and the circle will reappear.

You can practise drawing ellipses by placing a circular object – such as a plate or jug – at eye level.

The shaded area on each of the ellipses (left) is one quarter of the area of the ellipse bounded by the vertical axis and the horizontal axis. Your ellipse is incorrect if these quarters are not identical in shape. However, although each shaded area should be the same shape, it should be seen as a mirror image vertically, horizontally and diagonally. If you can observe this distinction when you come to draw an ellipse, then your drawing is more or less correct.

All shapes that are based on a circle – eg, cylinders and wheels – become ellipses when they are seen obliquely or from an angle.

Even more interesting than placing an object at eye level and drawing it, is to draw the wheels of a cycle or car from ahead or behind. In this instance the vertical axis of the ellipses will be long and thin. Changes in the width of an ellipse are dictated by the point from which you view the object.

BEGINNING TO DRAW OBJECTS

Having practised the previous exercises, now is the time to try drawing a real-life object instead of just copying diagrams or ideas. To begin, select a simple household object, like a cup or a bottle or a jar, anything in fact. Make sure it is not too complicated. Place it on the table in front of you and look at it carefully.

Notice its overall shape. Notice its height compared with its width. Notice the way the light falls on it. See its colour. See its texture. Is it reflective? Is it rounded? Is it angular?

What is happening when you look at an object in this way? Well, it is very similar to drawing it: you are considering the object as a shape or an area of colour or a form lit up. This is how an artist looks at an object, although without actually asking these questions. In fact the less he thinks about it consciously, the more he sees. For a novice, though, it can be useful to ask these questions. Instead of seeing a jug or cup the artist sees a shape, colour, texture and form. This is the image a camera sees, and this is how it is received on the retina.

Now have a go at drawing your object. First of all just try to draw an accurate outline. It might be easier if you place the object at your eye level so as to reduce the problem of perspective.

The effect of this exercise, which can be repeated over and over again, is to gradually educate your hand and eye to work together. You are very good at seeing and you can trust that the appearance is correct. What gets in the way are the clumsiness of the untrained hand and the ideas about what you see. Don't try to interpret what you see, just see it.

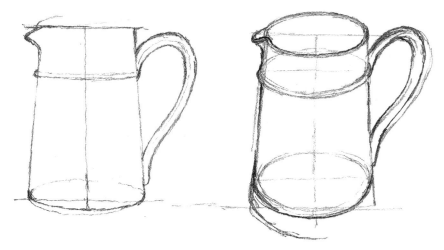

CORRECTING AS YOU GO

When you have drawn the outline as well as you can, hold up the drawing so that you can see it and the object without having to move your head. Notice which bits are correct and, more importantly, which bits are incorrect. Then carefully redraw over your drawing more correctly without rubbing out the incorrect lines first. Carry on correcting the marks and lines until the drawn shape begins to look more like the object.

When you draw the correct line over the incorrect without rubbing out first, you are more likely to move to a better likeness. If you rub out the first lines, the chances are that you will draw the same incorrect lines again.

It doesn't matter how confused or messy the lines get because the eye tends to go towards the correct ones and ignores the incorrect ones. The eye likes comparisons and will tell you very rapidly if two shapes are not similar. The shape of the object itself is always the correct one. Trust your eyes – they are a very accurate gauge of shape, colour and texture.

Now try drawing the same object in different positions. You might find some of these positions difficult. Don't give up because you think you're making a mess. Stick at it. Just keep using the same technique to produce more and more accurate drawings in outline. The more you practise, the better you will get.

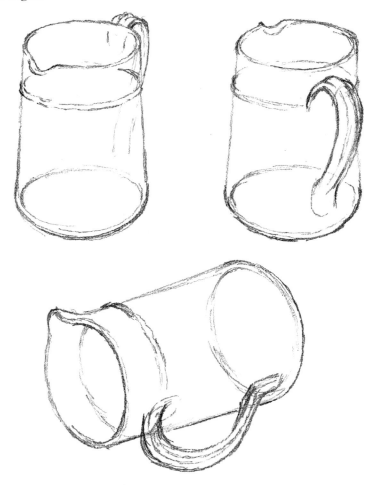

If a shape is incorrect, it is only a matter of discovering how. The cause can be one or more of a few simple things. Do the lines need moving up or down, to the right or the left, closer together or further apart? Do the lines need to be smaller or larger, straighter or more curved? Is the angle correct, or is it perhaps too obtuse or acute?

Be ruthless with your drawing, and don't hesitate to change anything you see as incorrect. If you adopt this attitude at the very start, it will become a habit which will stand you in good stead later on.

As soon as you start to feel tired or bored, stop at once. Don't go against your own inclination. When you come to really love drawing you will find yourself carrying on regardless and tiredness or boredom will not be factors.

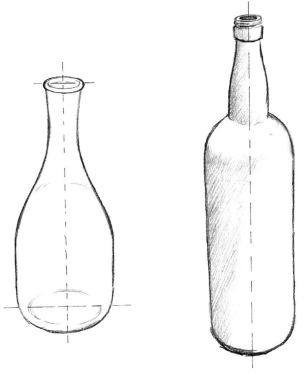

Now try several different objects. Again, don't try to be too ambitious. Pick simple objects you like the look of or find sympathetic in some way. It is easier to draw something you find pleasing. All artists come to love what they draw and so it is useful to start with something you already find attractive.

If you are worried about getting the shapes right, you can measure the objects by contrasting height and width and marking the central line through each object. The shape will be the same either side of the central line, rather like a mirror image.

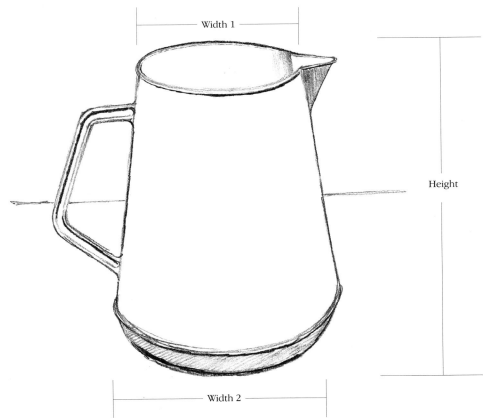

Width 1

Height

Width 2

BASIC SINGLE OBJECTS
Practise drawing a range of objects of differing shapes to consolidate what you have learnt so far.

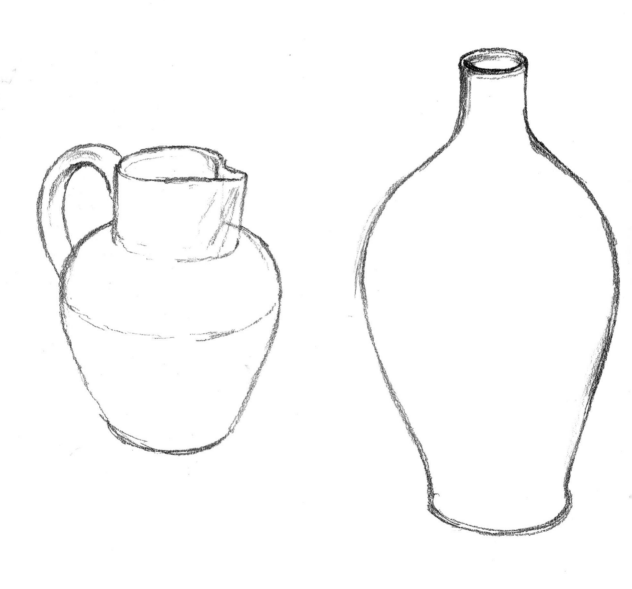

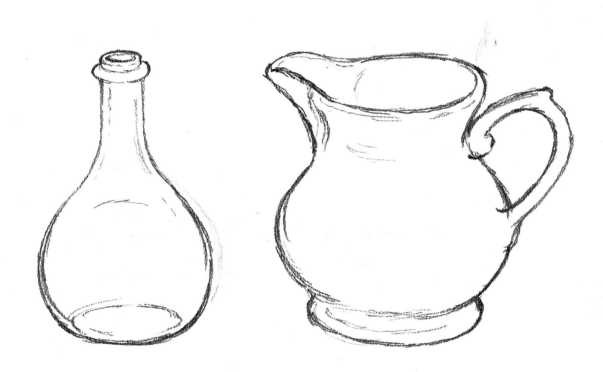

GROUPS OF OBJECTS

Now group two or three objects together, either of similar or contrasting shapes. Both ways can be fun. Relate the size, shape and proportion of each object to those of the other objects near it. You can then begin to see how interesting and complex drawing becomes.

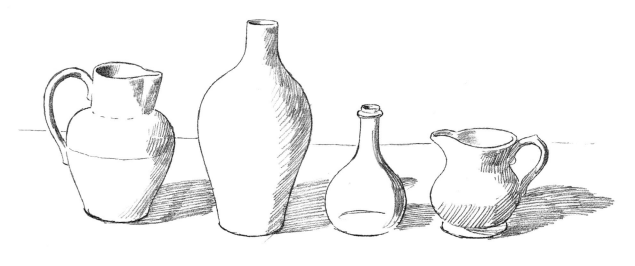

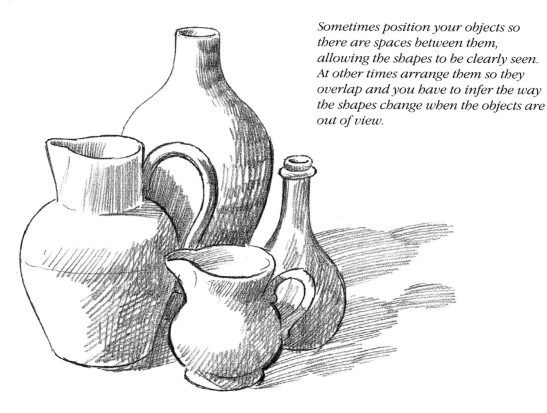

Sometimes position your objects so there are spaces between them, allowing the shapes to be clearly seen. At other times arrange them so they overlap and you have to infer the way the shapes change when the objects are out of view.

THE SHAPES BETWEEN

When drawing groups of objects, instead of always concentrating on the forms or shapes of your chosen items, concentrate on the space between them. This space also has a definite shape, bounded by the outline of the objects. By being aware of it, and treating it as part of your drawing, you can much more easily correct errors. If you get the spaces in between your objects right, the shapes of the objects themselves will also be right.

As you will begin to realize, in the visual world of the artist there are no empty spaces. Each space is something to draw. This also increases the interest in seeing.

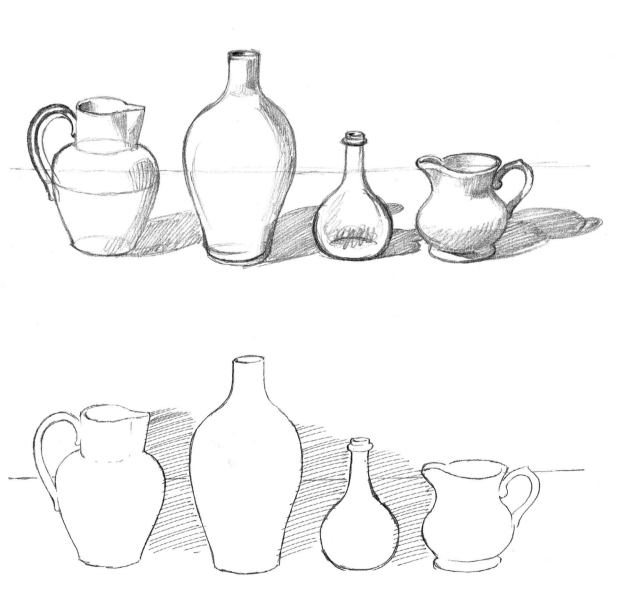

IDENTIFYING THE SOURCE OF LIGHT
The type of shadow that an object throws varies depending on the direction of the source of light. A simple way of learning about shadows is to arrange an object at various angles and note the differences. A lamp is an ideal of source of light for this exercise, enabling you to move the objects around to produce a maximum variety of shadows.

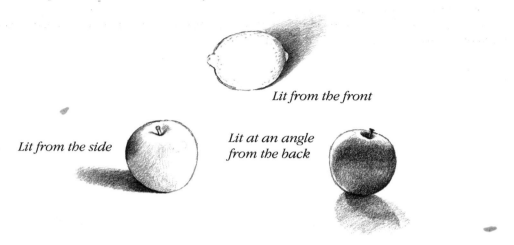

Lit from the front

Lit from the side

Lit at an angle from the back

Here, notice how the apple with the light full on it and the apple silhouetted against the light look less dimensional than the apples lit side on.

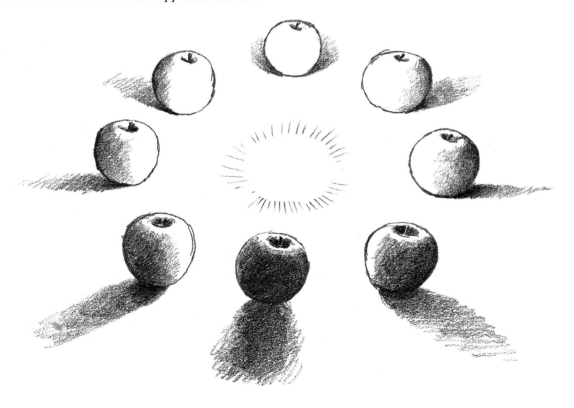

ARRANGING OBJECTS

When you have practised drawing groups of objects, spend some time just arranging objects into groups. The idea is not to draw them. Just arrange them, look at them carefully, see the shapes and patterns they make and then re-arrange them into different compositions.

The arrangement of shapes within shapes gives interest to this composition, as does a sense of confinement of the major elements of this meal in the making. The glassy eyes of the fish fix the viewer reproachfully.

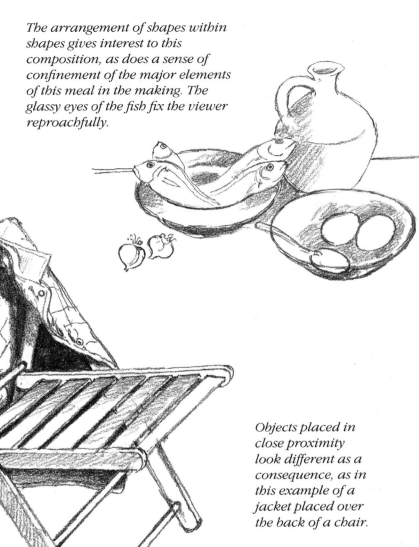

Objects placed in close proximity look different as a consequence, as in this example of a jacket placed over the back of a chair.

You will find still life arrangements all around you, wherever you go. Someone has thrown a coat over a chair. Someone has laid a table for dinner. The shapes of glasses, plates, cutlery, not to mention details such as flowers, napkins or groups of condiments, form different patterns and designs, depending on whether you are seeing them from above or from sitting position or even from table level. Once you become aware of such possibilities, your eye will start to look for composition as it happens naturally.

METHODS OF MODELLING AND SHADING

Hatching, or building up tone, is the most conventional way of showing the effects of light and shade. To make it effective, you need to practise. Start by producing strokes all in the same direction, about the same length and evenly spaced. Don't try to rush this. Areas can be hatched very rapidly and with great accuracy, but this takes practice. Start slowly. Build up speed.

There are various methods of hatching:

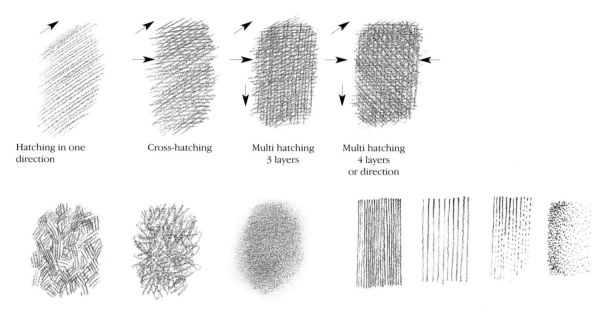

Hatching in one
direction

Cross-hatching

Multi hatching
3 layers

Multi hatching
4 layers
or direction

*You can use
groups of
lines in small
patches
evenly spread
over the
surface.*

*You can
build up a
cloud of tone
by making
the marks go
in all
directions.*

*You can
smudge
the marks
with your
finger.*

*You can use a pen to draw parallel lines.
These can be close together or far apart, or
you can use broken lines or dots in
varying densities.*

*If you want to cover an area of
your drawing quickly, you can
use a broader stroke, achieved by
using the side edge of the lead.*

SIMPLE PERSPECTIVE

Perspective is very important if you wish to make a drawing appear to inhabit a three-dimensional space. The rules are fairly simple, but there are many ways of contrasting the lines of perspective to give the right effect. Drawing from observation will help you to see how perspective works in fact. Here we look at three devices which help explain the theory.

Rule number one of perspective is that objects of the same real size, look smaller the further away they are from the viewer. Therefore a man of 6ft who is standing about 6 feet away from you, will appear to be about half his real height. If he is standing about 15 feet away, he will appear about 8 inches high. Stand him one hundred yards away and he can be hidden behind the top joint of your thumb, and so on.

The first diagram gives some idea of how to construct this effect in the picture plane. The posts apparently become smaller and thinner as they approach the vanishing point. The space between the posts also appears to get smaller. This image gives a good semblance of what happens in the eye of the viewer, and one can see the use that can be made of it to create apparent depth on the flat surface of the paper.

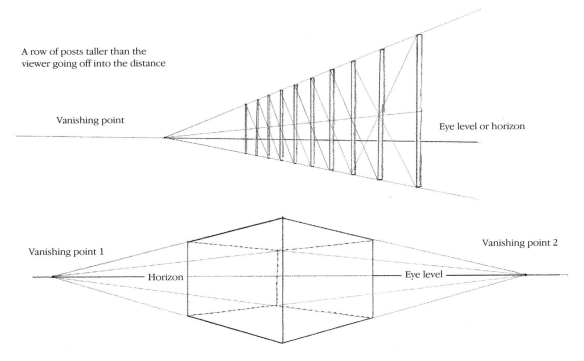

A row of posts taller than the viewer going off into the distance

Vanishing point

Eye level or horizon

Vanishing point 1

Horizon

Eye level

Vanishing point 2

In the constructed cube alone the size is inferred by the height above eye level, which makes this appear to be the size of a small house. The dotted lines show the far side of the cube, invisible to the eye (unless the cube is of glass). It is noticeable that not all the lines are parallel to each other, as they are in the cubes drawn at the front of this book, but actually follow the rules of perspective which takes the lines to the two vanishing points. This device is very convincing to the eye, and it is the great re-discovery of the Renaissance artists (particularly Brunelleschi), which had been lost as an aid to drawing since Roman times.

AERIAL PERSPECTIVE

Another rule of perspective is that as an object recedes from the viewer, it becomes less defined and less intense, thus both softer outlines and lighter texture and tone are required when we draw an object that is a long way off. These techniques also help to cheat the eye into convincing the viewer he is looking into a depth when he is in fact gazing at a flat surface.

Look at the drawing below and note how the use of aerial perspective and a few simple techniques gives the eye an impression of space moving out into the distance.

The tree in the middle ground has less texture and intensity than the bush.

The trees in the further distance are less well defined and more generalized in shape.

The nearest bush is still fairly strong in texture, in contrast to the tree.

The hills in the background are softer and fainter in definition.

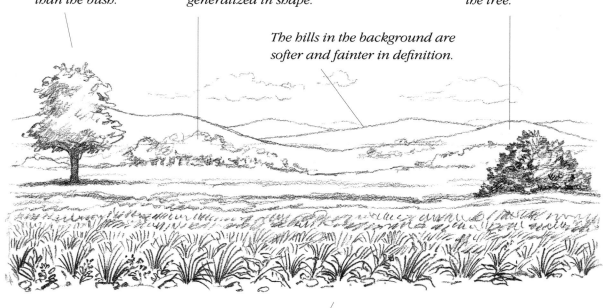

Detailed and strong texture and definition in close foreground. Gradually the grass loses its intensity and detail as it recedes.

DRAWING PLANTS

When drawing plants, start by observing the growth pattern of the plant. Observation is the key, because once you can see how the plant grows and the forms the leaves and petals take, it is quite easy to draw it and to invent it.

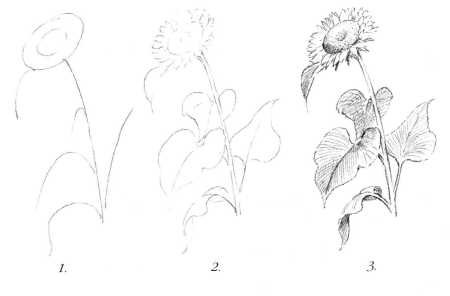

1. 2. 3.

1. Build up from a very simplified growth shape, noting the basic shape of the blossom and the characteristic line and position of the leaves.

2. Draw in the main shapes of the petals and leaves in their simplest forms.

3. Now draw in all the details, including the slight differences in leaves and petals.

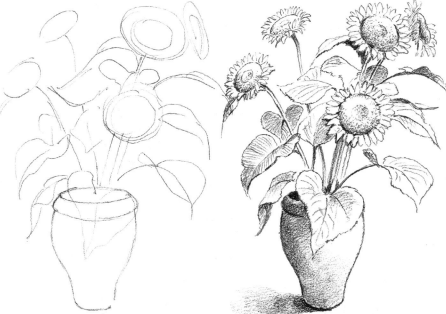

When you have completed this, try drawing a more complex group of flowers or leaves. You could use several examples of the same flower as we have done here.

CHOOSING A LANDSCAPE
The easiest landscape to start with is what is outside your window. What you see will be helpfully framed by the window, saving you the task of deciding on how much or little to include. Going out into the countryside will give you greater scope.

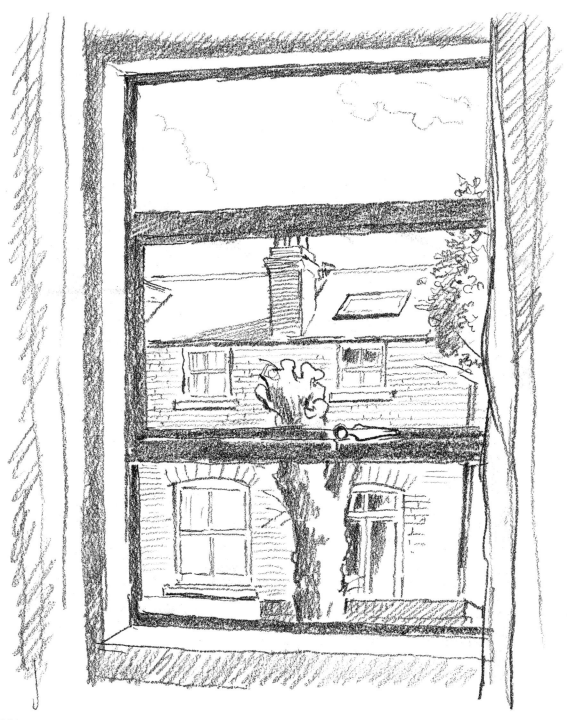

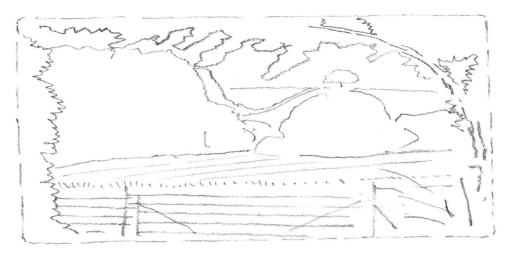

Once a scene is chosen, the main areas are drawn very simply. Noting where the eye level or horizon appears in the picture is very important.

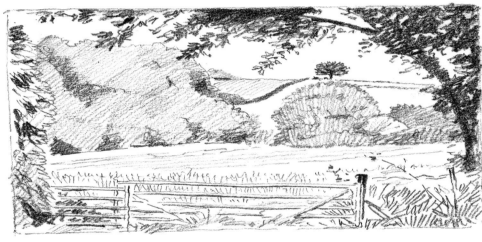

Attending to these basics makes it much easier to draw in the detail later.

The hands can be used to isolate and frame a chosen scene to help you decide how much landscape to include.

A card frame can be used instead of the hands.

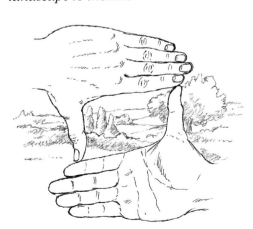

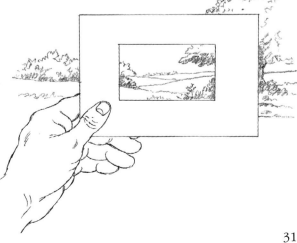

ANIMALS SIMPLIFIED

Drawing animals can be difficult. Rarely will they stay still long enough for careful study, although occasionally this can be achieved when, for example, a cat or dog is sleeping. Probably the best way to approach this subject is to find really clear photographs or master-drawings and carefully copy the basic shapes from these. You can see from the pictures of animals in this book how easily their main shapes can be drawn or even traced. Reducing the animal to simple shapes takes you half-way to understanding how to draw them. Once you have the outline the only problem is to draw in the details of texture and pattern: this does require more careful study.

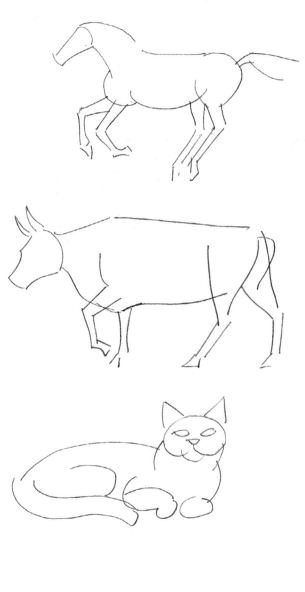

Try copying the drawings of animals on these pages. When you have done this, try applying the same simple analysis of shapes to illustrations of other animals.

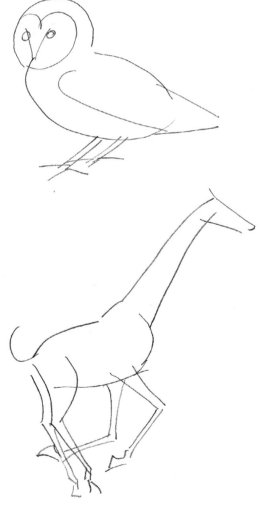

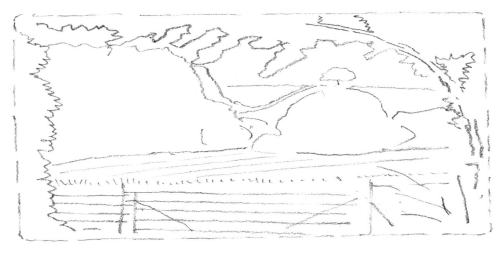

Once a scene is chosen, the main areas are drawn very simply. Noting where the eye level or horizon appears in the picture is very important.

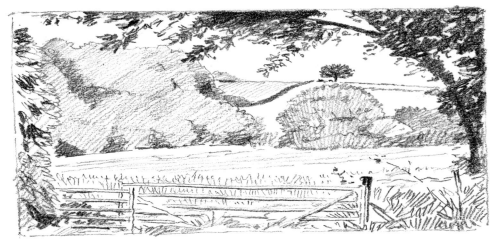

Attending to these basics makes it much easier to draw in the detail later.

The hands can be used to isolate and frame a chosen scene to help you decide how much landscape to include.

A card frame can be used instead of the hands.

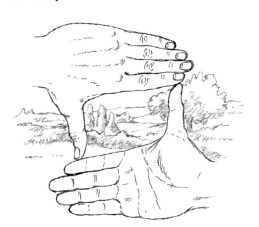

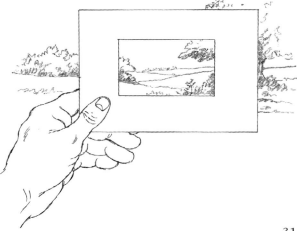

ANIMALS SIMPLIFIED

Drawing animals can be difficult. Rarely will they stay still long enough for careful study, although occasionally this can be achieved when, for example, a cat or dog is sleeping. Probably the best way to approach this subject is to find really clear photographs or master-drawings and carefully copy the basic shapes from these. You can see from the pictures of animals in this book how easily their main shapes can be drawn or even traced. Reducing the animal to simple shapes takes you half-way to understanding how to draw them. Once you have the outline the only problem is to draw in the details of texture and pattern: this does require more careful study.

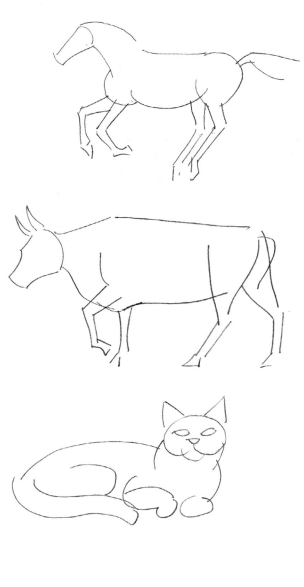

Try copying the drawings of animals on these pages. When you have done this, try applying the same simple analysis of shapes to illustrations of other animals.

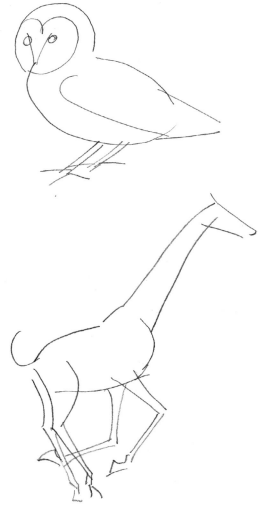

We will return to this type of drawing in more detail later in the book on pages 108–115.

THE HUMAN FIGURE: PROPORTIONS

As you can see from the illustrations shown here, the proportions of both male and female are similar vertically but differ slightly horizontally. The widest area of a man is usually his shoulders, whereas in a mature woman it is usually the hips. Generally, but by no means universally, the male is larger than the female and has a less delicate bone structure.

The difference between a fully grown adult and a child is more dramatic, with the average child's head being much larger in proportion to the rest of the body. Usually the legs and arms are the slowest to grow to full size.

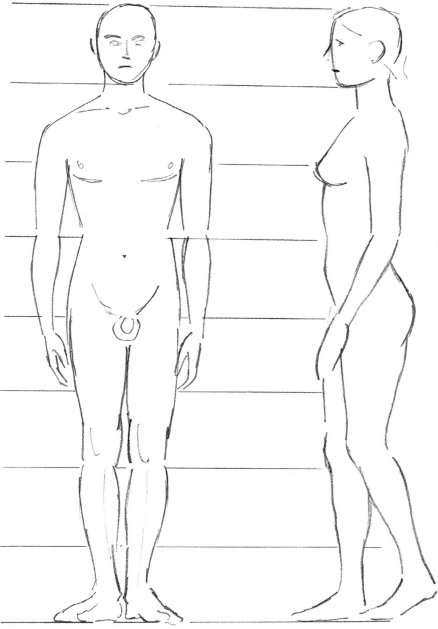

The illustrations on both pages show the proportions of a man and woman based on the classical ideal. The proportions given are based on the length of one head, which fits into the full length of the body about eight times.

Not many people conform exactly to the classical ideal of proportion, but it is a reliable rough guide to help you draw the human figure. These proportions only work if the figure is standing straight and flat with head held erect.

Classical proportion is worked out on the basis of the length of one head fitting into the full height of the body eight times, as you can see below. The halfway mark is the pubic edge of the pelvic structure, which is proportionally the same in males and females. The knees are about two head lengths from the centre point. When the arm is hanging down loosely the fingertips should be about one head length from the central point.

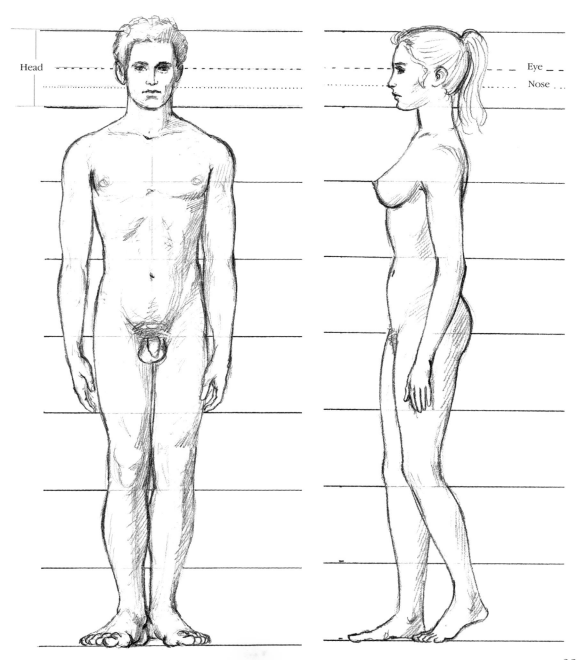

Head

Eye

Nose

THE HEAD: PROPORTIONS
Most of the significant differences evident in the face are due to variations in the fleshy parts rather than in the underlying bone structure. However, the forehead, cheekbones and teeth can be more prominent in some people than in others. A child shows a smaller jaw, which is the last part of the bone structure of the head to develop.

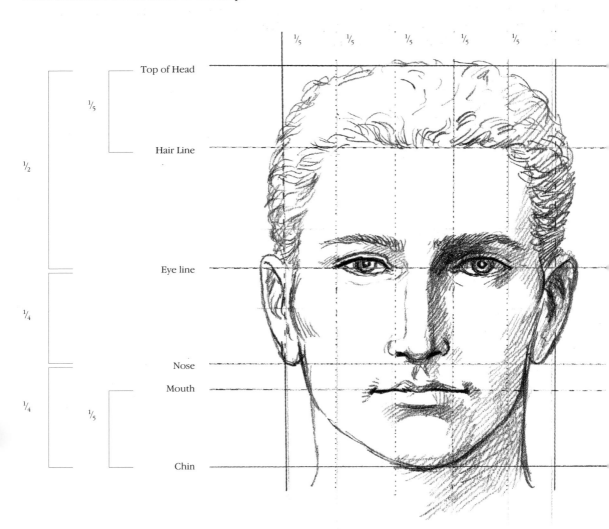

The main divisions proportionally can be clearly seen here. The eyes are half-way down the head and the length of the nose is about a quarter of the full length of the head. The mouth is about one fifth of the length of the head from the base of the chin if we measure to where the lips part. The width of the head when looked at full on and in profile is about three-quarters of the length of the head.

 When a subject is viewed face on, the distance between the eyes is one-fifth of the width of the head. The length of each eye from corner to corner is also one-fifth of the width of the head.

Unless there is balding, the hair takes up about half the area of the head. This is calculated diagonally from the top of the forehead to the back of the neck, as shown.

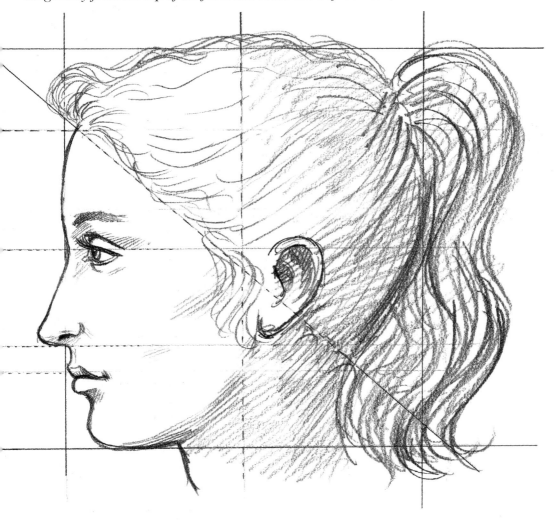

A common error when drawing is to put the eyes too close to the top of the head. This happens because the tendency is to look only at the face. Learning to take in the whole head as you work is vital if you are to capture the correct proportions of your subject.

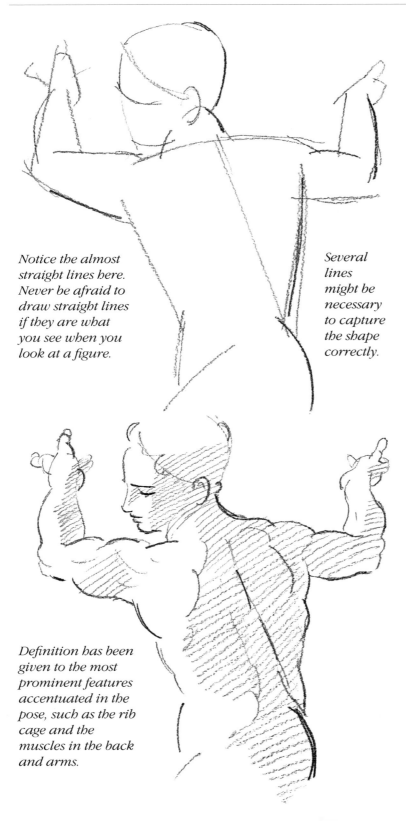

Notice the almost straight lines here. Never be afraid to draw straight lines if they are what you see when you look at a figure.

Several lines might be necessary to capture the shape correctly.

Definition has been given to the most prominent features accentuated in the pose, such as the rib cage and the muscles in the back and arms.

LOOKING AT FIGURES

When a beginner looks at the human figure, the greatest difficulty facing him or her seems to be where to start. There is so much to see that it can be confusing. Most artists try first to visualize the shape of the figure in its simplest form. That is, to see its almost geometrical character.

In the example shown here, the back is almost triangular until the point where it joins the hips. The arms, which are partially foreshortened, are simple, soft cylindrical shapes. The head is a slightly square egg shape.

If the artist can see these main shapes within a figure, it makes the task a great deal easier.

The basic shape and areas have been sketched in first. This is called blocking in the main shapes. In the second illustration, the shapes, although drawn in more detail, retain their simplicity. The lines are light and soft so that alterations can easily be made. This is the stage that professional artists work really hard at – correcting and re-correcting to get the shape right.

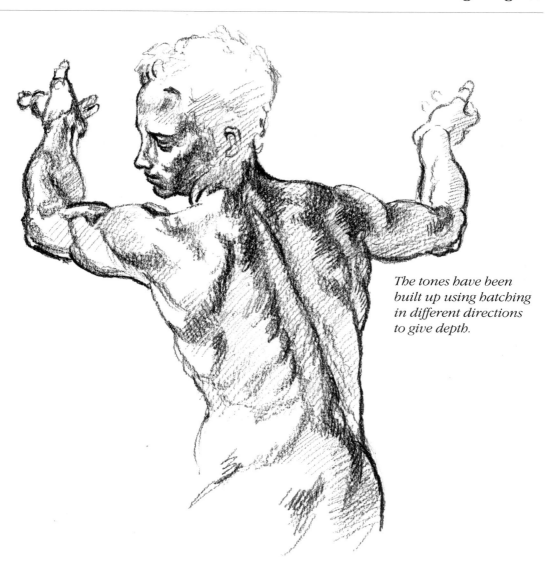

The tones have been built up using hatching in different directions to give depth.

Tone is what gives a drawing its finished appearance. You will notice that in the second illustration a light tone has been applied in large areas. In the final drawing the darkest tone was worked in first. With the lightest and darkest tones in place, the final decision was to work out the variation in tone between these extremes. Usually two or three tones are all that are needed to finish a drawing.

It is difficult to keep viewing a figure as a whole without someone being there to constantly remind you, but it is important not to concentrate exclusively on one area. If you want to get good at drawing figures, make an effort to draw each part of the figure in some detail over a period of weeks or months. Drawing the same parts over and over again will only improve them at the expense of some other area of the body, and expose your technical weaknesses.

WHEN THE RIGHT SIZE IS THE WRONG SIZE

The drawings of objects and figures produced by beginners are usually rather small. This is due to the phenomenon of drawing what is called 'sight-size': the size a subject or object appears to your eye. As you can see from the illustrations here, if you let this be your guide, the size of that subject or object on the paper will be remarkably small. The margin for error at this size is equally small. Sight-size does have its uses though, and the beginner may use it for measuring the shapes of very large objects, buildings or landscapes.

So, to start with, always draw to the largest size possible. On your sheet of paper, the objects or figures should take up most of the space. This is true whether you are drawing in a sketchbook at A4, on a sheet at A2 or on a large board at AO. If you draw large you can see your mistakes easily and are able to correct them properly because there is plenty of space to manoeuvre.

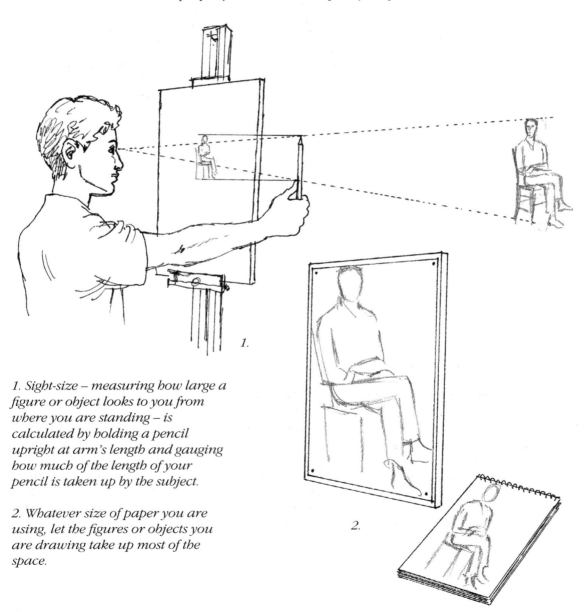

1. Sight-size – measuring how large a figure or object looks to you from where you are standing – is calculated by holding a pencil upright at arm's length and gauging how much of the length of your pencil is taken up by the subject.

2. Whatever size of paper you are using, let the figures or objects you are drawing take up most of the space.

The bigger the paper you use, the bigger your drawing has to be. This may seem daunting but it will give you more confidence when you get used to it. When you draw large, you begin to worry less about mistakes and have more fun correcting them. Eventually, of course, you can learn to draw any size: from miniature size to mural size is all part of the fun of learning to draw.

When you begin to feel more confident, fix several strips of underlay wallpaper to a wall and draw heroic size – that is, larger-than-life size. You will find the proportion goes a bit cock-eyed sometimes, but don't let that worry you. Drawing at larger-than-life size can be a very liberating experience. It can also show you where you are going wrong technically. Once you have identified your particular tendency for error, you will find that correcting it is relatively easy, enabling your skill to take a further step in the right direction.

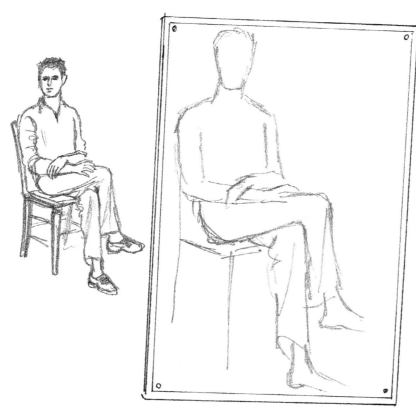

Drawing at larger-than-life size is both liberating and instructive. Errors are more easily seen and more easily corrected.

To start with you will probably find it difficult to draw large and will have to keep reminding yourself to be bolder and more expansive. It seems so natural to draw at sight-size in the beginning, but this has more to do with our natural self-consciousness and a mistaken belief that the smaller the drawing, the smaller the error. Once you discover how much easier it is to correct a large drawing, you will not want to go back to drawing at sight-size.

Object Drawing and Still Life Composition

In the last section you began to exercise your artistic talents by covering a wide range of drawing subject matter. Next you will be shown in greater detail how to expand upon and practise what you have learnt. In addition to consolidating your technical ability, you will be encouraged to develop further the art of looking.

When you have had plenty of practice you will find yourself noticing all sorts of interesting details in the objects around you, not just in the ones you attempt to draw. You will discover that, for an artist, the world is never boring because there is so much to see. Each time you look at an object, you will discover something new, no matter how many times you may have looked at that object before. This enhancement of awareness will lead to your perception deepening, enabling you to penetrate to the essence of seeing.

OBJECTS OF DIFFERENT MATERIALITY

After you have learnt to draw the shapes of objects correctly in outline, you can then tackle a variety of objects of different materiality with a view to making still life compositions. Over the next few spreads, we will look at a range of such objects and the different approaches you might consider when you come to organize your own arrangements and subject matter.

First, try drawing this fir-cone, which is simple in essence but complex in detail. You will need to use your powers of observation and your ability to see an object as a whole to get this right.

1. Look hard at the object and see the whole shape. Draw the outline as simply and as accurately as possible.

1.

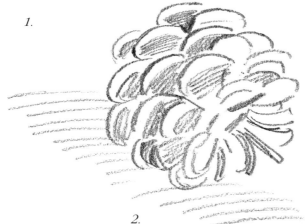

2. Now look at the various parts within the whole. Sketch in each shape within the overall shape you have already outlined.

2.

3. Once you have a sort of diagram of the object, you can draw in the details of light and shade, the exact shapes of each part and give dimension to your drawing.

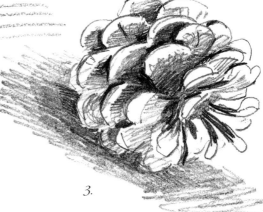

3.

Now try an object like a wineglass.

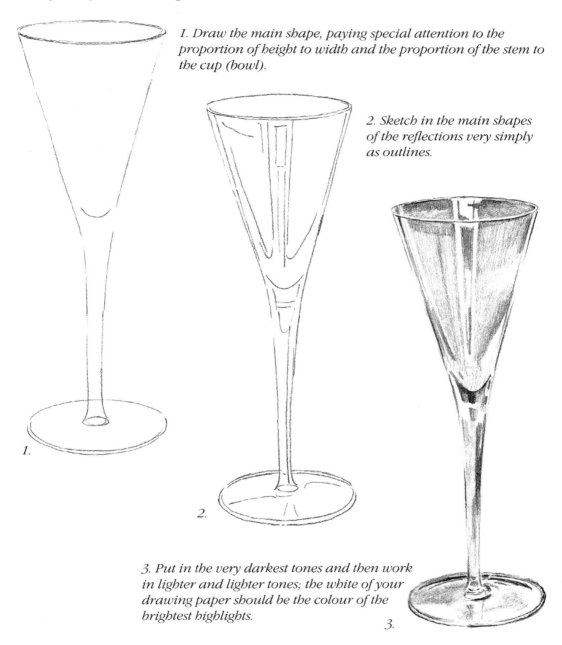

1. Draw the main shape, paying special attention to the proportion of height to width and the proportion of the stem to the cup (bowl).

2. Sketch in the main shapes of the reflections very simply as outlines.

1.

2.

3. Put in the very darkest tones and then work in lighter and lighter tones; the white of your drawing paper should be the colour of the brightest highlights.

3.

You'll find the approach outlined here quite effective. One point to watch: don't be confused by the subtleties of the tones, just simplify them. Make sure that the very strongest edges and shadows are vigorously put in, but be aware of the areas where they don't occur. In other words, the lines around the objects will not be even because some will be strong and clear and others soft and indistinct. If you observe this difference and get it right, your drawing will have much greater depth and dimension.

With a mechanical object – such as this cassette deck-cum-radio – the main problem is one of geometry. You must first draw a perspectively correct outline shape (in this case a rectangular box) which you then have to modify with curved dimensions. As the machine is man-made, there is a straightforward pattern to it, which you need to divide up simply.

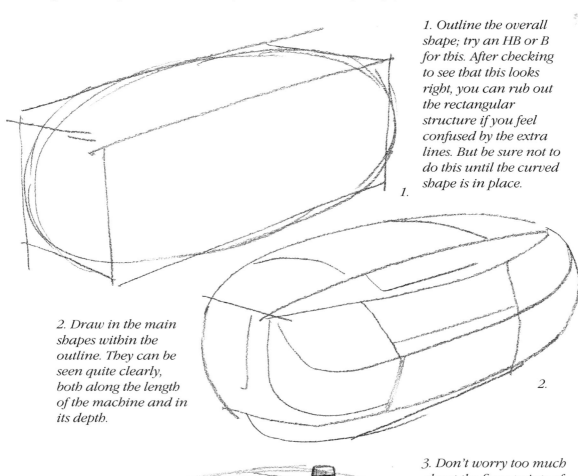

1. Outline the overall shape; try an HB or B for this. After checking to see that this looks right, you can rub out the rectangular structure if you feel confused by the extra lines. But be sure not to do this until the curved shape is in place.

1.

2. Draw in the main shapes within the outline. They can be seen quite clearly, both along the length of the machine and in its depth.

2.

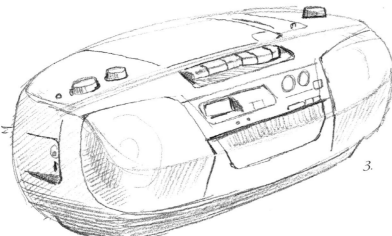

3.

3. Don't worry too much about the finer points of your drawing until you are confident about the main shape. Working out the texture and light and shade to give the machine height and depth is more important than the precision of details, such as push buttons, knobs, sockets and screens.

Try using a 2B or 4B for the tone. The variation between the line and tone will give a richer texture.

A SIMPLE STILL LIFE

Now we're going to try a simple still life arrangement. I have chosen a few oranges in a bowl for this exercise, because it poses an interesting challenge. The main problem is fitting all the oranges into the elliptical shape at the top of the bowl. Before you begin to draw what's in front of you, look at the composition closely for a few minutes to gain a sense of its size and proportion.

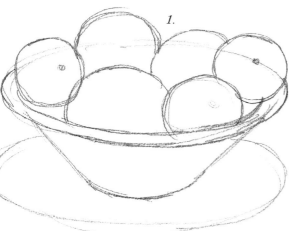

1.

1. First draw the outlines of each piece of fruit and the bowl. (Refer back to your practice of drawing ellipses on page 16.) Concentrate on getting the ellipse of the bowl right and the relative proportion of the bowl to the mass of fruit. Don't worry if the shape of the fruit isn't exact, just ensure that they fill the shape of the bowl effectively. At this stage, the precision of the drawing is not as important as getting the curves to look like the fruit.

2. Note the shape of the shadow cast on the table by the bowl. This will be a similar shape to the rim of the bowl. Observe the direction from which the light is coming, and then add the shadows very simply and lightly.

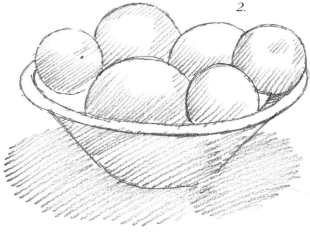

2.

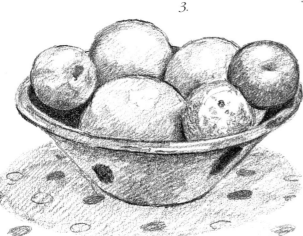

3.

3. Now elaborate on the tones of the shadows and any reflections in the bowl. As in previous exercises, use a light tone to block in the shaded areas. Then work on the variation in shadow and emphasize any edges that are well defined to the eye. Don't forget to leave your paper blank to indicate where the light falls most brightly.

Don't worry about the quality of the lines and shading when you first try your hand at drawing this watering can. It is an advantage if the result is a solid and chunky looking object. Accuracy of shape is good but atmosphere is better still, so don't be afraid to be expansive in your pencil work. The more battered an object, the less precise in geometric terms do its lines have to be.

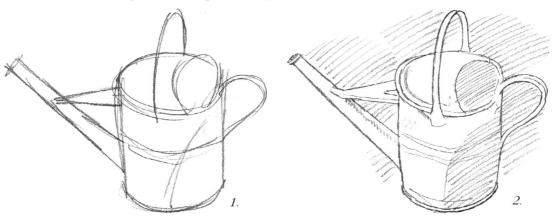

1. Draw in the main shape.

2. Block in the obvious areas of shadow using one fairly light tone.

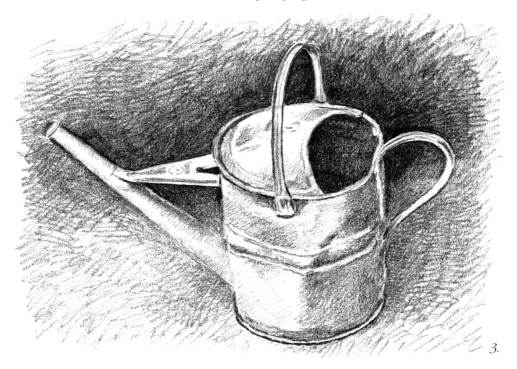

3. Now you can really go to work, giving plenty of texture as well as depth of tone to the object. The surfaces of the can will be worn and dented and have many small marks. Don't try to smarten them up. Let your pencil line reflect reality by keeping the texture gritty to give the effect of wear and tear.

With this wicker basket, your major problem will be how not to get lost in the complexity of what you're looking at. You need to discover the pattern of the weaving and decide how each piece of basketwork fits into the overall design. Once you have got the pattern worked out, you will not find the prospect of drawing it so daunting.

1.

2.

1. Draw a skeleton shape, outlining the basic structure of the main vertical struts and also the top and bottom of the basket.

2. Now draw the general effect of the weave. Pay particular attention to the top and bottom edges.

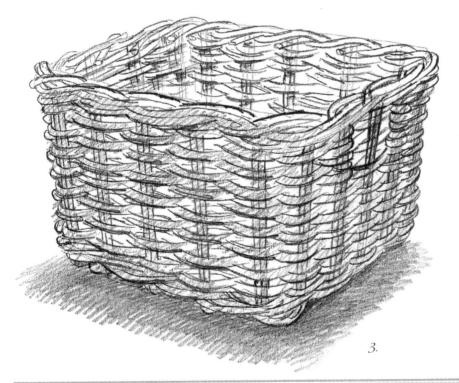

3.

3. Lightly sketch in the areas of light and shade, including the shadow cast on the surface the basket is resting on - in this instance a tabletop. Lastly, emphasize any lines that show up more clearly and where there are darker tones or shadows.

You can measure the objects you draw, by contrasting height and width and marking the central line through each object.

I got these bits of old hardware from a builder's workshop. Their complex shapes pose a very good test of drawing ability. When you first try to draw them, you may find it is impossible to get the proportions correct. Don't worry, just keep re-drawing and correcting your mistakes. The aim of these exercises is not to get them right first time, but to redraw and correct, to discover how you see the objects when you get used to them. The geometry may be complex or simple but the combination of shapes is always a challenge, even for a professional. So keep trying.

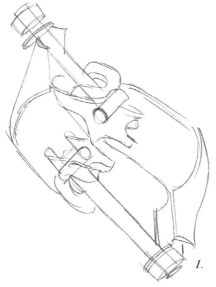

1. In very clear and simple outline, draw the shape of each element within the overall structure, being careful to relate the size of each piece as accurately as possible. If you don't succeed in doing this, your eye will pick up on it and you will realize that your drawing is not convincing. If you take pains to get this first stage right the rest of your drawing will be much easier.

2. When you are satisfied with your outline, give the detailed shapes within the main structure greater clarity. By drawing them as crisply as possible you will capture the machine precision that differentiates mechanical objects from natural shapes. Don't attempt any shading before the technical aspects of your drawings are right.

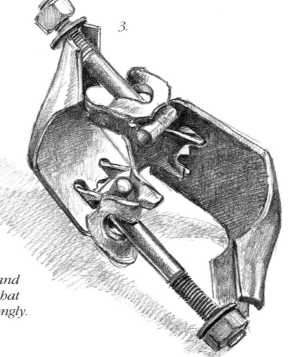

3. Finally, carefully put in the darks and lights of the reflections or textures so that the metallic quality comes across strongly.

Where you have an object that is composed of different shapes, it can be worth measuring each part against the others in order to get the proportions right.

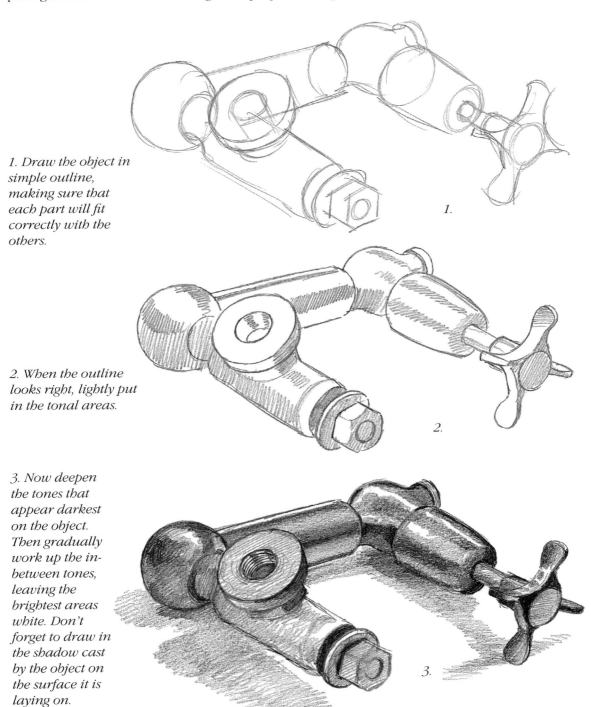

1. Draw the object in simple outline, making sure that each part will fit correctly with the others.

1.

2. When the outline looks right, lightly put in the tonal areas.

2.

3. Now deepen the tones that appear darkest on the object. Then gradually work up the in-between tones, leaving the brightest areas white. Don't forget to draw in the shadow cast by the object on the surface it is laying on.

3.

51

Over the next four pages you're going to practise drawing a series of different objects that vary in shape and function as well as materiality. Approach each subject in the way you have been shown in the preceding pages, concentrating first on structure and outline. Practice until you are sure of what each object looks like and how its structure can be shown.

Constant practice of drawing the structures of objects will help you to see in much greater depth and quality. Soon, when looking at objects, you will begin to pick up all sorts of subtleties that you may not have noticed before.

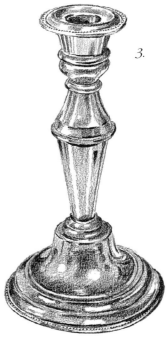

3.

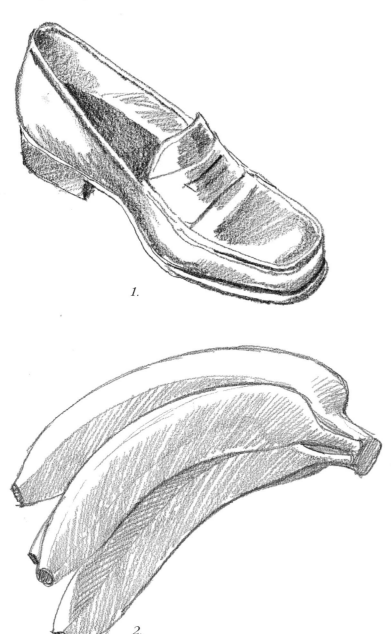

1.

2.

I have tried to reflect the material differences of these objects by using different grade pencils to produce variations in texture and tone.

1. This is drawn more coarsely in the tonal areas to emphasize the dark and light and give an effect of polished leather. I used a 2B.

2. These are drawn quite softly without too much contrast, using a harder B pencil.

3. This object shows the greater tonal contrast required for polished, metallic surfaces. For this I used a 4B.

Boots and shoes are satisfying objects to practise with, being rather characterful and also giving an impression of the absent wearer.

The examples of footwear shown below are less shiny than the shoe shown on the opposite page, being made from varieties of dull leather and kid, or suede. With these types of material, the handling of the tonal areas can be much looser to suggest the softer, non-reflective surface.

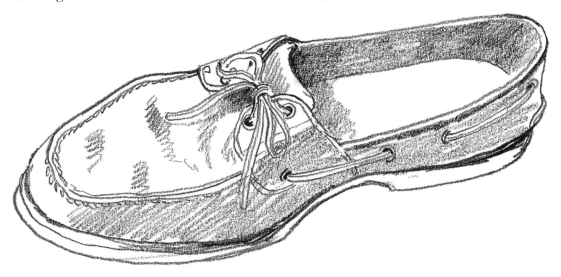

The rather wobbly line used here reflects the quality of softness characteristic of a moccasin.

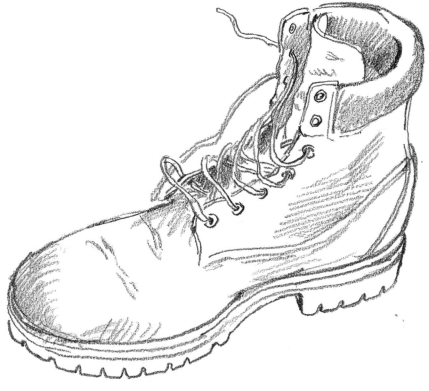

The sturdiness and rugged quality of this boot is achieved by not allowing the lines to be too smooth.

This next range of objects gives even more variety of texture and surface form. The headphones are slightly odd shapes and their form follows their function closely. The different types of stone share certain characteristics and yet are entirely individual.

1. The line chosen for these headphones can be anything from fairly loose to very precise. I opted for roughness over precision.

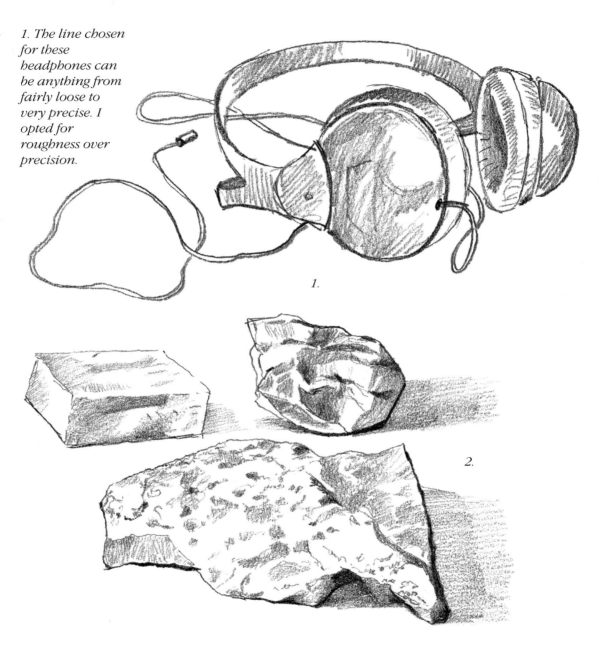

1.

2.

2. Correct drawing of form brings about the division of light and shade which enables the textural characteristics of an object to be shown. In these examples, those characteristics range from semi-transparency through chunkiness to density and crustiness.

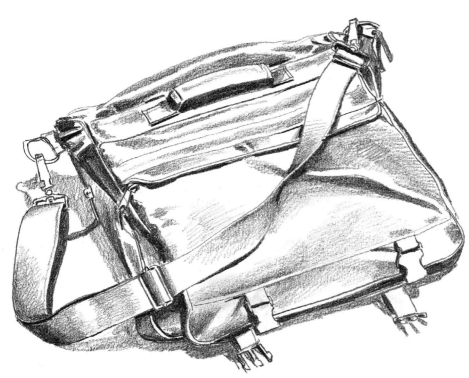

This satchel is drawn with quite dark shadows in a few places but is mostly fairly lightly toned to give the effect of a light-reflecting surface, although the material of the bag is black. If I'd felt it to be more true to the object, I could have put a tone of grey over the whole thing to indicate the colour.

The grain of the wood has been described in some areas to make this toy look more realistic. It's important not to over-do this effect and let the surface colour take precedence over the form. A good trick which helps to get this balance right is to look at the object you are drawing through half-closed eyes. You will immediately notice which parts are dark and which light.

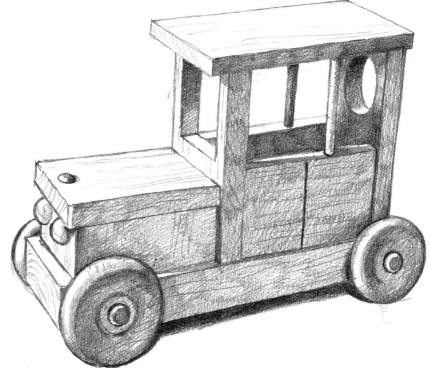

LOOKING AND DRAWING EXERCISES

Now give yourself a break from this regular drawing and try these two experiments which are favourite art school tests for new students. Both are limbering up exercises for what comes later.

1. Place a chair or stool against a simple background; just wall and floor. Now draw the outlines of the spaces between the legs and the struts and fill them in with shading or tone. The trick is to see only the shapes in the spaces rather than the object itself. Just go for the shape of the spaces between the parts and around the object. When you have done enough you will see the object in negative between the shaded spaces. Don't worry if you go wrong – have another go.

This exercise shows there are no empty spaces in any view of the world; there is always something, even if it is only the sky. This realization gives us tremendous freedom from trying to make objects purely representations of themselves.

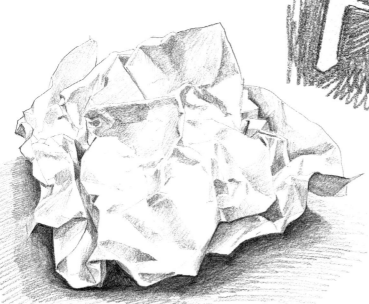

1.

2.

2. A more difficult test of looking and drawing is to take a sheet of paper, crumple it up, open it out a bit and then place it in angled light. Start with a small piece of paper slightly crumpled and progress to a larger sheet with more complicated crumpling. Carefully draw all the shapes, putting in the light and shade as you go.

This exercise is tricky to start with but does get easier with practice. The fun comes in seeing how many facets of the crumpling you leave out because you've got the shapes incorrectly aligned! You'll probably need three or four attempts at getting it about right.

The mere effort of trying to get your final drawing absolutely accurate will sharpen your attention to detail and help you to keep the overall picture in view. This will be invaluable later on when you come to tackle more difficult subjects.

STILL LIFE THEMES

When you have mastered the basics of structure and materiality, you can then consider devising a still life that incorporates different yet related objects, reflecting a common theme. A still life arrangement may present itself, as did the one shown here, incorporating a knife, worktop, pineapple and chopping board. Kitchens are good sources of this type of spontaneous still life, which look natural because it reflects an activity that you just happened upon and did not orchestrate.

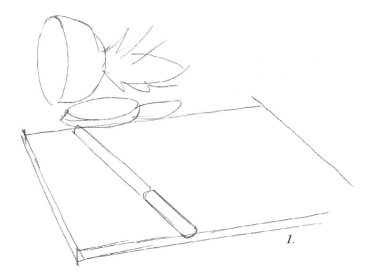

1. Draw the faintest outline to ensure that the proportions work well and that the angle of the knife and the size of the pineapple make sense visually.

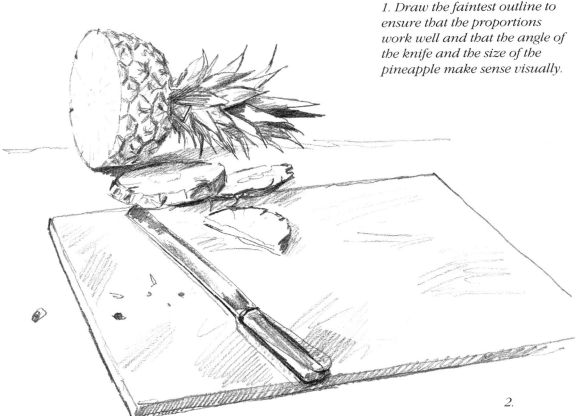

2. Add texture and tone to give the picture more material conviction. There was not a lot of shadow in the arrangement, but the different textures helped greatly to give depth and weight to the objects.

STILL LIFE THEMES

Before you tackle a group of objects as a still life, it's a good idea to draw them as individual items but close enough on the paper to relate them. When you have done this, repeat the exercise, only this time with the objects grouped; you might want to arrange them so they overlap, as in the examples shown on the next page.

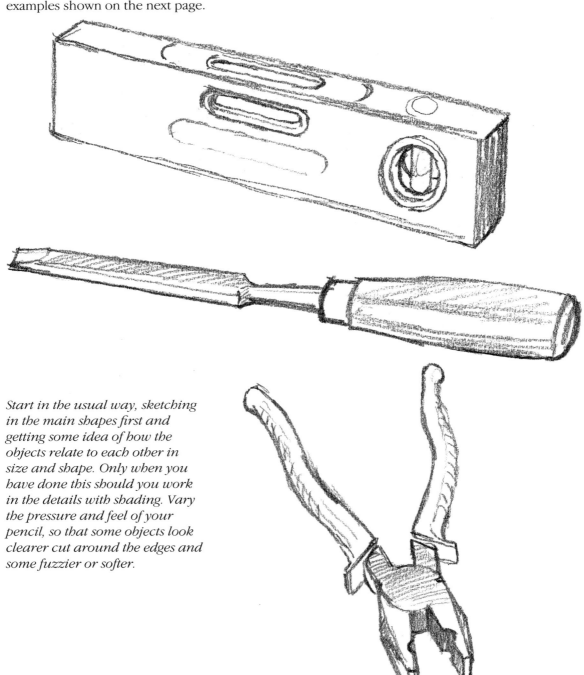

Start in the usual way, sketching in the main shapes first and getting some idea of how the objects relate to each other in size and shape. Only when you have done this should you work in the details with shading. Vary the pressure and feel of your pencil, so that some objects look clearer cut around the edges and some fuzzier or softer.

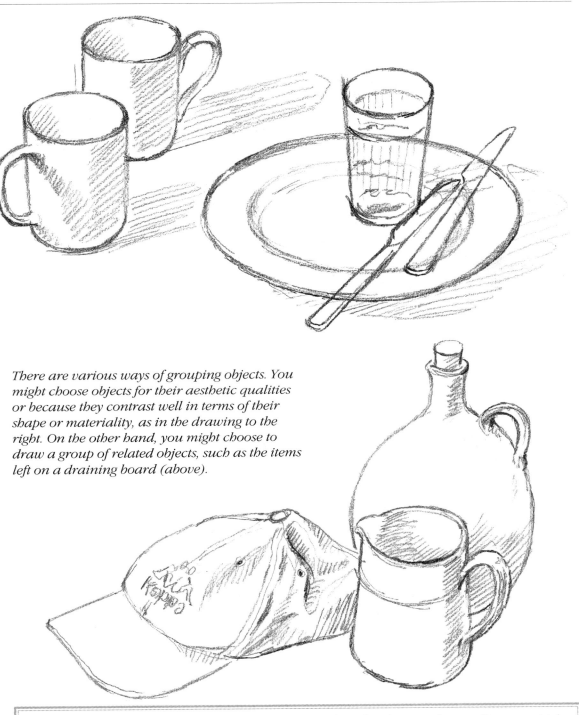

There are various ways of grouping objects. You might choose objects for their aesthetic qualities or because they contrast well in terms of their shape or materiality, as in the drawing to the right. On the other hand, you might choose to draw a group of related objects, such as the items left on a draining board (above).

Continually experiment with how you draw lines and use hatching, and try to discover which approach produces the most effective result. No two objects require the same treatment. Try drawing the same objects first in very clean-cut lines and then in very soft wobbly lines. Now compare the results. There is no absolutely right way of drawing. Trust your own judgement: if a result interests you, that's fine.

The great still life painters – such as Chardin, Cézanne and Morandi – often made use of similar objects time and time again. Here are copies of three of Chardin's still lifes for you to consider.

Notice how all three arrangements use very similar objects with variations in their balance and composition. The contrast between the height of one object and the rest, the variation in size of objects, the grouping of shapes to counterbalance and contrast to create interest to the eye – these elements show the master touch of Chardin.

These jugs and glasses and pots and pans look deceptively simple, but Chardin's great talent with soft and hard edges, brilliant reflections and dark soft shadows creates a marvellous tone poem out of quite ordinary objects. Really there is no such thing as an 'ordinary' object. When the subtle perception of an artist is present in a work, everything becomes extraordinary.

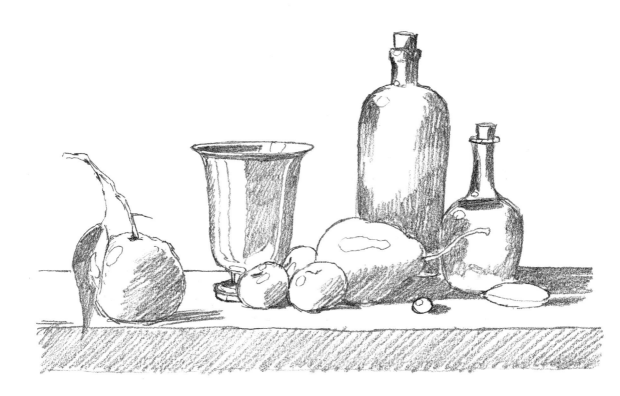

This composition relies for its effect on the different sizes of the objects and the spaces between them. The objects are almost in a straight line but there is enough variation in depth to hold the viewer's interest.

The pestle and mortar seem to be standing alone in opposition to the over-whelming, almost open-jawed presence of the pan.

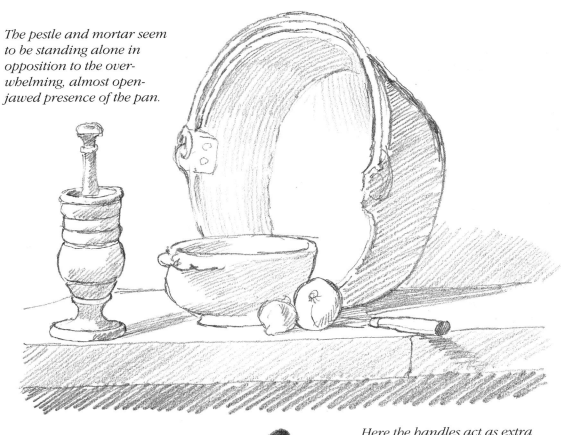

Here the handles act as extra dynamic shapes, defining the intervening space. The distance between these items, the eggs nestling against them as if seeking protection and the pepper mill at the edge of the table, produce an interesting tension.

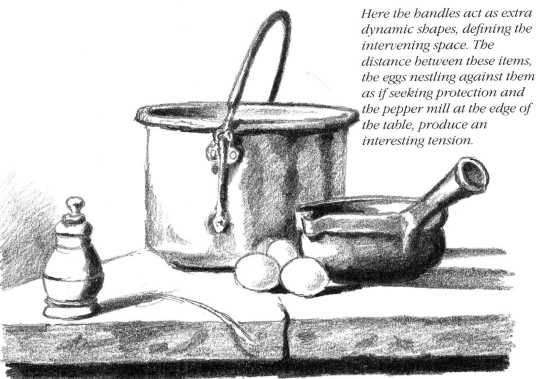

This arrangement of a still life in the Dutch manner, by Carol Griffin, is simple yet effective, and an interesting grouping of disparate shapes. The violin and the metronome are the dominant features, but the bowl of fruit stops the arrangement from being a musical still life. The balance between the objects gives a certain stillness to the whole. The shadows help to give definition to the composition as well as underlining the violin's dominance. They link the solitary piece of fruit outside the bowl to the rest of the composition and also put a question in the viewer's mind about the unity of the elements.

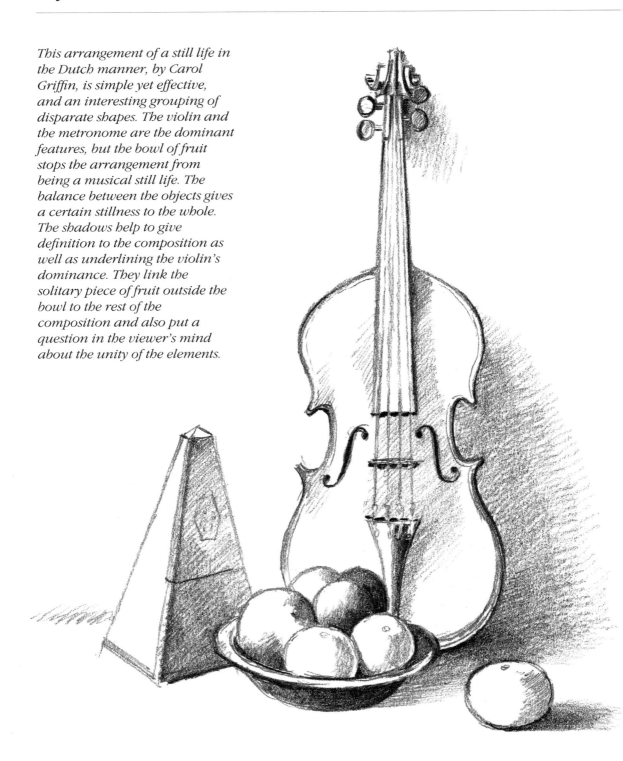

This next composition is, again, a very simple but effective arrangement. Both elements contribute to the strong effect of the contrast between the rigid angularity of the chair and the soft, fluid lines of the material of the overcoat.

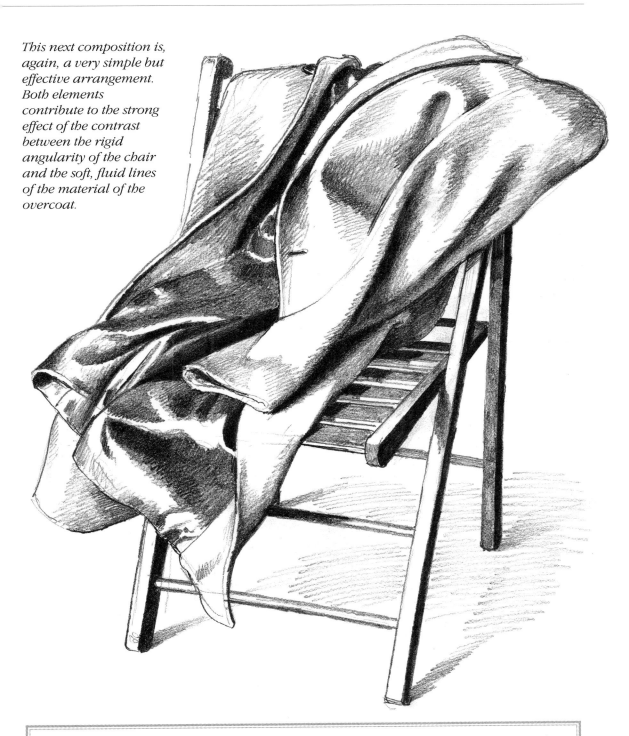

The more you try to draw objects and constantly make the effort to correct your work, the keener your own perception will become. In time you will draw with something approaching the quality that a practised artist appears to achieve with ease.

DIFFERENT ASPECTS OF STILL LIFE
All successful still-life arrangements exploit different aspects of the genre. In this series of copies of the works of professional artists, note how the objects are used either to repeat and reinforce the feeling of the group or, conversely, to interrupt and contrast the various elements. Either of these ways works depending on the effect you want to achieve.

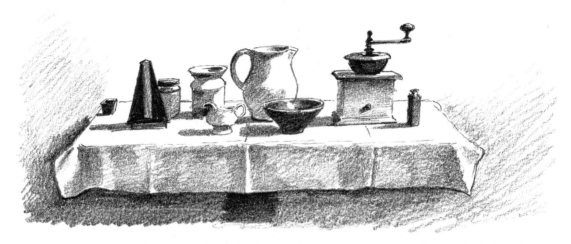

In this arrangement of a group of hard-edged objects, by Charles Hardaker, the interest appears to be in the variety of vertical shapes laid out on the brightly lit tablecloth with the table hidden beneath. This is a sharp, clear, lateral composition.

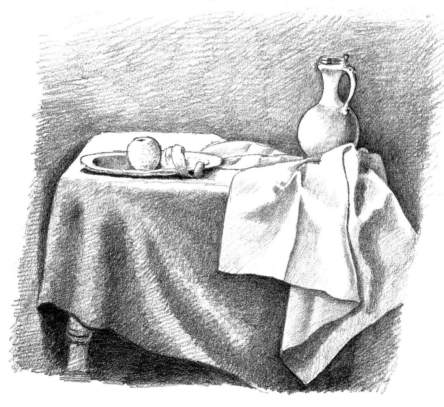

This cunningly arranged still-life, a copy of a Vermeer, is given its effect by the large light cloth folded over and draped across the corner of the table with the uneven tablecloth acting as a darker foil. The plate with a peeled fruit and the elegant jug contrasting against the soft shapes of the cloth add drama to the composition.

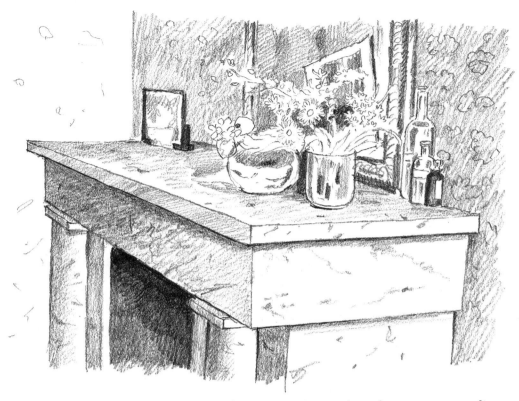

This copy of a Vuillard takes a very ordinary situation and produces an extraordinary piece of art out of it. It is a brilliant exercise in form and tone. The interest comes from the ephemeral objects set apparently accidentally on the solid, staid chimney-piece.

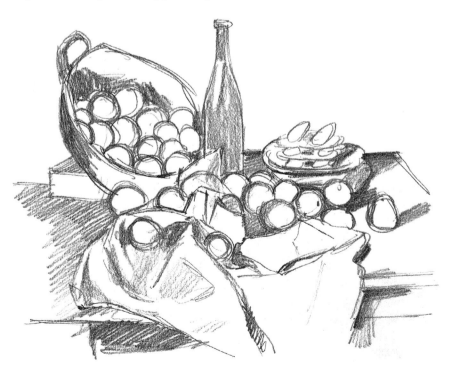

In this copy of a Cézanne, the bottle and folds in the tablecloth give assistance as a vertical element to the spilled abundance of fruit in the centre of the picture. The relationship of the structure of each object is submerged into the main shape and yet runs through the whole picture to make a very satisfying composition.

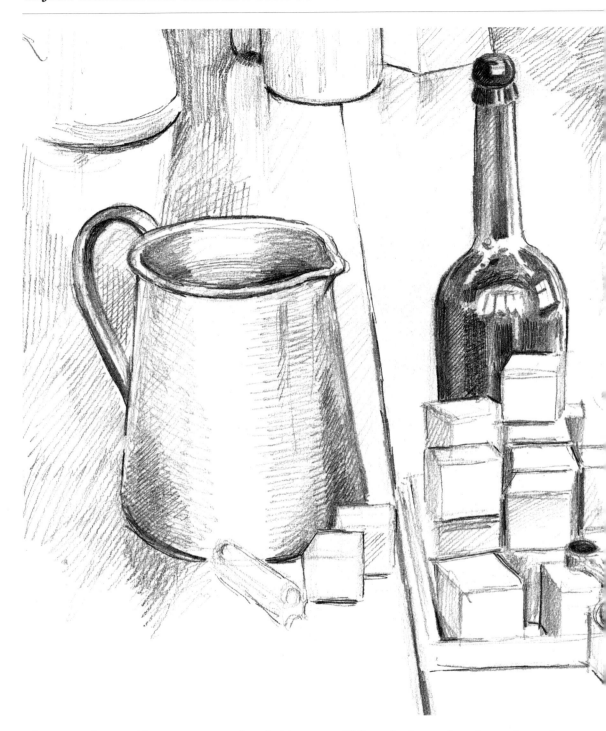

Place on a large table as many unrelated objects as will fit on it, then take a large sheet of paper and start drawing the objects, working your way across from one side of the paper to the other. When you have covered this first sheet, take another, move round the table and draw the objects you see, again starting at one edge of the paper and moving across.

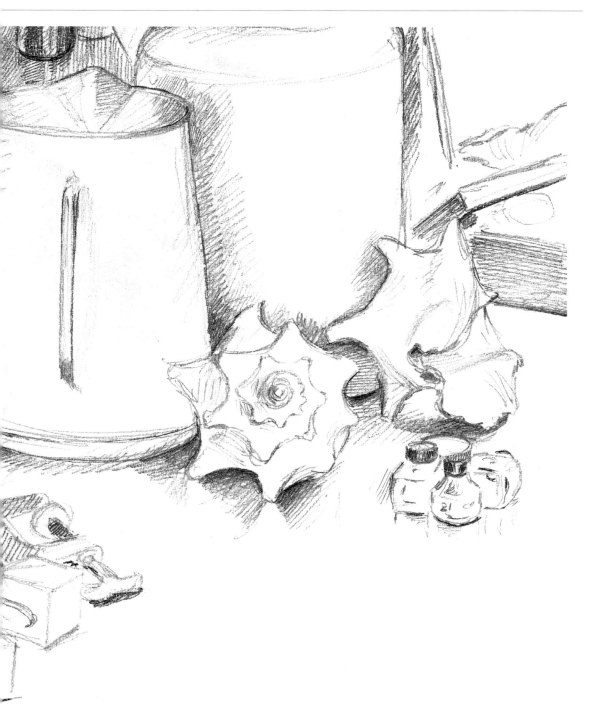

Each time you complete a page and move round to a new viewpoint, you will find that you have to relate the size of each object to the one next to it and include all objects in the background. Don't worry if you lose the composition, just keep observing and drawing. Don't concern yourself with the results either. The idea of this exercise is to keep you drawing for as long as possible, so that what you are doing becomes second nature.

STILL LIFE IN A SETTING

The last stage of still life drawing involves perspective and brings us naturally into the next section of the book. On this spread we look at still life compositions that incorporate the room in which they are set. This is a natural progression but, of course, involves you in more decision making. How much of the room should you show? How should you treat the lighting? Probably the best lighting is ordinary daylight and I would advise you to use it whenever possible. The extent of room area that you show depends on your confidence.

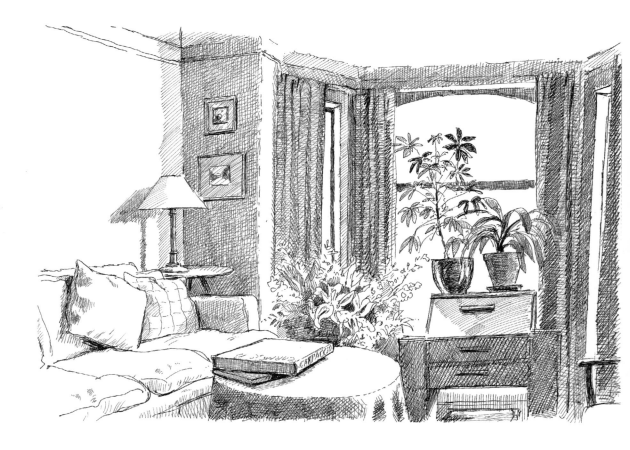

The interest in this drawing of one end of a room is with the objects set in the window and in various places around the room.

With an extended still life it is important to observe the details of the furniture and other main elements, such as the window frame. If your picture is to be a success, you must also be very aware of the source of light and make the most of how the shadows fall.

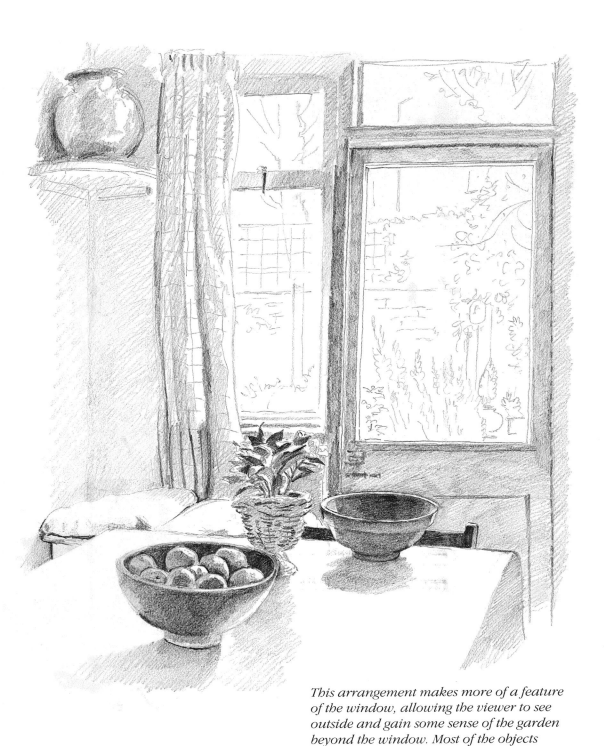

This arrangement makes more of a feature of the window, allowing the viewer to see outside and gain some sense of the garden beyond the window. Most of the objects shown are confined to the area of the table.

LARGE OBJECTS

Now we come to objects that cannot normally be considered as still life objects because of their size. You will have to step out of doors in order to draw them, and encounter the wider world.

There is very little cosmetic design to a bicycle and the interest for the artist is in the unambiguous logic of its construction.

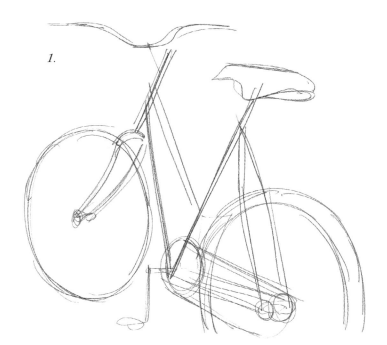

1.

1. Make a quick but careful sketch of the main structure, including the wheels; this is another opportunity for you to look at ellipses (see page 16). Ensure that the long axis is vertical. Now check that the proportions and angles are correct.

2. Begin to build on this skeleton, producing a clear outline drawing showing the thickness of the metallic tubes and tyres and the shapes of the saddle, handlebars and pedal and chain areas. Be careful to observe the patterns of the overlapping spokes on the wheel.

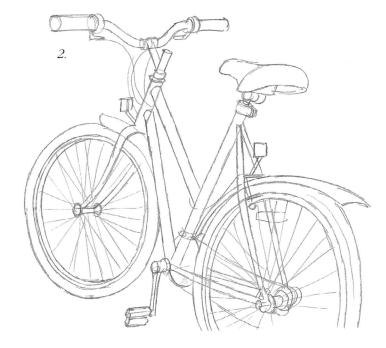

2.

*3. Add a bit of toning
and some lines to
emphasize the
shapes.*

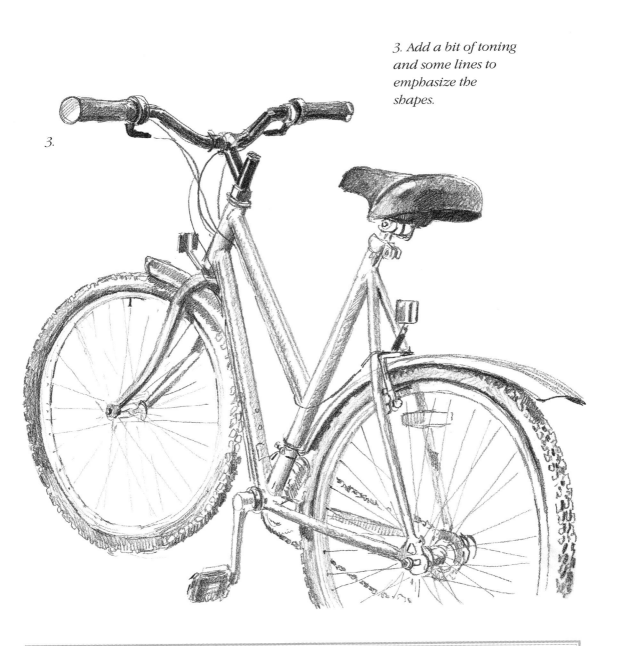

3.

The main problem the artist encounters when drawing machines such as bicycles, motorbikes or cars is how to retain a sense of the complete structure without losing the proportions of each part. Don't try to be too exact with the details. Concentrate first on simply sketching the main structure of the machine. You will find this structure has a sort of logic to it, which is why it works as a machine. To get such a drawing to work visually you have to see the object as its designer might have envisaged it.

I have deliberately drawn this motorcycle quite graphically. The style is intentionally slightly awkward, to convey a mechanical feeling. There is no need to produce a perfectly measured designer's drawing.

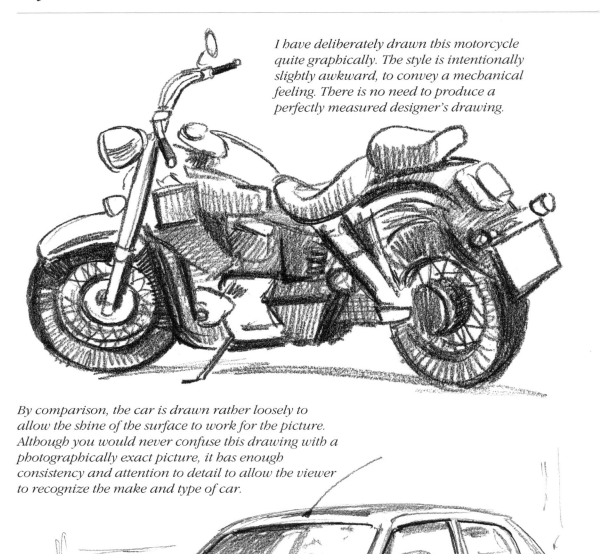

By comparison, the car is drawn rather loosely to allow the shine of the surface to work for the picture. Although you would never confuse this drawing with a photographically exact picture, it has enough consistency and attention to detail to allow the viewer to recognize the make and type of car.

Here we have two large dynamic objects. The Jeep has a chunky sleek look and a soft line actually enhances the shiny but solid look of the vehicle. Cars are, of course, plentiful and do keep still, as long as the owner doesn't suddenly jump in and drive off while you are in full flight of creative work. The boat has a sharper profile and more elegant line.

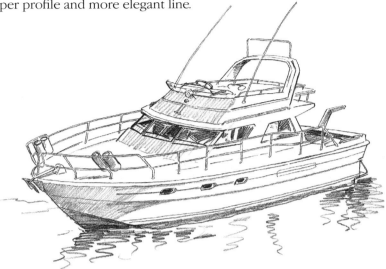

Here, the overall light colour contributes to the illusion of sleekness. Tone has been used sparingly; some is needed to indicate the shapes but the reflected light from the water and the white painted hull and super-structure call for brightness and well defined lines.

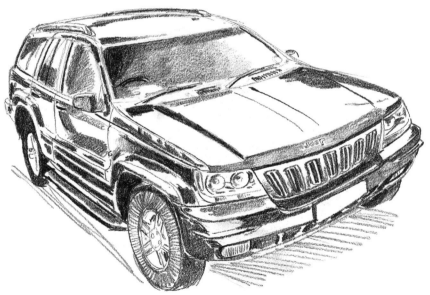

The slightly bulging shape of this rugged vehicle is given even more prominence by the angle. This viewpoint emphasizes the machine's strength and power, without making it look threatening.

An item of machinery can dominate a still-life composition, so long as the setting you choose seems right for it. A backdrop for a bicycle might be a hallway, a backyard or a garden, for example, or even the front of a house. A car would look at home as part of a street scene or centre stage in a garage with the door open. Such a scenario would give some interesting lighting, especially if there were other related objects close by. The possibilities are endless.

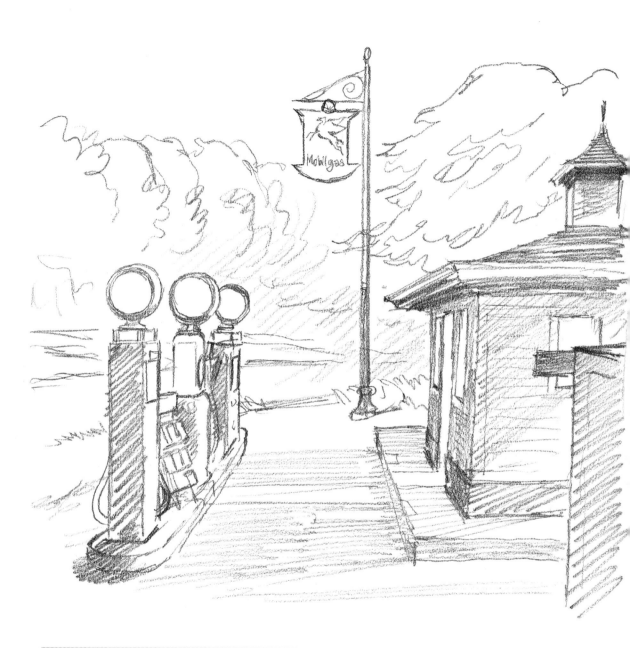

The style of your drawing can vary enormously and you should try to use different ways of handling line and texture until you find ways that suit your approach. Try sometimes drawing at speed without correcting much and sometimes proceeding very cautiously, making careful mark after mark, slowly building up a convincing effect.

However brilliant a drawing of an object might be, it is not actually that thing but an interpretation of it, a sort of visual reminder of what something might look like.

LARGE OBJECTS IN A SETTING
In both of these compositions the use of perspective is essential to their success. The styles adopted are also strikingly different, to fit their subject-matter.

In the revised copy of an old petrol station at night, by American artist Edward Hopper (opposite), I have deliberately omitted the figure that is in the original. The drawing derives its power and its interesting atmosphere from the strong shapes and unusual lighting.

The drawing of a modern petrol-station (below) is very contemporary and quite different in feel and look from the copy of the Hopper. The petrol station looks like a drive-in supermarket. Everything about the image is sharper, pristine even, and the car is redolent of power and speed.

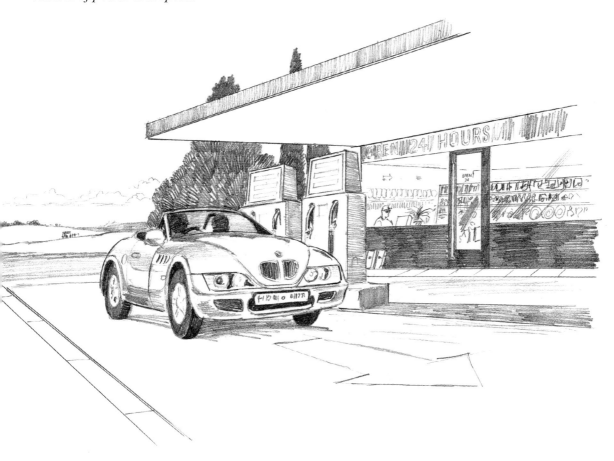

More About Perspective

Including some perspective in your drawings is a natural result of opening up your viewpoint. Diagrams can help you to understand what you are seeing. Obviously they are not quite true because in real life the eye moves around and looks up and down; the view as seen through a fish-eye lens would probably be more correct. However, the mind interprets the view seen and supplies the knowledge that, for example, the walls are really vertical and that the lines are really straight, and so the eye adjusts to accept this reality.

In this section we shall be looking at various methods of perspective and showing you how to demonstrate their validity for yourself. Perspective involves a good deal of visual deception and you need to know the rules if you are to use it effectively in your drawings. Perspective exercises can help you to understand what is happening to your view. However, only the direct experience of drawing from observation will make you aware of how perspective actually works.

PERSPECTIVE VIEWS

Look closely at the two sets of drawings on this page. At the top are perspective views of two hammers as seen lying on a flat surface somewhere just below eye level. Below are two almost diagrammatic drawings of the same hammers in profile.

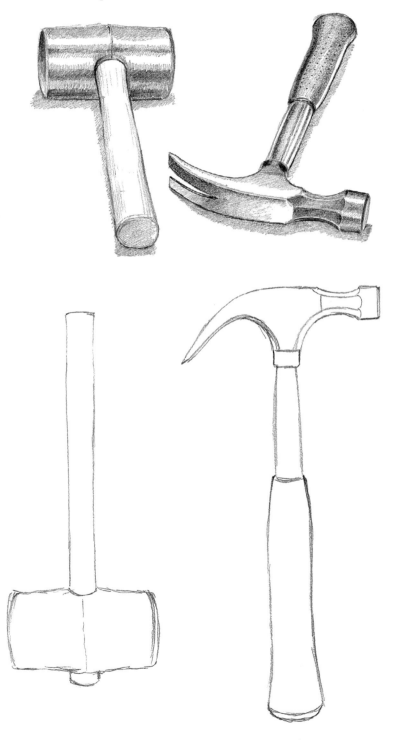

As you can see, the handles of the hammers shown in perspective are much shorter than those of the hammers shown in profile and the head of the hammer pointing towards you (top right) seems to be about the same length as the handle. Although we know that the object is longer than it is wide, from a view in which the length is foreshortened it will appear the other way round.

The eye is not too disturbed by this seemingly strange distortion of the proportions of objects and understands that our view of an object changes according to the point from which that object is viewed. You can measure the proportions of an object seen from an oblique angle quite accurately by holding your pencil out at arm's length with the pencil vertical, and measuring the apparent length of the object and comparing it with the width (see page 40). Once you have convinced yourself that perspective does give the appearance of depth, you are ready to go ahead and try more difficult subject matter.

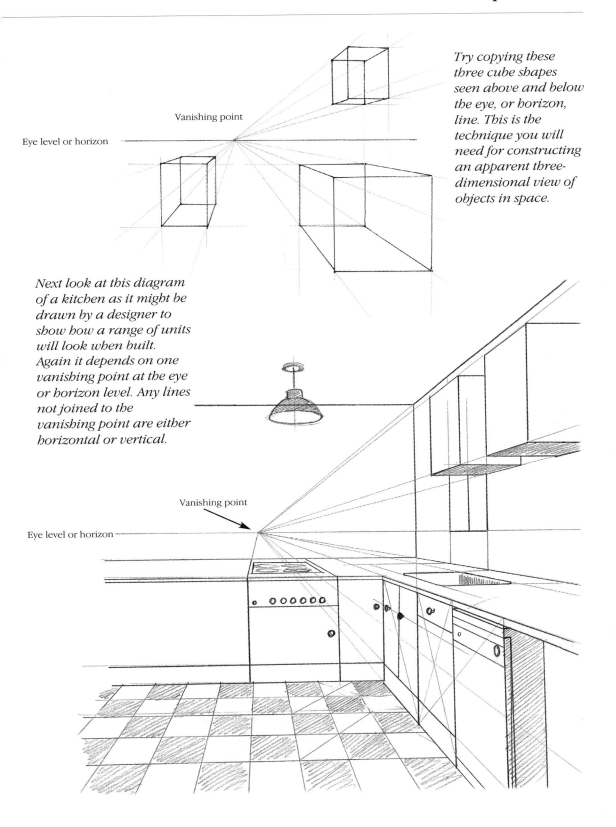

Try copying these three cube shapes seen above and below the eye, or horizon, line. This is the technique you will need for constructing an apparent three-dimensional view of objects in space.

Vanishing point

Eye level or horizon

Next look at this diagram of a kitchen as it might be drawn by a designer to show how a range of units will look when built. Again it depends on one vanishing point at the eye or horizon level. Any lines not joined to the vanishing point are either horizontal or vertical.

Vanishing point

Eye level or horizon

79

This fence (right) looks fairly straightforward, but you can see how the posts appear to diminish and get closer to each other as they recede into the background, and that the texture of the grass in the foreground is more obvious than that at the far end of the bank.

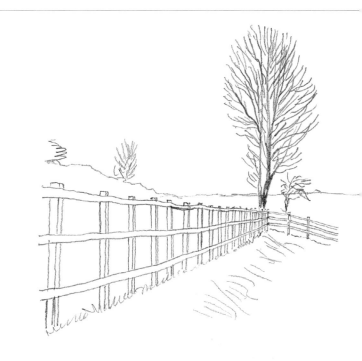

The perspective in the drawing below is made even more obvious by the diminishing width of the hedge, the size and spacing of the trees and the fact that the same effect is evident both sides of the path, as well as above and below eye level.

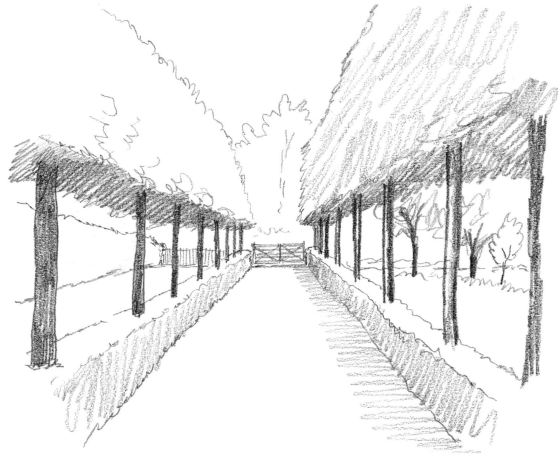

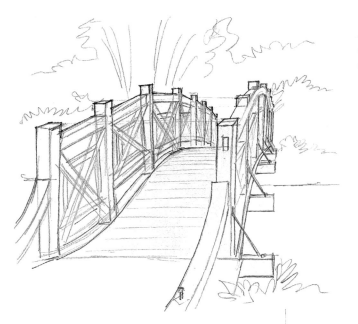

Here the perspective may look more complex because of the construction and curvature of the bridge, but essentially the effect is the same as in the other drawings, one of diminishing height and spacing of the uprights.

These two diagrams are just to show you how the appearance of diminishing space between verticals or horizontals can be calculated to look correct. By drawing a line halfway between the top line and the bottom line of the height of a vertical object (in this instance, a post) it is possible to construct a series of diagonals that will fix the position of the next vertical. When you draw a row of posts, repeat this process until the space is filled or the intervals are too close to measure.

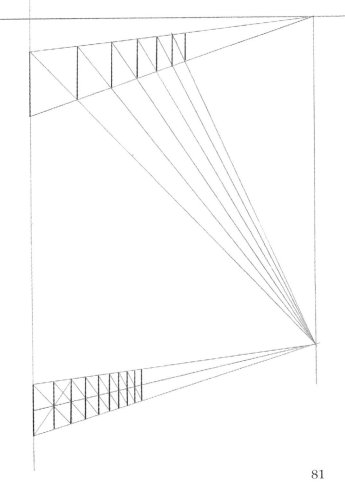

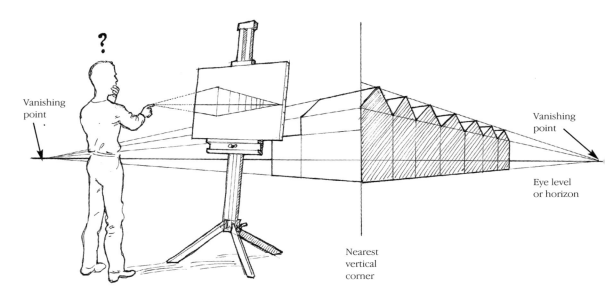

Vanishing point

Vanishing point

Eye level or horizon

Nearest vertical corner

These drawings are to give you some idea of how to construct a drawing to show a building in perspective. The key lines are the eye level or horizon line and the lines along the top and bottom edges of the building. Both top and bottom lines converge at a vanishing point on eye level, although on the other side of the perspective. the converging lines would not meet until they had come off the paper.

Now try drawing either a long building or a short street from one end. Again, this can be set up by drawing guide lines to mark eye level (your eye-level), the nearest vertical corner, and lines converging on the eye level above and below it to represent the base and the top edge of the building. The vanishing point on one side of the vertical should be fixed on your eye level line even if the one on the other side is too far away to make it onto your paper.

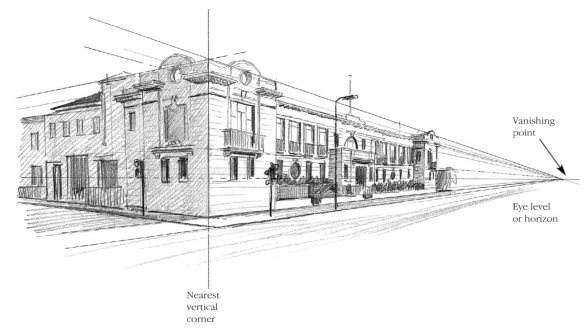

Vanishing point

Eye level or horizon

Nearest vertical corner

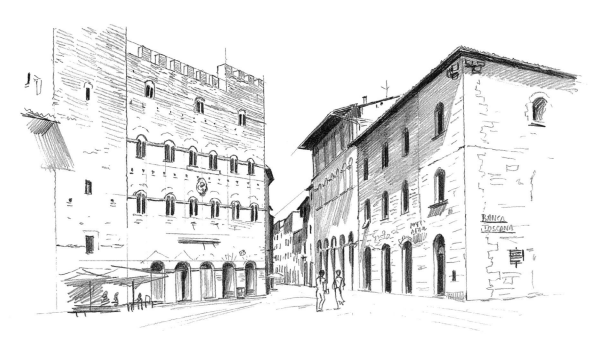

Here one building is set at an angle from the main
street. This means that although the horizon line will be
the same for the other buildings in the drawing, the
vanishing point for this particular building will be
much further to the right on the horizon. The vanishing
point of the main part of the street is just behind one of
the doors at the right-hand side of the oblique building.

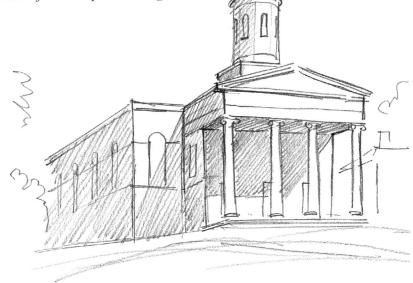

This church with a
pepper-pot tower is set up
on a rise in the ground,
so the horizon is very low
in the picture, just below
the level of the steps.

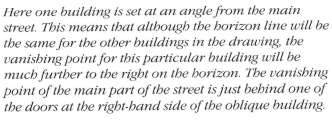

IRREGULAR PERSPECTIVE

We now look at a large piece of architectural work in which the perspective is not entirely regular, in this instance because of the sloping ground and the slightly odd type of fortification. The horizon line is very low and so the line of the top of the arch is at about 60 degrees from vertical. Because very few of the lines are horizontal or vertical, such a drawing does not demand that you organize the perspective to perfection. When faced with a view like this it is better to forget perspective and trust that your eye will give you all the information you need.

Interesting here are the massive areas of wall and the chunky simplified masses of building which give a very strong combination of shapes. The handling of the shadows is important too, because they increase the impression of simplicity and the building's monumental size.

The next sketch shows how to handle a very large building which has multiformed decorative details all over it. Start by trying to draw the very simple shapes of the main construction of the building; what you will get is a picture that looks like a cardboard cutout, as here. Once this main block of the building has been worked out, and you have made sure that the perspective makes sense visually, only then should you begin drawing the proliferation of details that are on the exterior. These details will mostly be too small to draw accurately, but you can try to get the right effect by using marks that give an impression of the shapes.

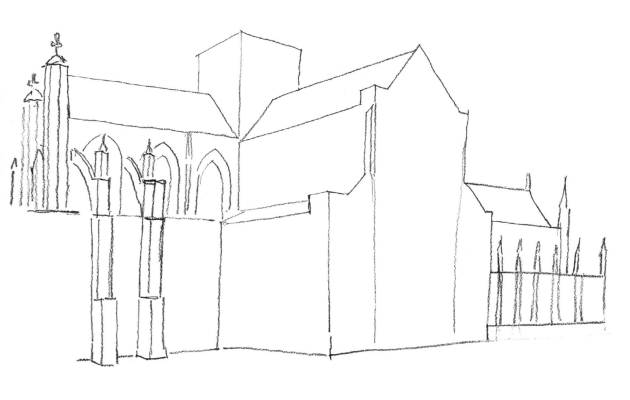

With large, complex buildings it is important not to try to draw every detail at first. Aim to get down on paper simplified block shapes to give the effect of the architecture. When you have done this you can then put in as much detail as you can manage, but don't worry if some parts end up as scribbles or smudge-like marks. The eye allows the imagination to fill in the features that are only roughly indicated. Try to bear in mind that buildings are mostly vertical and have horizontal layers of structure.

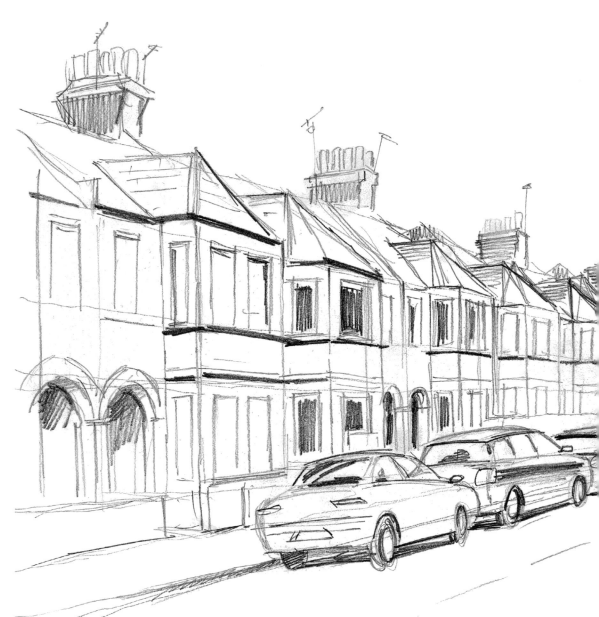

Drawing architecture is probably the hardest thing you will do until you come to draw the human figure and face. It is great fun if you persevere and produces hours of intense investigation in pursuit of the sort of impression that looks something like the view in front of you.

It is good practice to take a photograph of the view that you are drawing and compare the two. You will find that the photograph is not necessarily more correct than the drawing, because the perspective in a photograph is always slightly exaggerated. Nevertheless, the comparison of the two can show how the perspective works. The correct perspective will probably be somewhere between your drawing and the photograph.

CONSTRUCTING A VIEW ALONG A STREET

The best possible subject to give you a lot of practice of perspective drawing is a view along a corridor or a street, particularly if the street is narrow. If you set yourself up to draw looking down the length of the street, you will notice how the lines of the roofs and lines of the base of the buildings converge towards the distance. Not only that, but any structure on the surface of the buildings, such as ledges, door frames or window frames, gives the same effect. If you can get the angle of the convergence of these lines accurate enough, the street will appear to recede into the depth of the picture.

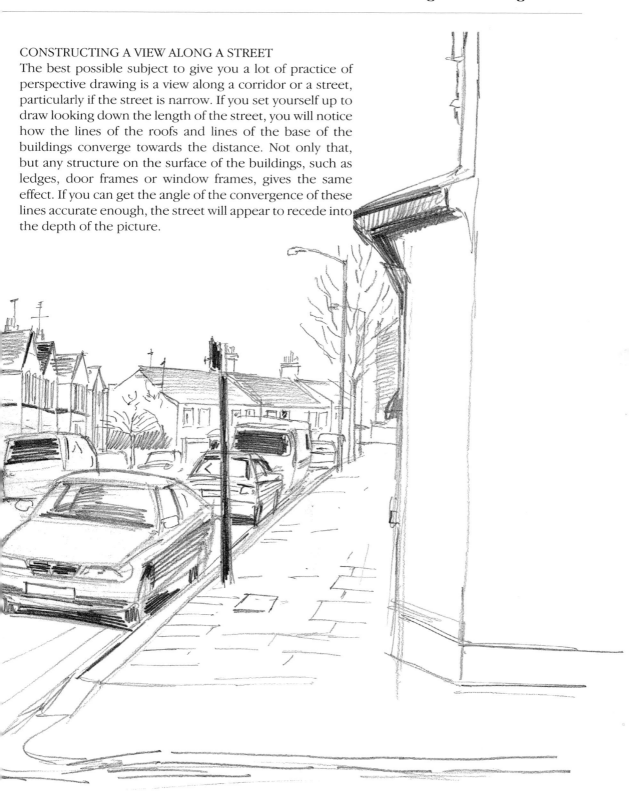

The Natural World

We have included in this section plants, trees, landscape and animals. These different subject areas pose similar problems for the artist. Whether you are looking at a plant or a horse, the first objective is to look at the shape and movement that runs through your subject and simplify it. Each animal has a general shape which can be simplified in order to see how the animal works. The artist's discovery of the function of plants is arrived at in a similar way

After the practice of drawing many different kinds of plants, you will come to see that there is a general pattern of growth most of them share. The understanding you gain of the basic shapes of plants will stand you in good stead when you come to devise your own landscapes. A sure eye is needed to balance and contrast the different arrangements of trees or plants to help create an interesting picture.

PLANTS

Plants are very accommodating subject matter when you are learning to draw. They don't keep moving; they remain the same shape while you are drawing them; a great many of them you can bring indoors to observe and draw at your convenience; and they offer an enormous variety of shapes, structures and textures.

To begin with, choose a flower that is either in your house, perhaps as part of an arrangement, or garden. In the series of exercises here we concentrate on the principal focal point, the head in bloom, although it is instructive to choose a plant with leaves because they give an idea of the whole. Study the shape of your plant, its fragility and how it grows. Now attempt to draw what you see, following the approach outlined in the captions.

Using a well sharpened pencil, which is essential when drawing plants, outline the main shape of the bloom and the stalk.

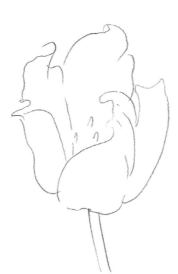

Draw in the lines of the petals carefully.

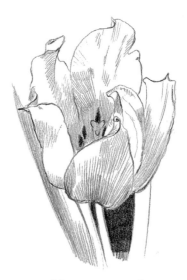

Add any tone or lines of texture.

What you may notice in this exercise is how exquisite the texture and structure of the petals and stamens are and how carefully you need to trace the line. Don't use heavy lines because the effect they produce will contradict the delicacy of the plant.

In some places around the petals you will need to emphasize the sharpness of the line, while elsewhere your touch will need to be very light, the line almost invisible.

The type of pencil you use for drawing plants should be no different from your usual choice, but it must be kept sharpened to a good point. A blunt point will deaden the characteristic elegant edge of flowers. Any shading you attempt with a blunt pencil will produce a similarly coarse result.

1. Ensure that the ellipse for each floret is angled in the right direction, otherwise the shape of the plant won't be correct.

Now try drawing a more complex plant with several blossoms or florets on one stalk, as here. This time, the construction lines at the beginning have to be more exact in order for all the flowers to fit together on the stalk in the right proportion. After that, carry on as before.

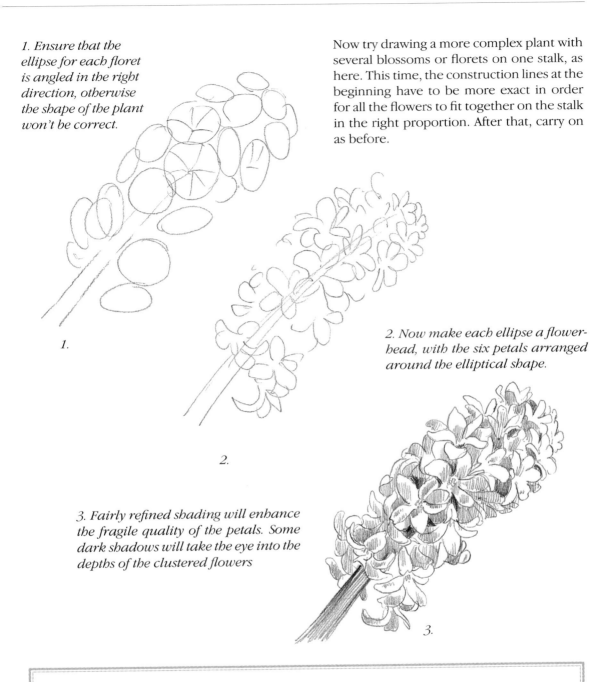

1.

2.

2. Now make each ellipse a flower-head, with the six petals arranged around the elliptical shape.

3. Fairly refined shading will enhance the fragile quality of the petals. Some dark shadows will take the eye into the depths of the clustered flowers

3.

When drawing flowers it is tempting to try and indicate colours by using different tones. This is not a good idea because it tends to destroy the clarity of the form. It won't achieve the result you intended either. As in other types of drawing, concentrate on using well the effects that can be applied successfully.

By contrast with the other examples, this lily is a very sculptural looking flower. It is shown in three stages of bloom; as it is just opening, almost fully extended, and at full bloom just before it begins to die off.

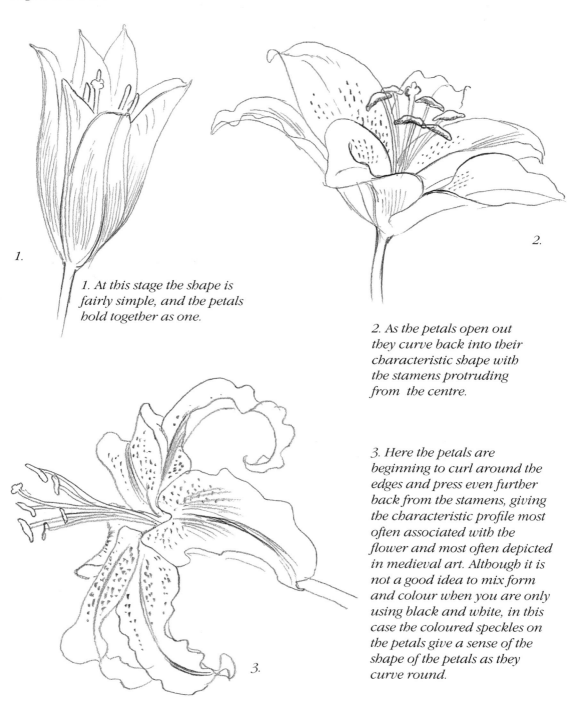

1.

1. At this stage the shape is fairly simple, and the petals hold together as one.

2.

2. As the petals open out they curve back into their characteristic shape with the stamens protruding from the centre.

3. Here the petals are beginning to curl around the edges and press even further back from the stamens, giving the characteristic profile most often associated with the flower and most often depicted in medieval art. Although it is not a good idea to mix form and colour when you are only using black and white, in this case the coloured speckles on the petals give a sense of the shape of the petals as they curve round.

3.

Now experiment with a range of different shapes and find slightly different ways of drawing them. As you can see from this selection, each subject has been approached from a different viewpoint. I did this because I wanted to get a better idea of the plants' form and habit and what gives them their individual character. Try this for yourself. You will find your method adapting to the requirements of the subject and that you are perhaps drawing only an outline or making a more detailed line drawing but without adding the tonal areas indicated. Sometimes you might find yourself adding tone to enhance the feeling of the shape.

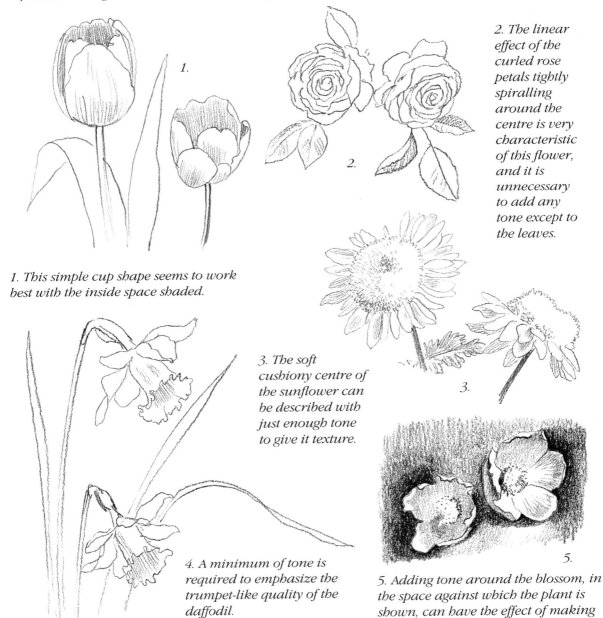

1.

2. The linear effect of the curled rose petals tightly spiralling around the centre is very characteristic of this flower, and it is unnecessary to add any tone except to the leaves.

2.

1. This simple cup shape seems to work best with the inside space shaded.

3. The soft cushiony centre of the sunflower can be described with just enough tone to give it texture.

3.

4. A minimum of tone is required to emphasize the trumpet-like quality of the daffodil.

4.

5.

5. Adding tone around the blossom, in the space against which the plant is shown, can have the effect of making the flowers look brighter or more delicate.

93

LARGE PLANTS

Large plants are ideal practice for drawing trees. They display many similar characteristics and they ease you into upping the size at which you draw. Potted plants are ideal subjects and give plenty of opportunity for practising the growth of the leaves and how this growth is repeated throughout the plant. The same pattern of leaf growth can look quite different when viewed from other angles. It is worth experimenting: drawing the plant from beneath, from above, and also side on just to give yourself experience of how the shapes alter visually.

As with smaller plants, attention to detail is important. You need to investigate how each leaf stalk connects to the main stem and be scrupulous about the number of leaves you put in each clump: don't put in more leaves than are actually there, or too few.

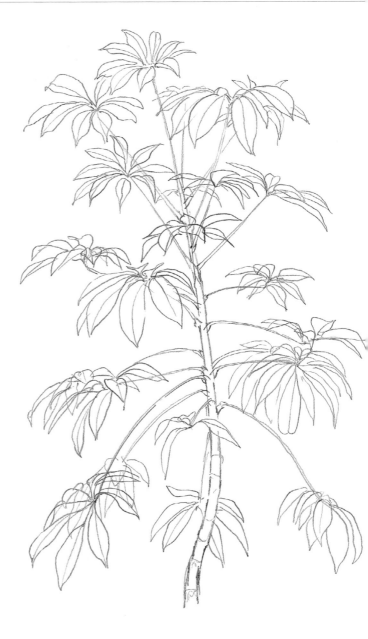

In this example each leaf has a characteristic curl. Once you see the similarities in the pattern of the plant, the speed at which you draw will increase. It is important to feel the movement of the growth which the shape shows you through the plant and how it repeats in each stalk.

Once you start drawing larger plants, you realize that drawing every leaf is very time consuming. Some artists do just this, but most devise a way of repeating the typical leaf shape of the plant and then draw in the leaves very quickly in characteristic groups. It is not necessary to count all the leaves and render them precisely, just put in enough to make your drawing look convincing.

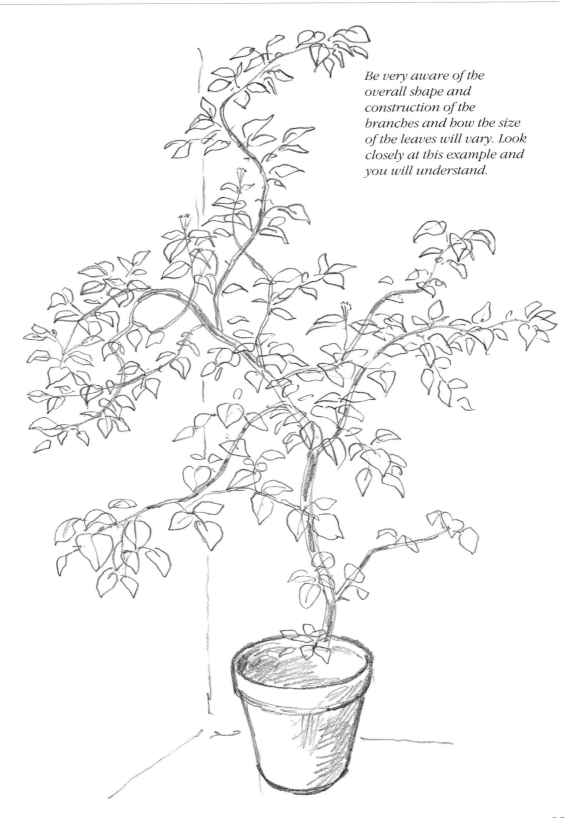

Be very aware of the overall shape and construction of the branches and how the size of the leaves will vary. Look closely at this example and you will understand.

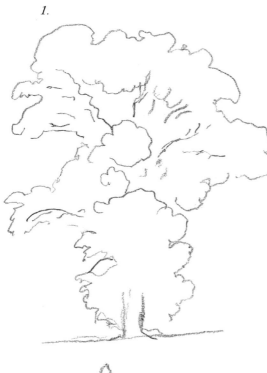

1.

TREES

The idea of drawing trees can be a bit daunting because there seems to be so much to them. To begin with, just concentrate on capturing the overall shape by looking at the outline of the whole mass of the tree. Draw a line around the extremities of the branches and the twigs. Contrast that with your line for the trunk. Don't concern yourself with the details of leaves or even branches.

1. This oak has cloud-like branches of leaf growth projecting from the trunk to form the main shape. The sun was shining from behind the viewer, hence the absence of shadow.

2. The central poplar, with its vertical, elongated, cone-shape construction of leaves and branches, was well lit.

3. The sun was directly overhead here, and I have indicated this by leaving a very light area at the top and adding tone towards the bottom, to create the effect of branches overhanging the lower parts, creating shadows.

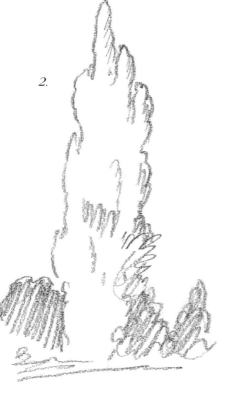

2.

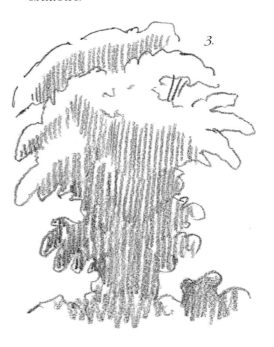

3.

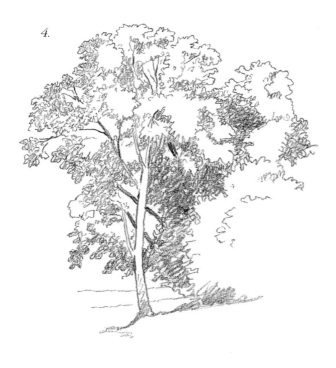

4.

4. *When you have had more practice with tree-shapes, look for examples that will enable you to have a go at using the pencil to capture an indented and more detailed outline, as here. You can add some textural marks to give the effect of leaves, particularly in the shady areas. Also make sure that some of the large branches are visible across the spaces within the main shape of the tree.*

5. *When you look at a tree with the light mostly behind it, you get the effect of a silhouette which gives a nice simplicity to the overall shape.*

6. *In this small group of cedar trees the feathery layers of leaves and branches contrast well with the vertical thrust of the rather simple trunks. Again, the sun was behind the subject.*

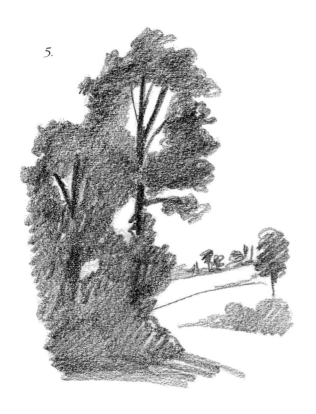

5.

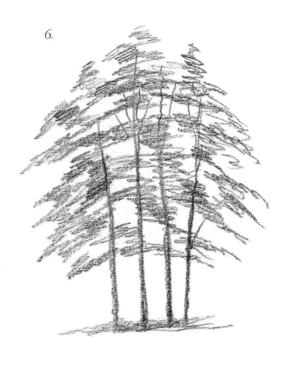

6.

TREES IN THE LANDSCAPE

This loosely drawn copy of a John Constable composition shows you one way of simplifying your approach to landscape drawing. Here the areas of trees and buildings have been executed very simply. However, great care has been taken to place each shape correctly on the paper. The shapes of the trees have been drawn with loosely textured lines. The areas of deepest shadow show clearly with the heaviest strokes reserved for them.

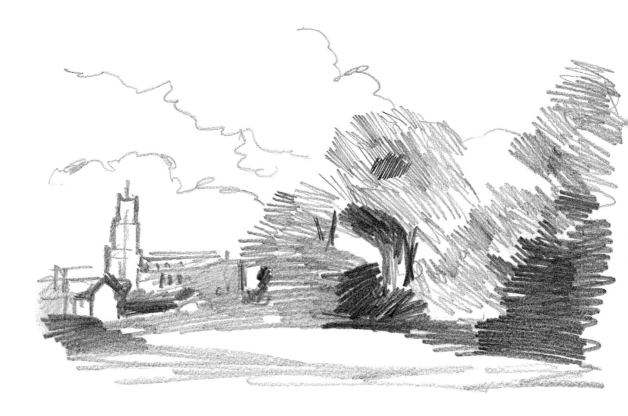

When producing landscape drawings it is very easy to be daunted by the profusion of leaves and trees. Do not attempt to draw every leaf. Draw leaves in large clumps, showing how the brightly-lit leaves stand out against darker clumps of leaves in the shadow. Each group of leaves will have a characteristic shape which will be repeated over the whole of the tree. Obviously these will vary somewhat, but essentially they will have a similar construction. Find a method of drawing the textures of leaves in large areas. It looks a bit like loose knitting, as you can see from the examples here. You can do no better than to look at Constable landscapes and notice how well he suggests large areas of leaves with a sort of abstract scribble. He also suggests the type of leaf by showing them drooping or spraying out, but he doesn't try to draw each one. The only part of your landscape where you need to draw the leaves in detail is in the nearest foreground. This helps to deceive the eye into believing that the less detailed areas are further back.

When you are more confident, start trying to draw the trees in your landscape in more detail. Take care over your placement of various emphatic points, such as buildings, reflections in water, darkly shaded tree-trunks and the clarity of the horizon. If you misplace them, this will have consequences for your drawing. It is very easy to understate emphatic areas like shadows and overstate the sharpness of man-made objects. The horizon line may be lightly drawn but it needs to be clear.

Don't forget that all you are doing here is making marks with a pencil on paper. You are not really drawing leaves and trees. You are putting down pencil-marks to create an impression in the eyes of the viewer, to communicate the effect of a landscape.

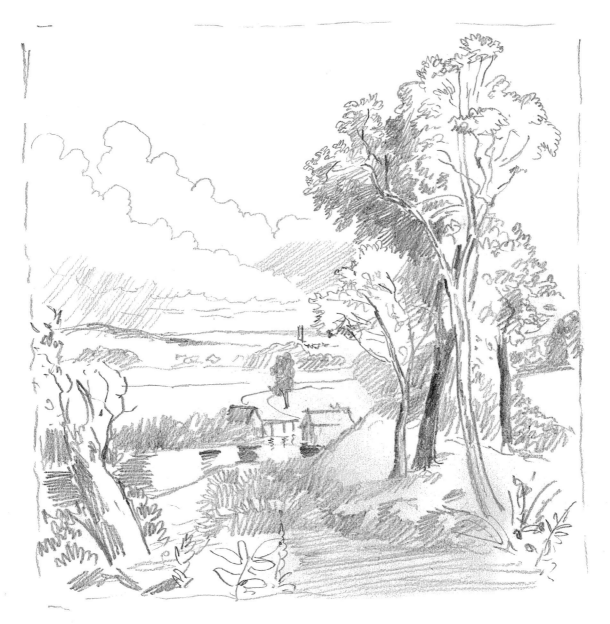

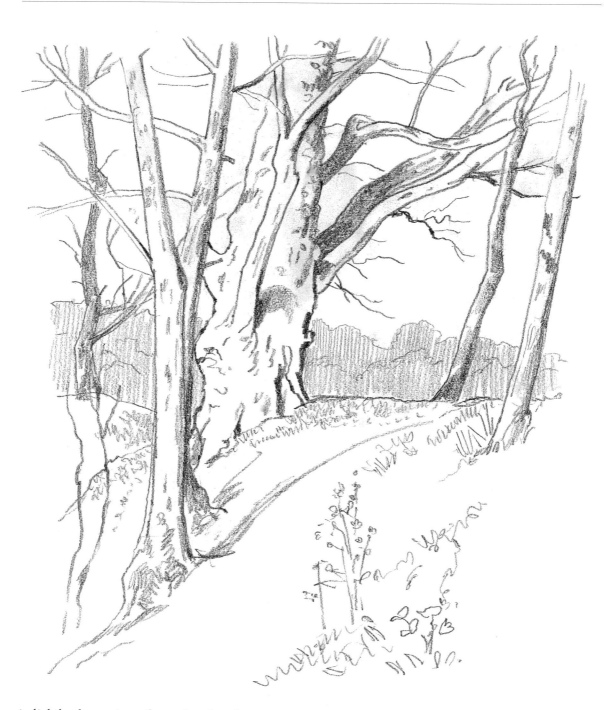

A slightly closer view of trees in a landscape can create an unusual arrangement, as here where the landscape is seen fairly indistinctly through the trunks of the trees. You will find that different species of trees can have quite different shapes. Some are smooth branched with flowing shapes, while others writhe and bend dramatically. If the trees are varied, their shapes can create a very interesting study of patterns against the sky.

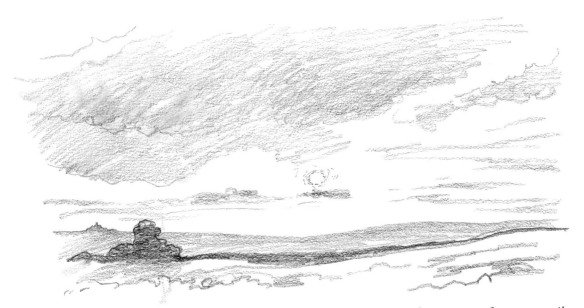

The structure of this landscape is not difficult but you have to vary the texture of your pencil marks in order to get the misty softness of the clouds and the effect of the sun making the landscape itself disappear into a hazy distance.

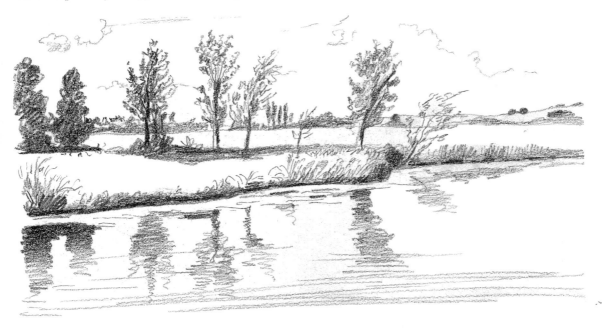

There is a variety of challenges here, but none too difficult. The main interest is in the reflections in the water, which give a sort of reversed picture. To render such reflections, simply draw shapes that are similar to the originals but less definite and slightly broken up to suggest the effect of the water.

LANDSCAPES FROM DIFFERENT PERSPECTIVES

It is a good exercise to try drawing the same landscape from two or three different viewpoints. It is always worth walking about after you have picked on your area of landscape to find the best place to work from. Here you see three different points of view of the same seaside bay with cliffs, distant headland, village, coastguard hut with flagpole and wooden jetty.

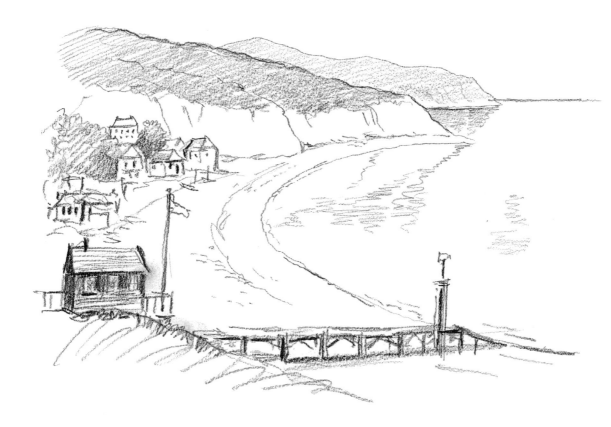

This view is from fairly high above the scene and, as a result, the sea's horizon is high in the picture and the distant headland is clearly seen beyond the cliffs at the end of the bay. The coastguard hut and jetty act as nice complements to the cliffs framing the village and the bay between them.

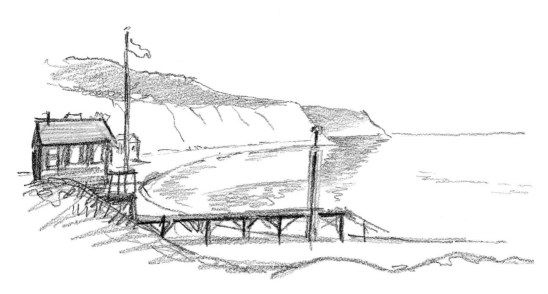

Now you see the same view from lower down, on about the same level as the coastguard hut. From this perspective the distant headland is almost obscured. The village is mostly hidden behind the hut, and the hut and jetty act as a setting for the cliff on the far side of the bay.

In this view, seen from even lower down, the hut is above eye level. The village has disappeared and now the hut and jetty are the most important elements in the picture. By adjusting our perspective, we have re-defined the area of the landscape and completely changed the nature of the drawing.

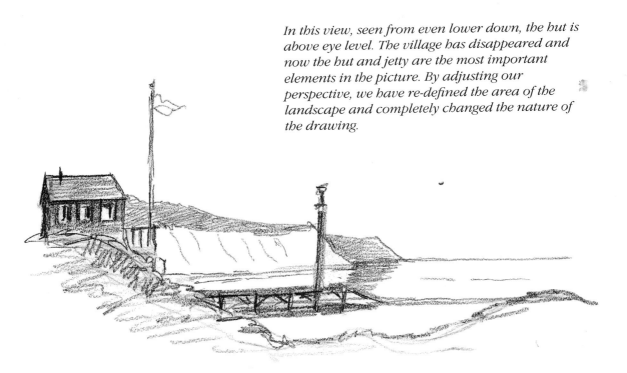

Here we have two more examples of the effect a change of viewpoint has on a composition. The various elements of the picture become more or less important depending on the position they are viewed from. In the first picture, the fence is seen as merely serving a practical purpose but it is not a major effect. However, the shift of perspective evident in the second picture has given it much greater prominence. The reverse is true of the lake.

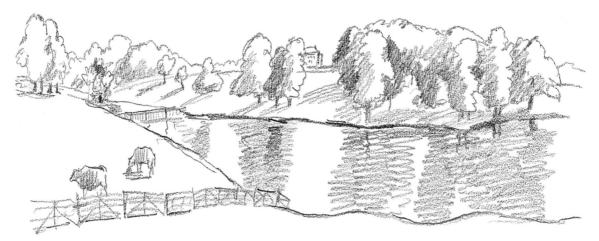

Both the position of the cows in the field and the fence, running down to the water, give a strong lateral movement to the picture. The view across the lake engenders a feeling of space.

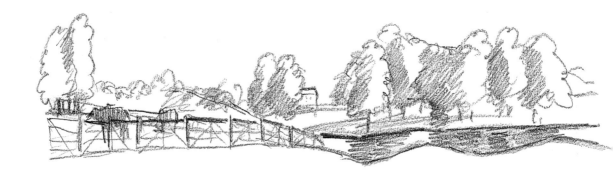

Seen from a lower angle, the impression of distance given by the expanse of lake – a mere sliver of water here – is dramatically reduced. The fence, trees and sky have now become important elements in the composition, the cows much less so.

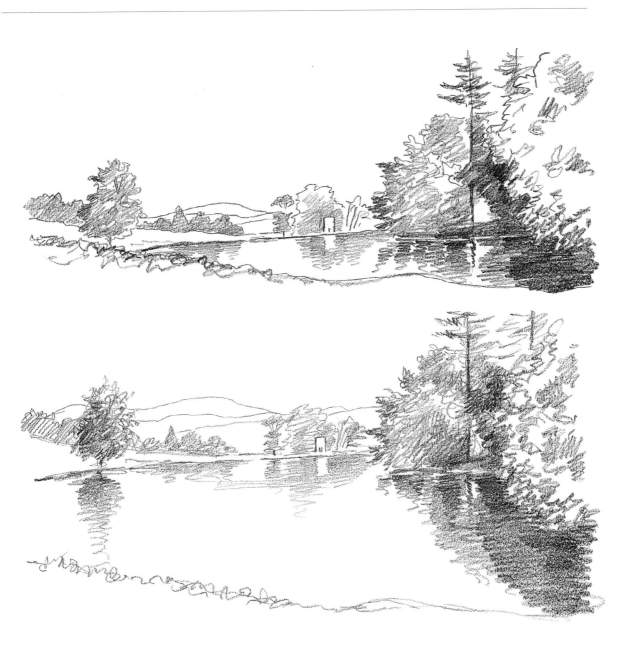

A similar effect is obvious in this view across a stretch of water. In the top view all elements are shown quite well but without making a feature of any one of them.

By raising the viewpoint (bottom) the water becomes a much more dominant feature and the trees less so. The hills in the background, now increased in size relative to the other elements, give the viewer the impression of this being mountainous country.

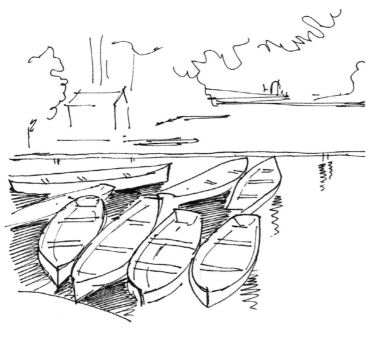

TRYING OUT DIFFERENT MEDIA

So far, because you have been drawing in pencil, you have made detailed studies from which to build up your landscapes. Now try making your initial study in pen and ink. The benefits of ink are clarity, simplicity and boldness of effect. You will have to be daring and commit yourself with every mark, using highly simplified, blocked out shapes for the main elements.

Here the shapes of the boats are clearly defined by the blocks of dark tone in between them, creating a strong sculptural effect. The rest is a mere outline of distant landscape.

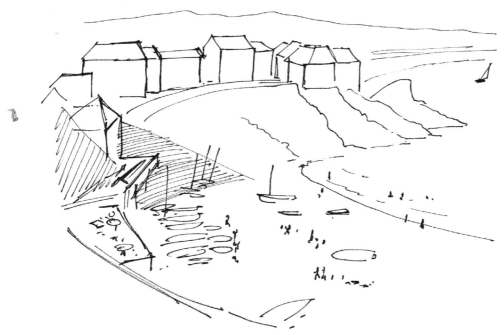

This is almost a map of what your final drawing might be; simple outlines with blocks for the buildings, the line of the hills and the bay, an extensive patch of shadow across the beach and small marks showing boats and people on the beach and in the water. Drawing like this gives sculptural value to a scene, providing a sort of skeleton on which you can build your picture.

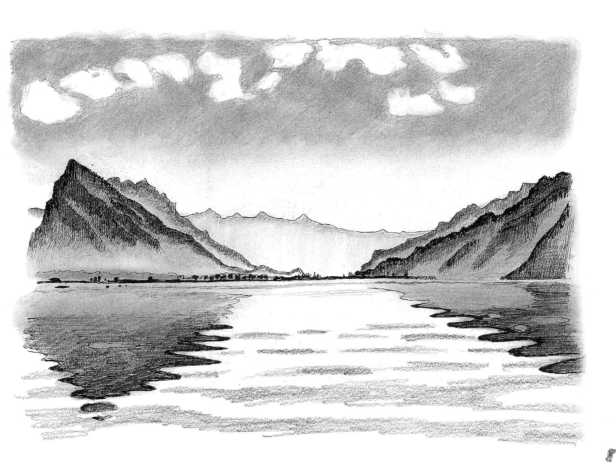

Having taken the plunge with some ink drawing, now try out a landscape in which you might use pen and ink and pencil or charcoal as well. A sort of mixed media picture. Here is a relatively easy landscape with large hills close to water and reflecting in it, with a cloudy sky above. Use the pencil or charcoal softly to smudge in the clouds (you can smudge the marks made with pencil or charcoal with a paper napkin to give a very soft effect) and then draw with the pen the outlines of the mountains and the strongest reflections of them. Fill in some of the darker areas with ink but don't overdo it. Then with the pencil or charcoal, tone in the large dark areas and smudge it again to get softer effects. You will have to make stronger pencil marks close to the pen lines or else they will not blend in with the main shape. Finally the lighter part of the reflecting water can again be smudged in with pencil or charcoal.

Use a normal graphic pen of about 0.1 or Fine Point, or if you want the drawing to stand by itself and not just use it as a basis for another finer drawing, use a 0.3 or 0.5 or Medium Point.

ANIMALS

When drawing animals, start with the simplest, such as insects. Most insects have a very simple structure, with their skeleton on the outside, so you can draw them almost diagrammatically. Sometimes if they have furry bodies or delicate wings, it becomes more complicated. Note the examples here and how relatively simple the shapes are. Moving onto birds, frogs and animals like snakes, again the basic shape is very simple. Careful observation of these shapes from photographs, drawings or from life will show you how straightforward the structures of these creatures are.

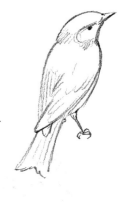

1. Side views often show the characteristic shapes of birds more clearly.

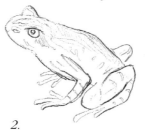

2.

2. The frog has a blunt, triangular shape when seen from the side, a view that allows you to see its large back legs clearly.

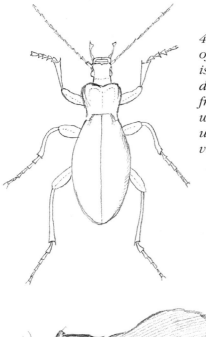

4. The shape of the beetle is often best displayed from above – which is usually the view we get.

3. The furry body of the bee contrasts with its delicate wings and thread-like legs.

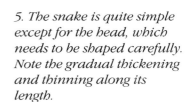

3.

5. The snake is quite simple except for the head, which needs to be shaped carefully. Note the gradual thickening and thinning along its length.

6. The supple, undulating weasel has a sinuous quality.

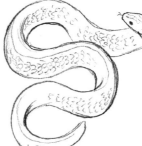

6.

5.

With larger animals, the skeleton is hidden so you have to judge the structure from the outside shape, which may be covered in fur. However with careful observation you can simplify the basic shapes of heads, bodies, ears and legs, not to mention tails. With a little practice, you will soon get the feel of your subject.

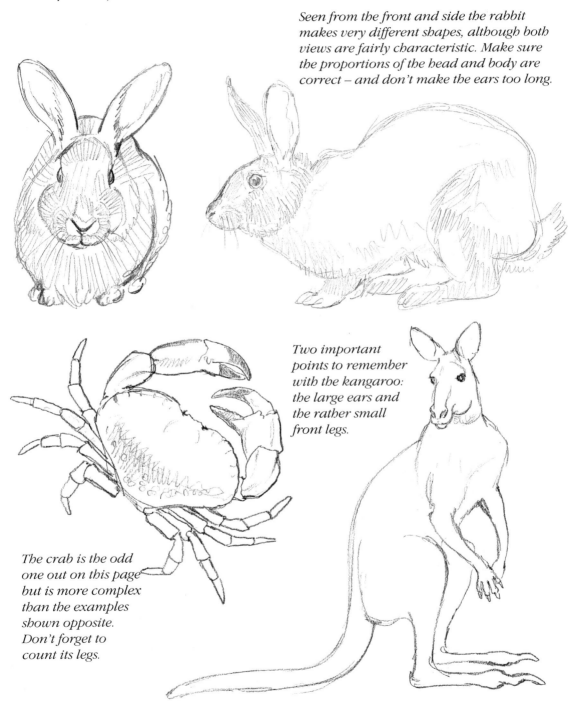

Seen from the front and side the rabbit makes very different shapes, although both views are fairly characteristic. Make sure the proportions of the head and body are correct – and don't make the ears too long.

Two important points to remember with the kangaroo: the large ears and the rather small front legs.

The crab is the odd one out on this page but is more complex than the examples shown opposite. Don't forget to count its legs.

ANIMALS IN MOVEMENT

Trying to capture the movement of animals is a different proposition altogether. Fortunately, there are plenty of excellent photographs and drawings of animals in action to help you gain the necessary practice. Pictures of birds on the wing, animals eating or startled give a very clear idea of characteristic movements.

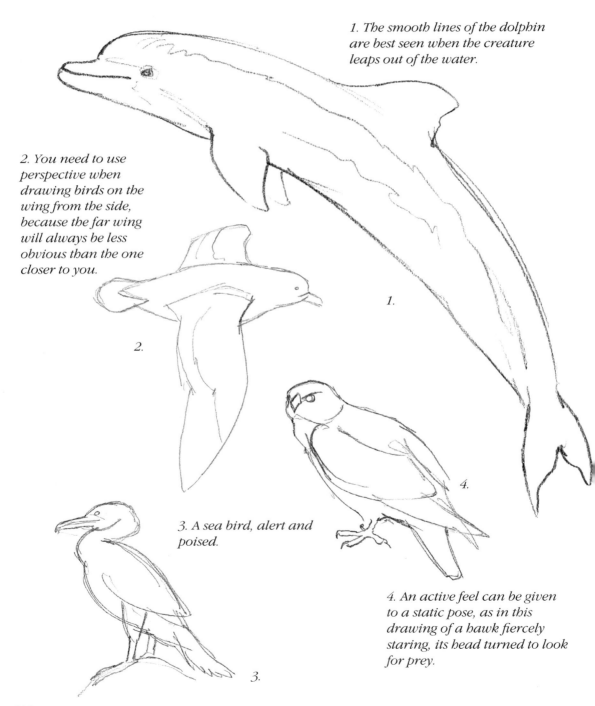

1. The smooth lines of the dolphin are best seen when the creature leaps out of the water.

2. You need to use perspective when drawing birds on the wing from the side, because the far wing will always be less obvious than the one closer to you.

1.

2.

3. A sea bird, alert and poised.

4.

4. An active feel can be given to a static pose, as in this drawing of a hawk fiercely staring, its head turned to look for prey.

3.

It is not always easy to bring the effect of movement into a drawing, even when copying from a photograph of a moving creature. Try to suggest a taut or fluid look to the structural lines. Don't hesitate to simplify if that will communicate the illusion of movement. I used this technique with the drawing of the hare below – using a slightly nervous scribble to suggest the creature's agitation and readiness to run.

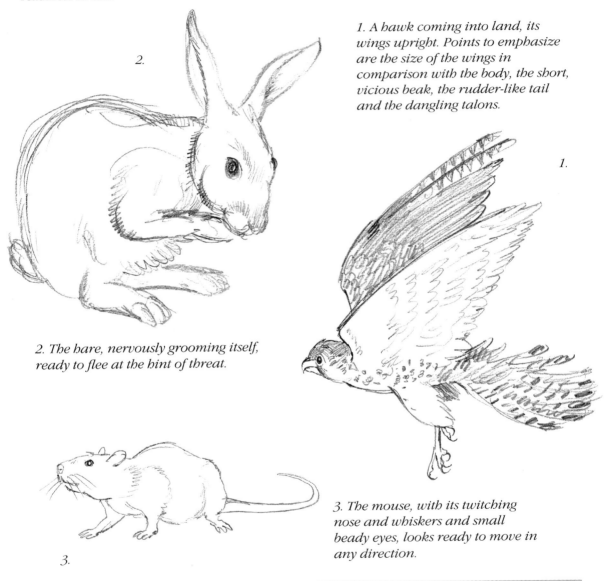

1. A hawk coming into land, its wings upright. Points to emphasize are the size of the wings in comparison with the body, the short, vicious beak, the rudder-like tail and the dangling talons.

2. The hare, nervously grooming itself, ready to flee at the hint of threat.

3. The mouse, with its twitching nose and whiskers and small beady eyes, looks ready to move in any direction.

Don't be afraid to simplify the basic shapes of the creatures you are drawing. Consider them as other types of objects whose form you are trying to capture on paper. Choose a line that is sympathetic to their materiality; for example, soft, fluid lines for fur and broken lines for birds' feathers.

LARGE ANIMALS

When you come to draw large animals, try to convey a sense of what each type represents. I envisaged the animals depicted here in very different ways. The very distinctive pattern of the tiger makes him into a sort of dandified ruffian, despite his status as a ruthless killer. The elegant horse with his smooth, muscled shape and sensitive head has a poetic, heroic quality. The great elephant, solid but slightly shambling with his strangely creased hide and rather coarse-looking trouser legs – all power but also gentle, rather like a favourite grand relation.

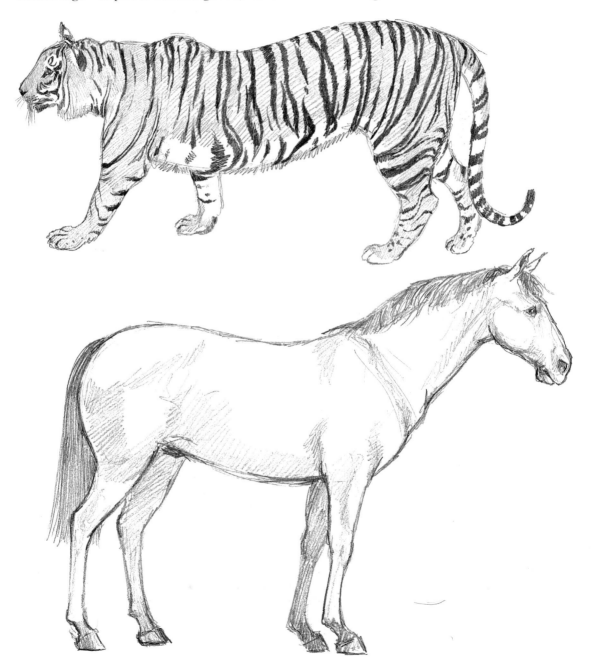

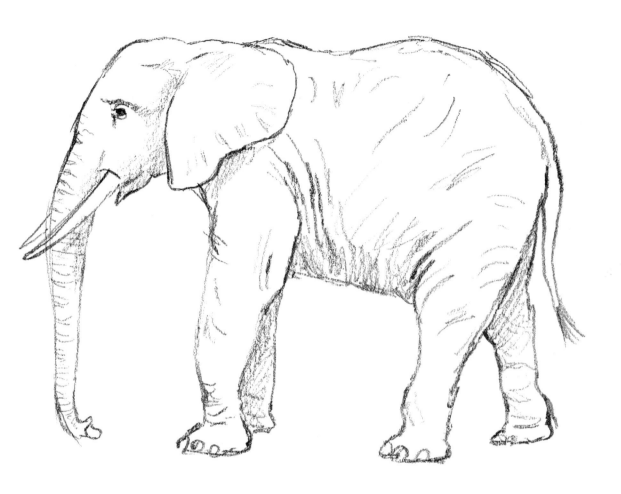

With larger, more statuesque animals you need to make sure
that the proportions of legs to bodies and heads to bodies are
carefully worked out. The examples here show the variations
you can encounter. The low slung heavy body of the tiger, with
its sinuous shape and patterned stripes, is very different from the
rather elegant shape of the horse, for example, with its long
head, long neck and slim elegant legs. The elephant has a much
looser unstructured look: large sack-like body, loose-trousered
legs, long curling trunk and large flat ears.

The way you use the pencil will help enormously to get across the effects of the different
textures. Sharp clear-cut lines work well for the horse, soft, wobbly lines for the elephant.
The tiger requires an approach that lies somewhere between these two extremes.

DRAWING ON THE HOOF

Now comes the stimulating, if more difficult, exercise of taking your sketch-book and going out to find an animal subject to draw, preferably one that is relatively static. A horse gently grazing, or farm animals, which tend to be relatively calm when close to people, will provide good opportunities for you to practice your drawing skills. If you live near a farm, or zoo, you could take a half-day out to draw just one or two animals several time, from as many angles as possible. Don't worry about them moving, just keep starting new drawings. Don't worry either if your shapes don't come out well. Keep drawing and trying. The results aren't important. Sketchbooks are meant to be experimental, and the more often you do this type of practice the better you will get at it.

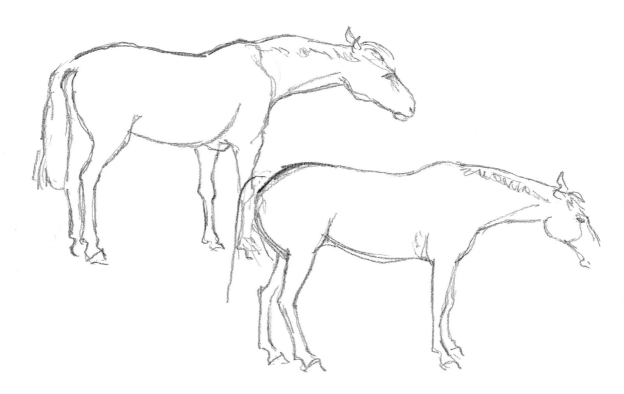

I sketched the shapes in loose flowing lines and didn't concern myself about the finished article. As soon as the horse changed position, I started again, sometimes for a few seconds, sometimes for a few minutes.

The pictures shown here are taken from a sketch-book in which I used up about ten pages on drawing a horse that was loose in a field. I didn't manage to finish any of the drawings, but that wasn't the point. I drew the horse as he wandered around me. Each time he moved and took up another position I'd begin another drawing.

This exercise is brilliant for practising the co-ordination of eye and hand. More importantly, it doesn't allow you time to evaluate what you are doing.

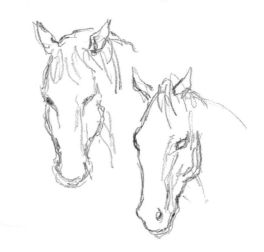

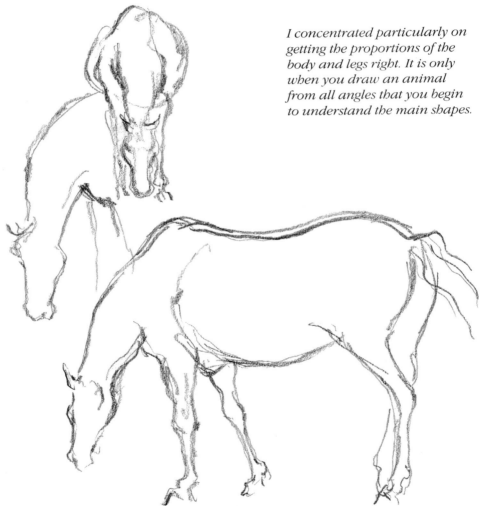

I concentrated particularly on getting the proportions of the body and legs right. It is only when you draw an animal from all angles that you begin to understand the main shapes.

Figure Drawing and Portraiture

The human figure is the hardest and yet most satisfying subject to draw and no artist ever really exhausts its possibilities. Attendance of a life-drawing class is the best way to learn how to do this. However, if you are trying to teach yourself, discipline and an eye for detail will take you a long way. The best way to start is by observing people carefully: the way they move, sit and stand and how they look in different lights and from different angles. The great figurative artists studied the human form for their entire lives without reaching a limit with it, so there's plenty of scope!

STARTING TO DRAW FIGURES

Before you begin, refer back to the diagrams of proportions in human beings to re-acquaint yourself with the basic lessons you learnt there (see pages 34–35). Now find pictures of people in various natural poses and try this exercise.

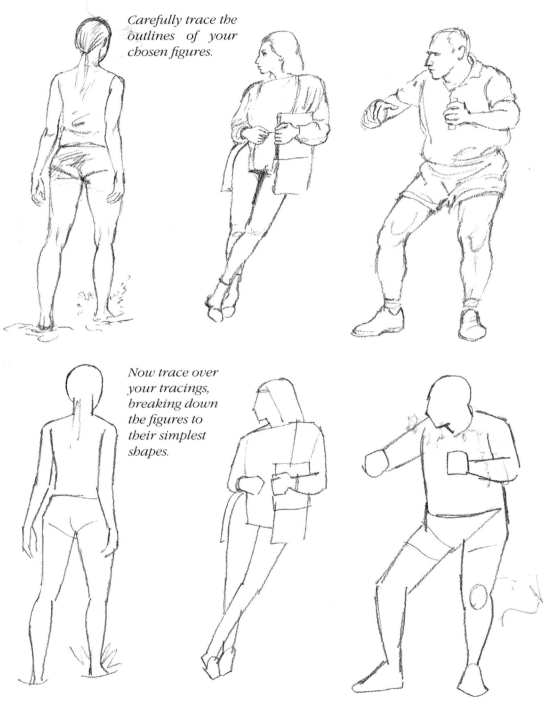

Carefully trace the outlines of your chosen figures.

Now trace over your tracings, breaking down the figures to their simplest shapes.

This way of drawing shows you how to tackle figure drawing using very basic lines to describe the position of the figure and gradually build a more solid structure around these lines until you have got a complete figure.

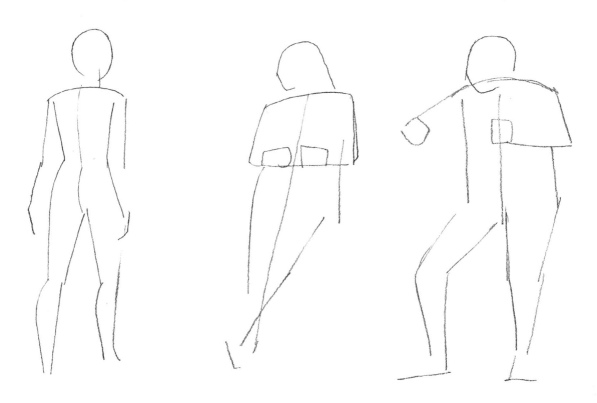

Now trace over your second tracings, putting in only the absolutely essential lines in order to show the movement of the figures. Take a central line through each figure, draw the main line of the shoulders, the main shape of the head and then make very simple lines to describe the arms and legs.

Don't include any other details. In my examples you can see that for each figure the head is given simply as a rounded shap, and a line running through the torso and legs serves to give the feel of the pose. Pare down your drawings to absolute essentials, as I have done.

When you have reduced your figures to these simple shapes, build them up again until you have worked back to the shapes of your original tracings. The method is exactly the same as that shown here. You simply reverse the process. Begin by tracing over your last drawing.

DRAWING FROM LIFE

Once you have practised the previous exercise a number of times and gained in confidence, you should be ready to tackle drawing a real person. Get a couple of different people to pose for you for about twenty minutes. Approach your subjects exactly as you were shown in the previous exercise.

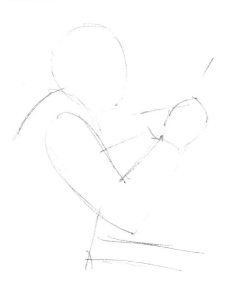

Draw the essential shape, movement or pose first and then try to fill it out a bit, but don't worry about the detail.

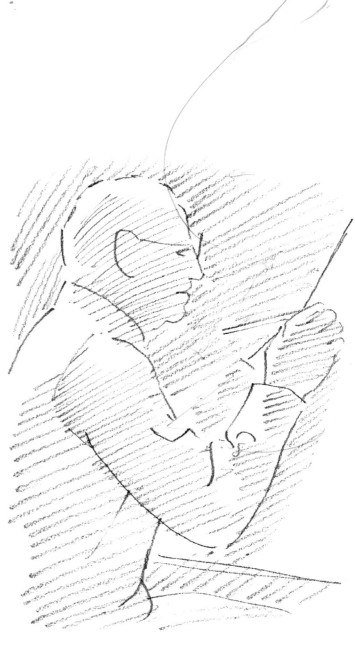

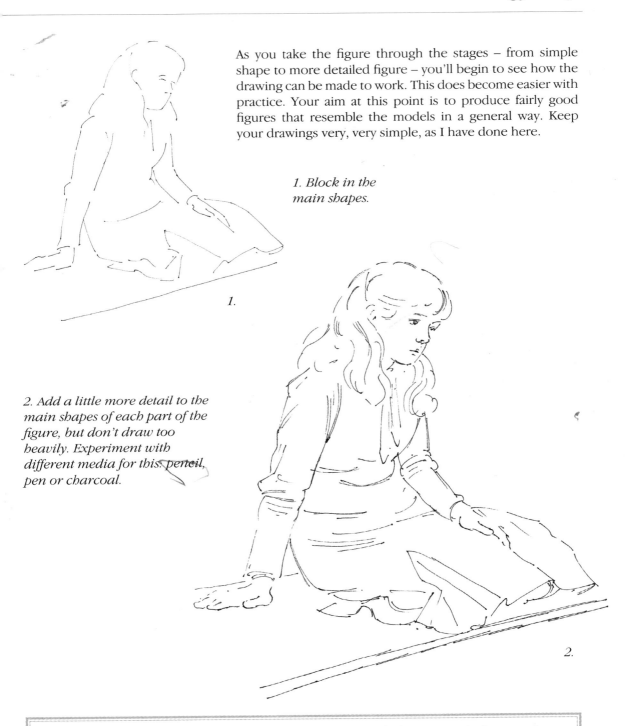

As you take the figure through the stages – from simple shape to more detailed figure – you'll begin to see how the drawing can be made to work. This does become easier with practice. Your aim at this point is to produce fairly good figures that resemble the models in a general way. Keep your drawings very, very simple, as I have done here.

1. Block in the main shapes.

1.

2. Add a little more detail to the main shapes of each part of the figure, but don't draw too heavily. Experiment with different media for this: pencil, pen or charcoal.

2.

Although you can be as thorough as you like, it is a good idea to stop before you have drawn every bump, wrinkle and indentation. The aim of simplifying is a very valuable part of learning to draw effectively.

STUDYING DIFFERENT POSES

Now try working from photographs or models with a view to giving yourself experience of capturing different kinds of poses. If you can find good photographs of action poses or poses with some movement in them, use them first to trace and then to copy, keeping the original next to your drawing as reference.

Get used to looking at the whole shape, including the shapes enclosed by the limbs, in order to see the general outline. The more variety you can get in these sorts of sketches the better. Get used to moving your hand quite fast, but observing closely the essential lines of the figures. Again, don't concern yourself with details. They are not important at this stage.

The sketches shown here are to give you ideas of the types of poses you might like to attempt.

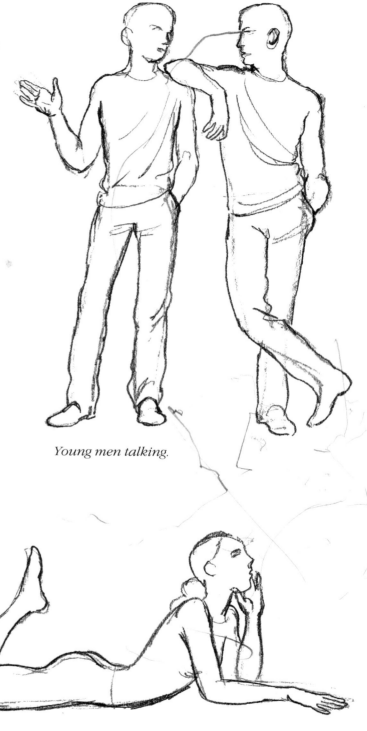

Young men talking.

A girl relaxing, probably talking or watching a video.

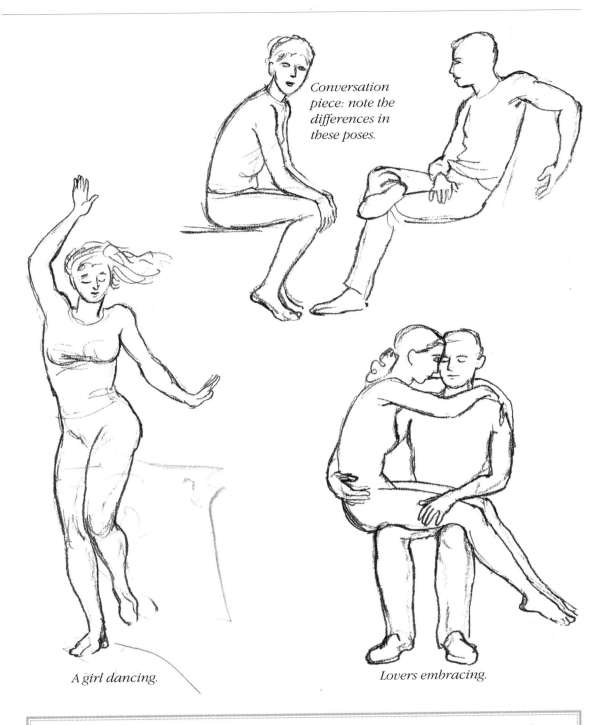

Conversation piece: note the differences in these poses.

A girl dancing.

Lovers embracing.

When you have traced a moving figure from a photograph, try to copy the same figure straight from the photograph. Place the tracing over the copy and note the differences. This exercise is useful for alerting you to inaccuracies. Repeat the exercise, using the same photograph, until it is difficult to tell the straight copy from the trace.

POSES IN CLOSE UP

Here we begin to look at the figure and how the shape changes in different poses. You can explore this for yourself by getting someone to adopt different positions for you to study.

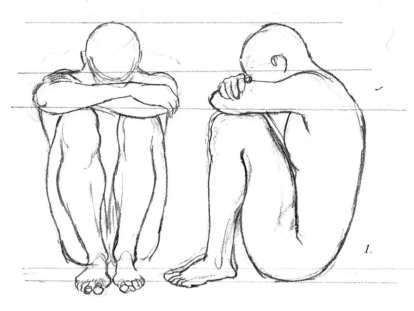

1.

1. Look at this drawing of a man sitting curled up, his limbs folded to make a compact shape. Note the way you can measure the thighs and lower leg against each other and then measure both of these elements against the torso. See how the arms tuck into each other so neatly. I have added some boxing in lines to show the compact-ness of the pose.

2. In this more relaxed pose the use of foreshortening is vital to the success of the drawing. Part of one leg and arm have been fore-shortened to convey the effect of a limb pointing towards the viewer.

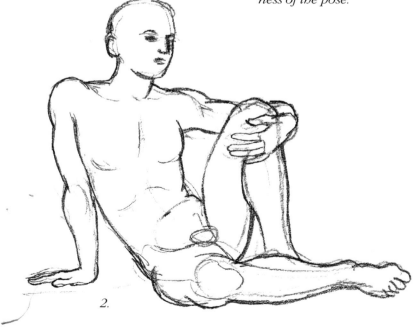

2.

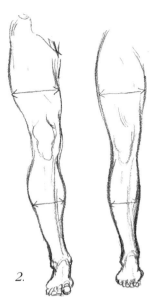

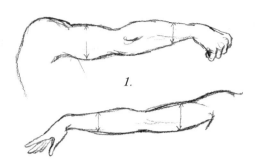

1.

2.

1. The upper arm is thicker than the lower arm or forearm. The wrist is the thinnest part of the arm and the furthest from the torso.

2. The leg below the knee is generally thinner than the leg above the knee. The thinnest part of the leg, the ankle, is furthest from the torso.

3.

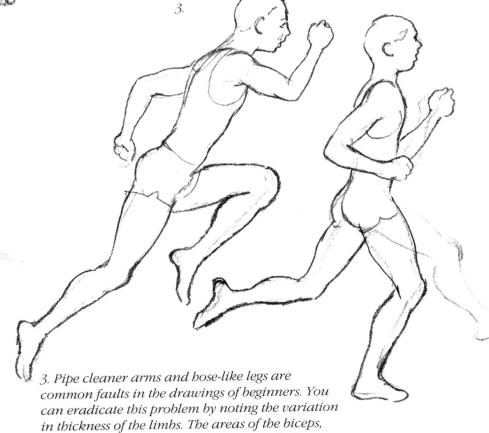

3. Pipe cleaner arms and hose-like legs are common faults in the drawings of beginners. You can eradicate this problem by noting the variation in thickness of the limbs. The areas of the biceps, shoulders, thighs and calves are generally the fleshiest and most pronounced parts.

THE NUDE
Classical poses can provide excellent practice for drawing the male and female anatomy. Try to obtain prints of these two examples and then practise copying them. If you take your time to get each shape right, such practice will prove invaluable.

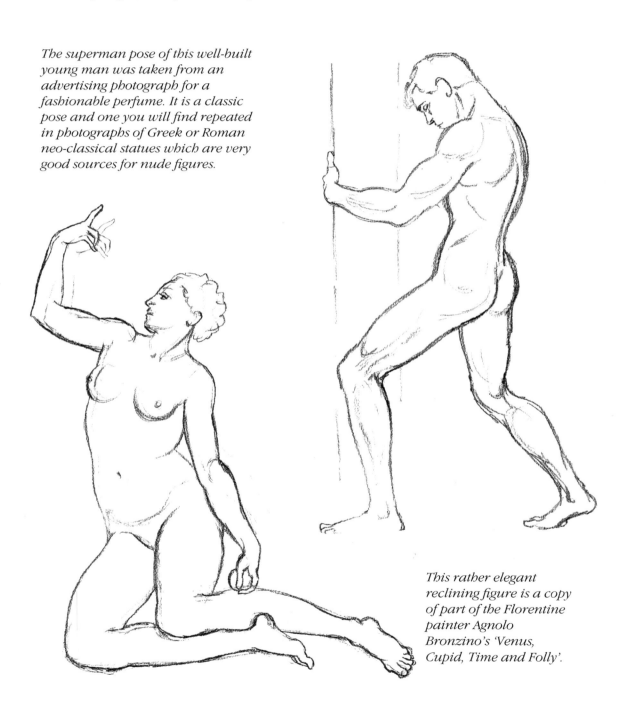

The superman pose of this well-built young man was taken from an advertising photograph for a fashionable perfume. It is a classic pose and one you will find repeated in photographs of Greek or Roman neo-classical statues which are very good sources for nude figures.

This rather elegant reclining figure is a copy of part of the Florentine painter Agnolo Bronzino's 'Venus, Cupid, Time and Folly'.

THE TORSO

If your figure drawing is to be correct, you need to understand something of the largest part of the human body, the torso or trunk. This is the area from the shoulders down to the pubes, ignoring the head, arms and legs. Compare these back and side views of the male and female torso. Once you understand the effect of these differences, you should find it easier to draw either of the sexes.

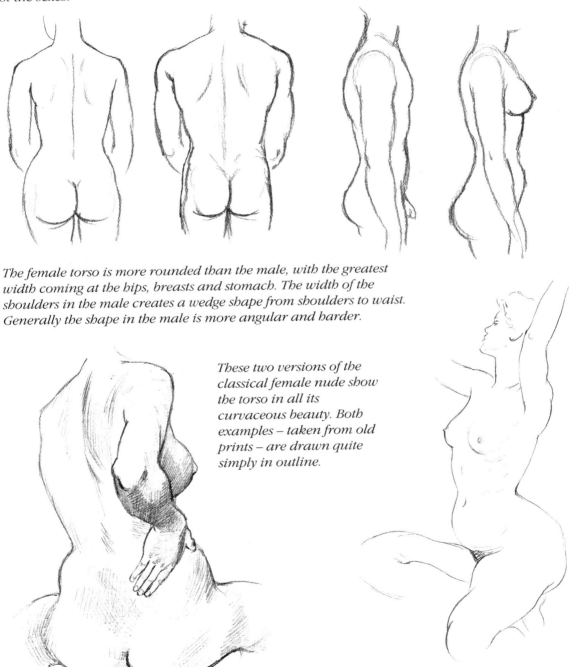

The female torso is more rounded than the male, with the greatest width coming at the hips, breasts and stomach. The width of the shoulders in the male creates a wedge shape from shoulders to waist. Generally the shape in the male is more angular and harder.

These two versions of the classical female nude show the torso in all its curvaceous beauty. Both examples – taken from old prints – are drawn quite simply in outline.

THE BODY IN MOVEMENT

These drawings show what happens to the body when it turns, bends or stretches. Note these changes for yourself, then copy the drawings, concentrating on the most obvious shapes.

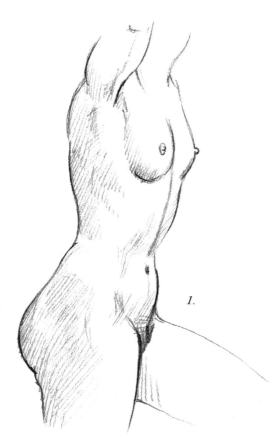

1.

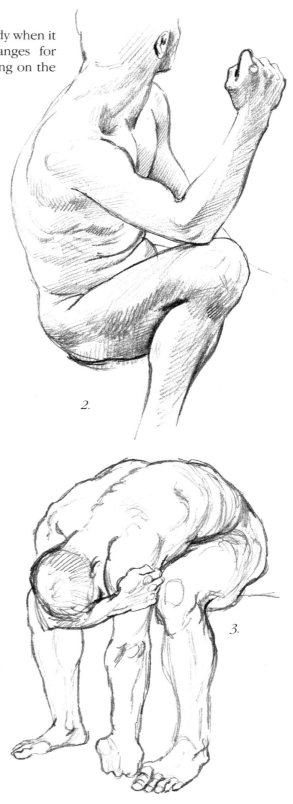

2.

3.

1. The body stretched out and lithe. Note the flexing of the muscles, the flattening of the stomach and the vertical pull.

2. The elbow on the raised knee makes an interesting geometrical figure of angles and solidity. Note the folds around the middle and the hump as the body twists.

3. Sitting and bending over makes a square, chunky shape, with the ribs and backbone standing out clearly.

When you draw a moving figure it pays to try the movement for yourself so that you can 'feel' it from the inside. Even if you don't actually perform the same movement, imagine what it would feel like. Feeling what you are drawing will help you to bring expressivity to your work.

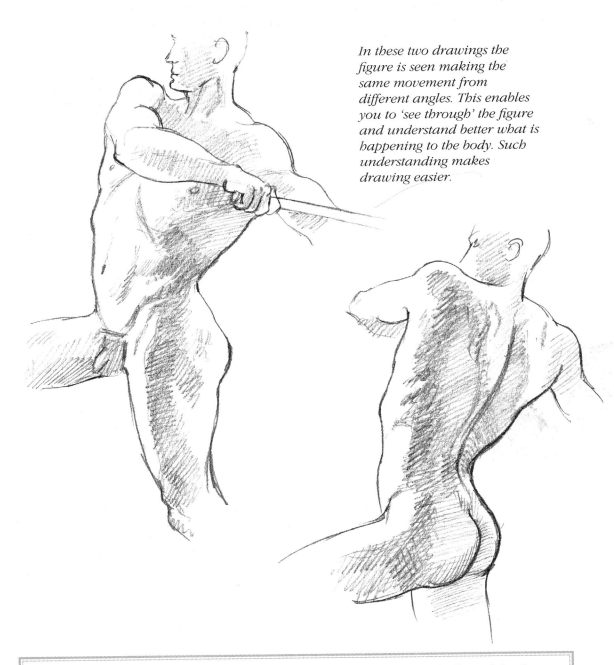

In these two drawings the figure is seen making the same movement from different angles. This enables you to 'see through' the figure and understand better what is happening to the body. Such understanding makes drawing easier.

The shading in each of these drawings is just to show the dimensional effect of the figure. Try it for yourself, keeping it simple.

THE LONG AND SHORT OF PROPORTION

As we saw earlier with our work on perspective, what is nearest to us appears to be proportionally larger than what is further away. You can see this clearly from these two drawings. With foreshortening, the actual relative sizes of parts of the body are meaningless. What determines this relative size in art is the view or perspective from which they are seen.

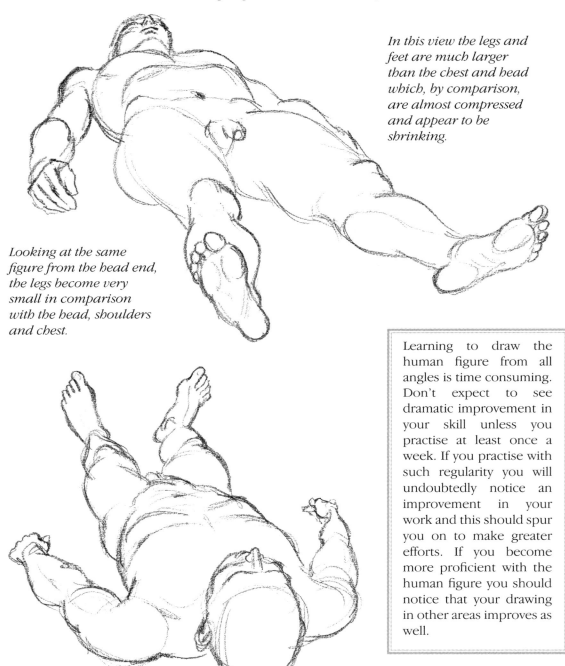

In this view the legs and feet are much larger than the chest and head which, by comparison, are almost compressed and appear to be shrinking.

Looking at the same figure from the head end, the legs become very small in comparison with the head, shoulders and chest.

Learning to draw the human figure from all angles is time consuming. Don't expect to see dramatic improvement in your skill unless you practise at least once a week. If you practise with such regularity you will undoubtedly notice an improvement in your work and this should spur you on to make greater efforts. If you become more proficient with the human figure you should notice that your drawing in other areas improves as well.

CLASSICAL PROPORTION

Michelangelo's Adam shows off the artist's knowledge of anatomy in a wonderfully balanced work which combines powerful muscularity with grace and beauty. If you study his drawings and sculptures carefully, you will gain much knowledge of the structure of the human figure. Michelangelo liked to allow the musculature to show in his figures, so the definition is clear and easy to copy. If you are unable to get to see any of his many works and copy them first-hand, work from photographs of them which are widely available.

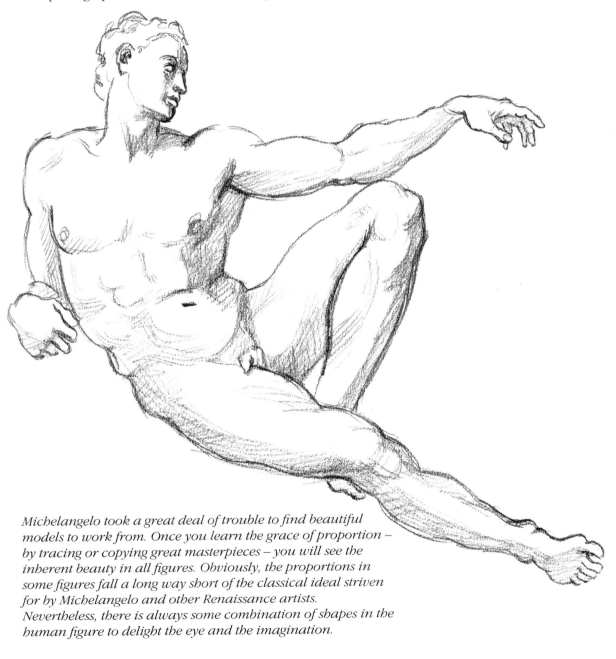

Michelangelo took a great deal of trouble to find beautiful models to work from. Once you learn the grace of proportion – by tracing or copying great masterpieces – you will see the inherent beauty in all figures. Obviously, the proportions in some figures fall a long way short of the classical ideal striven for by Michelangelo and other Renaissance artists. Nevertheless, there is always some combination of shapes in the human figure to delight the eye and the imagination.

PRACTICE: THE 'ROKEBY VENUS'

Now that you've looked at some possibilities with the human figure in a variety of positions, try drawing from a famous classical figure painting, Velasquez's 'Rokeby Venus', using tone to increase the dimensional qualities of your drawing.

Pay attention to the direction of the light source, as this will tell you what is happening to the shape of the body. Keep everything very simple to start with and don't concern yourself with producing a 'beautiful' drawing. Really beautiful drawings express the truth of what you see.

Direction of light source

Line of hip

1. Sketch in the main outline, ensuring that the proportions are correct. Note the lines of the backbone, shoulders and hips. Check the body width in relation to the length and the size of the head in relation to the body length. Pay special attention also to the thickness of the neck, wrists, ankles and knees. All of them should be narrower than the parts either side of them.

2. Finalize the shape of the limbs, torso and head. Then draw in the shapes of muscles and identify the main areas of tone or shadow.

3. Carefully model in darker and lighter tones to show the form. Some areas are very dark, usually those of deepest recession. The highlights or very light areas are the surfaces facing directly towards the source of light and should look extremely bright in contrast to any other area.

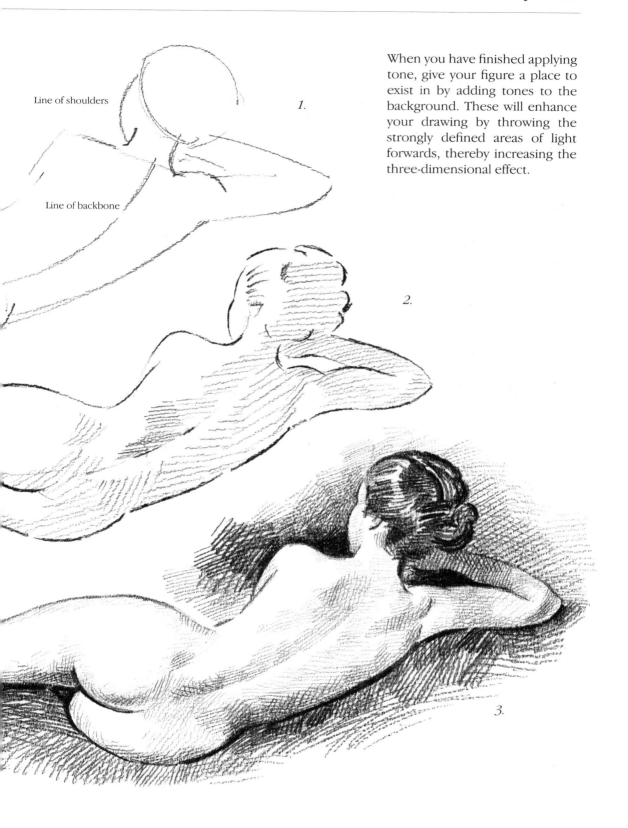

Line of shoulders

Line of backbone

1.

2.

3.

When you have finished applying tone, give your figure a place to exist in by adding tones to the background. These will enhance your drawing by throwing the strongly defined areas of light forwards, thereby increasing the three-dimensional effect.

133

CLOSE UPS OF FEET AND LEGS

Quite often, students of drawing tend to fudge the feet when drawing the body. They will, for example, produce a wedge-shaped extremity to the leg and this will, at best, look as though the model is wearing socks. It is worth making something of a feature of feet because the viewer's attention nearly always goes to the extremities of objects; thus the hands, feet and head are often noticed in a drawing. Sometimes artists leave them out altogether, but this is not good practice for a student.

Feet are not as difficult to draw as hands, but they can be tricky from some angles and this can result in awkwardness in your drawing. It's a good idea to practise drawing them from the front, back and both sides. To begin with, try drawing your own feet in a mirror. Feet do differ quite a lot and rarely conform to the classical model. Try to give yourself practice of drawing a female foot, a male foot and a small child's foot. Look at these examples, taking note of the major characteristics.

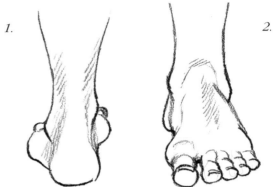

In these views you can see that the inner ankle bone is higher than the outer ankle bone.

1. Note the ball of the heel and the Achilles' tendon.

2. Looking from the front, notice how the line fluctuates to take in the large toe, the instep and the heel.

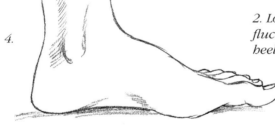

4. From this angle the large toe partly obscures the smaller toes. Note the instep and arch of the foot.

5. An outside view shows the flatter part of the sole and the toes more clearly.

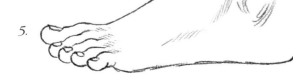

3. Note the proportions of the toes in relation to one another and in relation to the whole length of the foot.

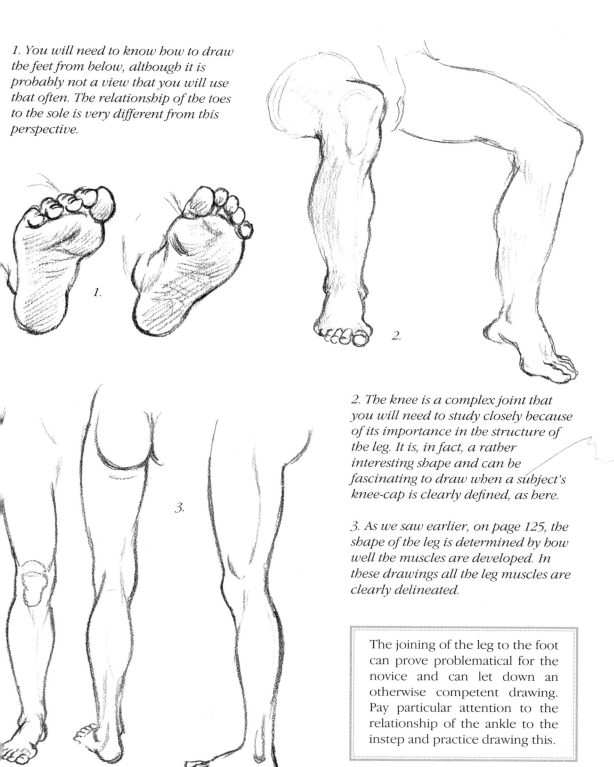

1. You will need to know how to draw the feet from below, although it is probably not a view that you will use that often. The relationship of the toes to the sole is very different from this perspective.

1.

2.

3.

2. The knee is a complex joint that you will need to study closely because of its importance in the structure of the leg. It is, in fact, a rather interesting shape and can be fascinating to draw when a subject's knee-cap is clearly defined, as here.

3. As we saw earlier, on page 125, the shape of the leg is determined by how well the muscles are developed. In these drawings all the leg muscles are clearly delineated.

The joining of the leg to the foot can prove problematical for the novice and can let down an otherwise competent drawing. Pay particular attention to the relationship of the ankle to the instep and practice drawing this.

CLOSE UPS OF ARMS AND HANDS
Elbows and wrists are extremely important features but are often poorly observed by students. By paying extra attention to these joints when you are drawing the arms you will enormously increase the effectiveness of your drawing.

1. Look back at the copy of Michelangelo's Adam (on page 131) and note one of the most famous renderings of the arm and hand known to art. You can see from this drawing how the arm provides a background to the expressions or actions of the hand.

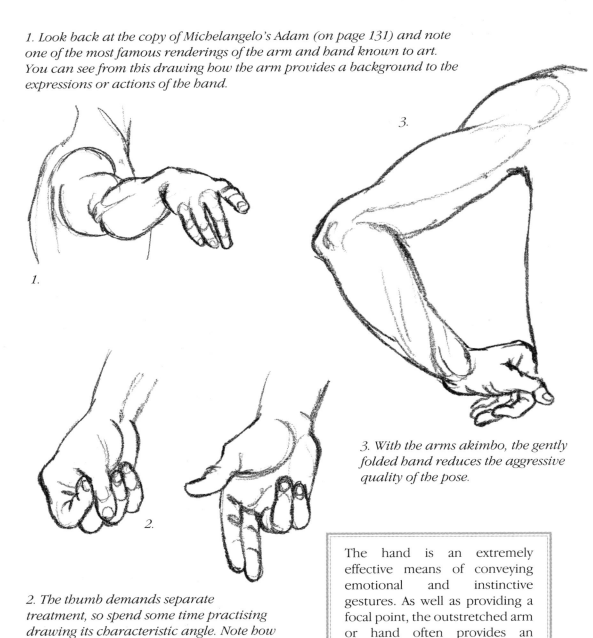

3. With the arms akimbo, the gently folded hand reduces the aggressive quality of the pose.

2. The thumb demands separate treatment, so spend some time practising drawing its characteristic angle. Note how in poses the thumb helps to define the direction in which the hand is pointing.

The hand is an extremely effective means of conveying emotional and instinctive gestures. As well as providing a focal point, the outstretched arm or hand often provides an important key to a picture.

The next stage is to begin to draw hands very simply from all possible angles. Start with an easy angle, such as the one shown here. You can do a lot with your own hands by using a mirror, or you can try drawing someone else's hands.

1.

2.

1. Sketch out first the main lines, the direction in which the fingers point and the basic proportions of fingers to palm, finger joints and the relative spacing of joints on fingers.

2. Once you are sure these basic lines are correct, fill out the shape.

3. Finish off by adding tonal values.

3.

CLOSE UPS OF HANDS

When you have gained in confidence, look particularly at hands coming towards you with the fingers foreshortened. Don't be put off if this seems quite difficult and your drawing looks a bit odd. Try again, and keep trying until you get the result you want.

You cannot practise drawing hands too much. Vary your experience of types of hands: male and female, old and young, strong and delicate. It is also a good idea at some stage to draw each finger and the thumb separately about three times life-size.

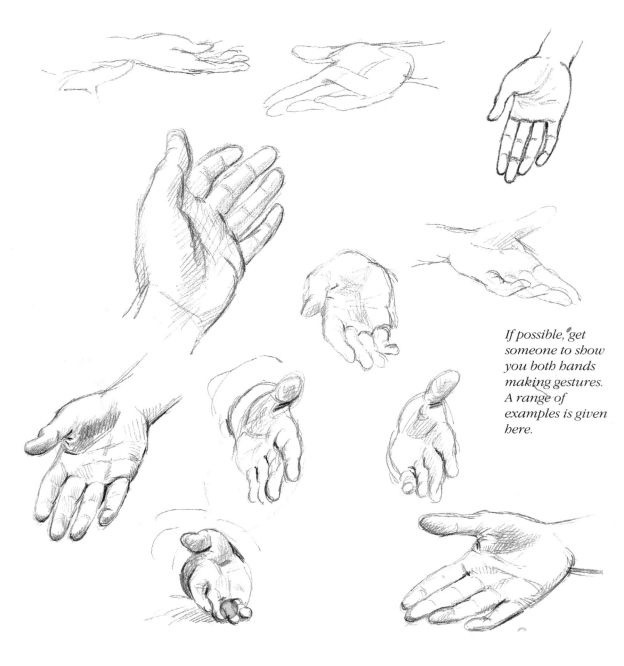

If possible, get someone to show you both hands making gestures. A range of examples is given here.

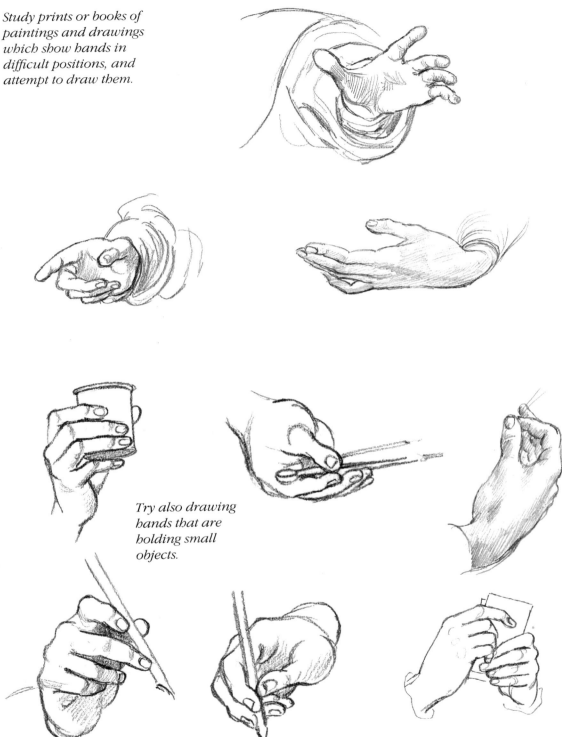

Study prints or books of paintings and drawings which show hands in difficult positions, and attempt to draw them.

Try also drawing hands that are holding small objects.

THE HEAD AT DIFFERENT ANGLES
It is important to draw the shape of the head and the position of the features from different angles, as the appearance can differ radically. A wide range of angles is given here. Compare the finished versions with the structural drawings and note how the proportions change.

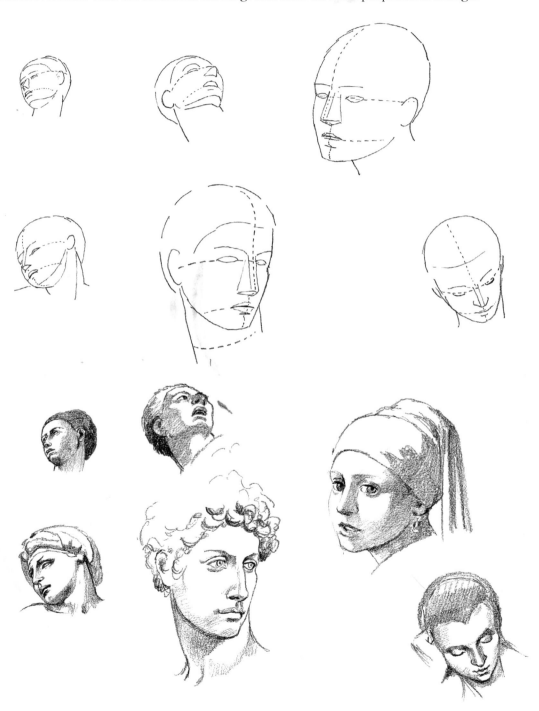

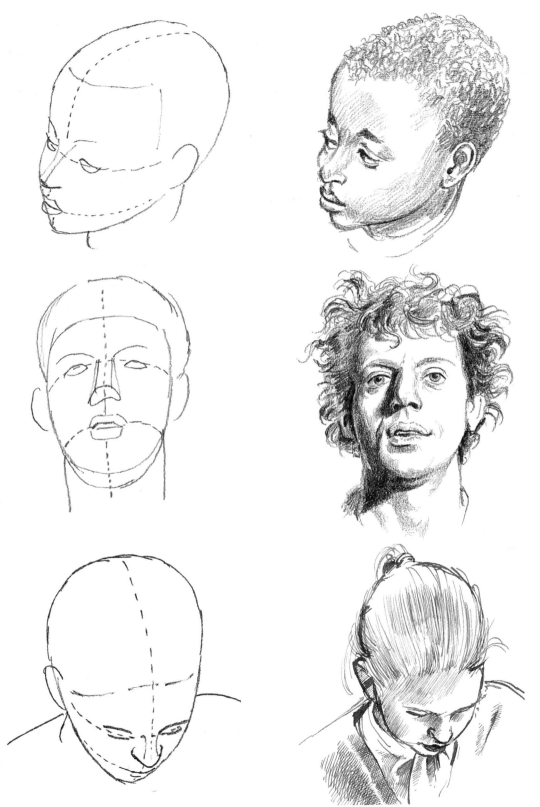

THE HEAD AT DIFFERENT ANGLES: PRACTICE

As you will have noted from some of the examples shown in the previous spread, when the head is seen from either above or below the lines of the mouth and eyes will curve round the shape of the head in a lateral direction. Seen from below, they will curve downwards at the outside corners. Seen from above, they will curve in an upwards direction at the corners. The forehead when seen from below will tend to disappear and the area under the nose and the chin appear much larger in comparison. The nose viewed from below shows like a triangle at right angles from the face with the nostrils clearly seen and often partially obscuring one of the eyes. Seen from above, the chin and upper lip tends to disappear while the length of the nose and forehead seems to increase.

Try to simplify the angles shown here, as was done on the previous spread. You will be given the opportunity to draw all these portraits in their entirety later.

1. A three-quarter view emphasizes the angle of the chin and the back of the head. The eye farthest from the viewer is partially hidden by the bridge of the nose and almost appears to curve around the edge of the face.

1.

Never forget that the central line from the top of the head through the centre of the eyes, nose and mouth and chin is of critical importance in constructing the shape of the face on the head (check back to pages 36–37 to refresh your memory of the proportions of the head).

2. Here the eyes curve round the head because the boy is looking down and his chin is tucked in. His features are clear and simple, and typical of a boy his age (about 8 years).

3. The effect of the eyes curving round the head is also very evident here, as is the curve of the mouth for the same reason: the backwards tilt of the head. The nose appears to jut upwards out of the face. The area under the chin is greatly increased, altering the shape of the neck.

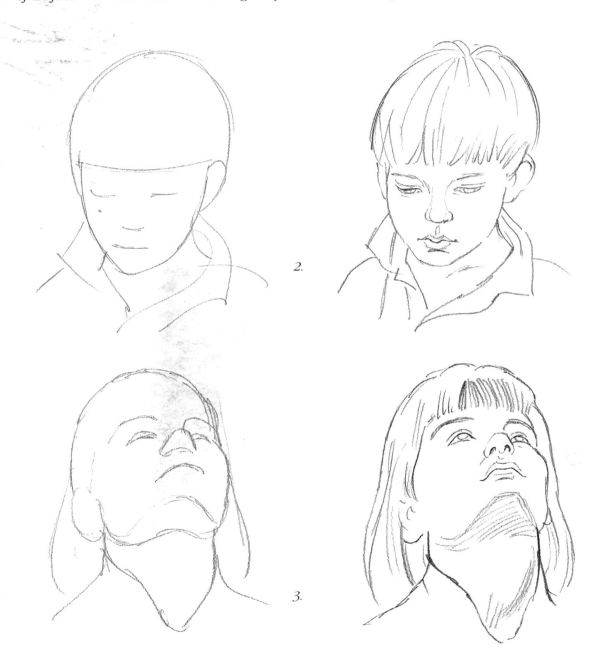

2.

3.

EXPRESSIONS
We also need to look at the different kinds of expression which the face presents us with. These examples are all taken from classical paintings or photographs.

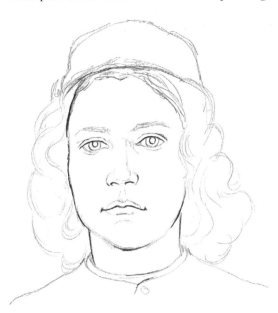

Taken from Botticelli, this gives a very simple, clear view of the features in relaxed, attentive mode.

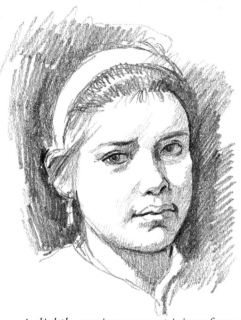

A slightly anxious or suspicious face with one eyebrow lowered, eyes to one side, mouth closed firmly; from Velasquez.

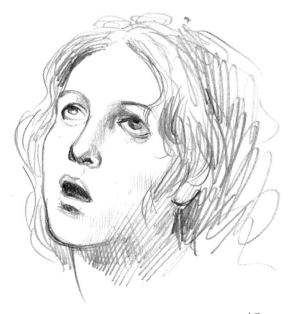

Religious awe, as depicted by Caravaggio.

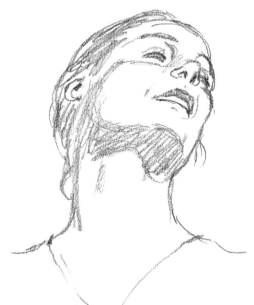

A joyous expression, with a contented open smile; from Riefenstahl's film of the 1936 Olympics.

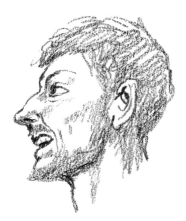

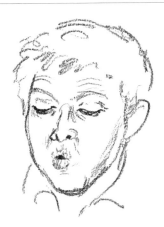

Smiling, expectant, obviously enjoying some event but slightly apprehensive or unsure.

A surprised face, looking down at something with pursed lips, or perhaps just trying to blow out a candle.

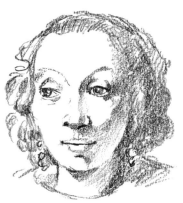

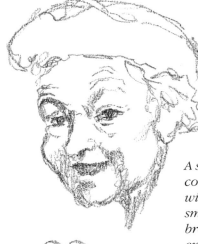

A wide-eyed gentle smile, eyebrows raised but eyelids half down.

A slightly conspiratorial look with open-mouthed smile and wrinkled brow as though enjoying a good joke.

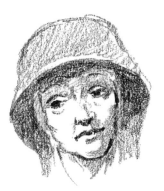

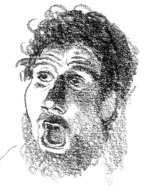

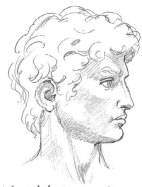

A dolorous face slightly inclined, with a faintly wry smile.

Mouth agape in a shout or gasp, eyes wide open, brow wrinkled in some astonishment or perhaps terror.

A head that seems to express defiance, alertness and power; taken from a Michelangelo statue.

EXPRESSIONS: PRACTICE
The faces on these pages show more extreme expressions than those on the preceding spread
and have an almost caricaturist quality.

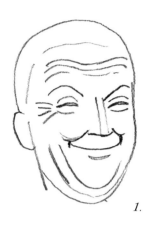

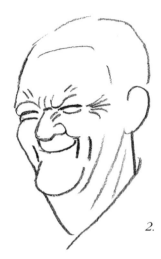

1.

2.

1–2. The main lines are of primary importance when drawing very expressive faces. Here I put in sharply and clearly all the wrinkles around the eyes and nose. The massive folds of skin and muscle on the forehead, cheek and chin are also emphasized.

3.

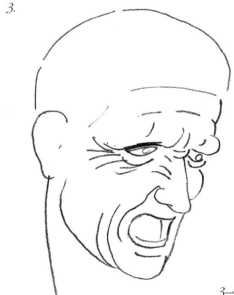

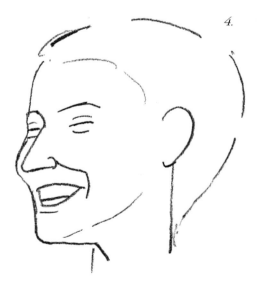

4.

3–4. Here note particularly the pad of flesh under the eyes, and the large crease from the corner of the nostril down to the corner of the mouth. In the man there is a web of creases at the outside corner of the eyes and also parallel lines on the forehead.

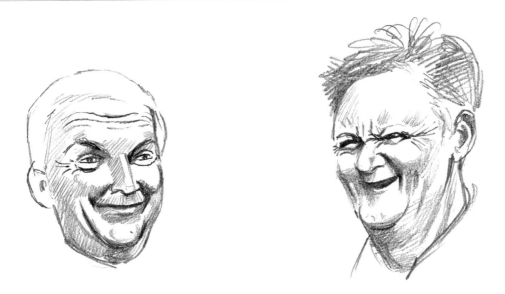

1–4. For the final stage I added tone to the folds and wrinkles to give them more solidity. However, in all these examples a successful outcome hinged on the accuracy, clarity and strength of the lines. These lines are the key to expression.

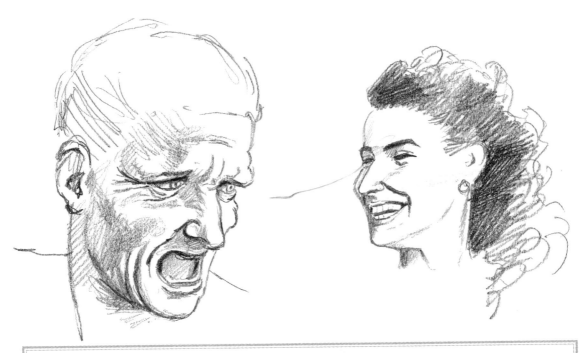

The easiest way to practise these sorts of facial qualities is to make faces at yourself in the mirror. All good cartoonists do this. If you're too inhibited to act out expressions, take photographs of your friends pulling faces and then carefully copy those.

DETAILS: MOUTH AND EYE

Now to look at the features in detail. Try drawing close ups of the eyes and mouth and then the mouth and eyes from the side view. If you haven't got a model, experiment with your own features. You will need to use two mirrors to get a side view. Position yourself very close to the surface of the glass so that you can see every detail.

With the mouth, first pay attention to the inner and outer edges of the lips. The strongest line on any mouth, whatever its shape, is where the lips part. This line will be very definite, clear-cut and extend along the whole length of the mouth. From the side it is even more obvious.

The outer edges of the lips should not be drawn strongly. Many beginners over-emphasize this edge and end up with a pair of painted plastic lips that seem to jump off the surface of the face. Draw the central part of the upper lip fairly clearly because usually this part has a well defined edge. This is often not the case with the lower lip, except possibly for a tiny part of the middle edge, although the crease between the chin and the lower lip can sometimes be quite deep.

Don't forget to show the vertical groove of the septum above the centre of the upper lip; note, too, that this varies in intensity. Now look at the corners of the mouth. Are they deeply incised or not? Do they curl up or down? Is there a large pad of flesh outside the corner of the mouth or not? All these points give individual character to a mouth.

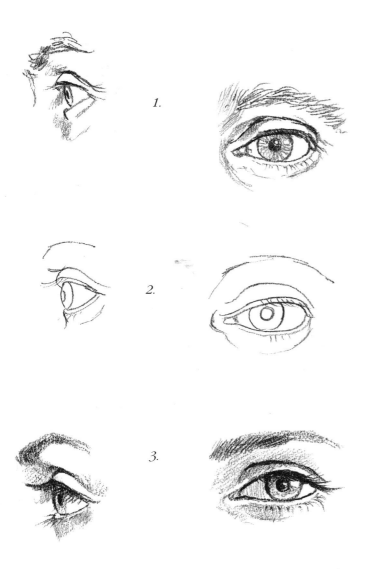

1.

2.

3.

1. The inner corner of the eye has the formation that indicates the tear duct. The outer corner is much simpler. Look carefully at the configuration of the eyebrows, drawing almost each hair going in the right direction. In older faces the eyebrows tend to appear bristly and growing in various directions. In younger faces, the eyebrows grow smoothly in one direction. Compare this example with figure 3.

2. The construction of the eye can be seen fairly clearly from the side. Notice also how the iris (coloured part) of the eye takes up quite a large area of the open eye and be careful not to exaggerate the amount of white of eye showing, as this makes the eye look terror stricken. Usually about an eighth of the iris is hidden beneath the upper lid and the lower edge just touches the lower lid.

3. The lower lid must be drawn faintly because, except in the very elderly, in whom there are fewer lashes and the lower lid droops, the lower lid doesn't register as strongly as the upper lid. The lower lid, because it faces upwards, reflects the light and appears to be brighter. The upper lid looks darker and heavier because it is facing downwards and the lashes are thicker.

The only feature on the eye that is more defined than the lids is the pupil, which often shows a tiny highlight in its black centre.

DETAILS: NOSE AND EAR

The nose is only tricky when it is drawn from the front.

Be careful not to make it too long. Look carefully at the width of the central ridge because this will determine the depth of shadow cast either side of the nose. The deepest shadow shown around the nose from the front is usually in the corner near the eye and eyebrow. The nostril crease between the cheek and nose is often distinct, and the nostrils themselves will be shadowed.

Make sure you get the shape of the nostril correct or it may look like somebody else's nose. Unless the lighting is unusual, the shadow under the projection of the point of the nose must be shown clearly. Check the width of the lower end of the nose with the length of the nose from nostril to bridge.

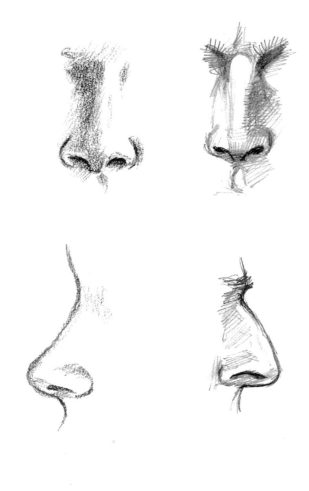

To begin with, you will find the convolutions of the ear unfamiliar. You need two mirrors to get a clear view of your own ear. The length and breadth of the ear need to be calculated correctly. The inner part is towards the bottom of the ear. The length of the lobe can vary.

JUVENILE FEATURES

The child's features are much simpler than the adult's because no droop or tiredness has set in yet. If you want to draw the facial features at their freshest, a child offers the best opportunity. Unfortunately, children find it difficult to sit still for longer than a few minutes, so you have to be quick.

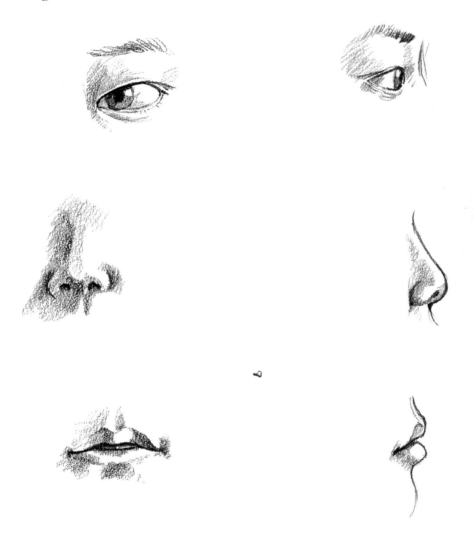

The smoothness and uncomplicated shapes of youth are evident in the features of this 12-year-old Chinese boy. The almond shape of the eye is, of course, characteristic of his race and particularly easy to draw because there is so little to it.

HANDLING FORM AND CLOTHING

The handling of drapery and clothing is not particularly difficult, but it does require some study in order to be clear about how materials behave and what happens when they are covering the body. The results from your study can, of course, be used as a background for still life, but the main purpose of these exercies is to teach you how folds work. How materials behave depends largely on the type of fabric. With practice you will come to understand those differences.

1.

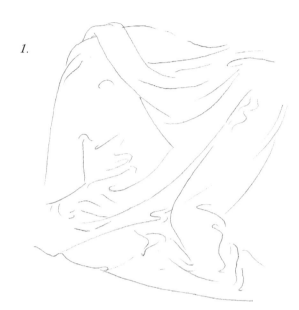

A useful exercise for learning about the behaviour of clothing is to choose an item in a soft fabric – such as wool or silk – and drape it over something so that it falls into various folds. Now try to draw what you see.

1. Draw the main lines of the large folds. When you have got these about right, put in the smaller folds.

2. In order to capture the texture of the material, put in the darkest tones first, and then the less dark. Make sure that the edges of the sharpest folds contrast markedly in tone from the edges to the softer folds. In the latter the tone should gradually lighten into nothing.

2.

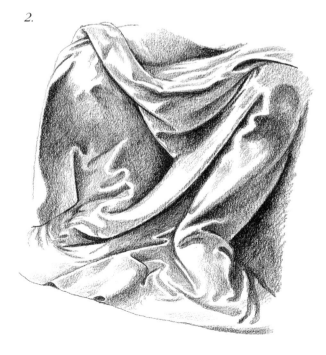

Try drawing an arm in a sleeve or a leg in trousers and carefully note the main folds and how the bend in the arm or leg affects them. In sleeves, the wrinkles can take on an almost patterned look, like triangles and diamond shapes alternating.

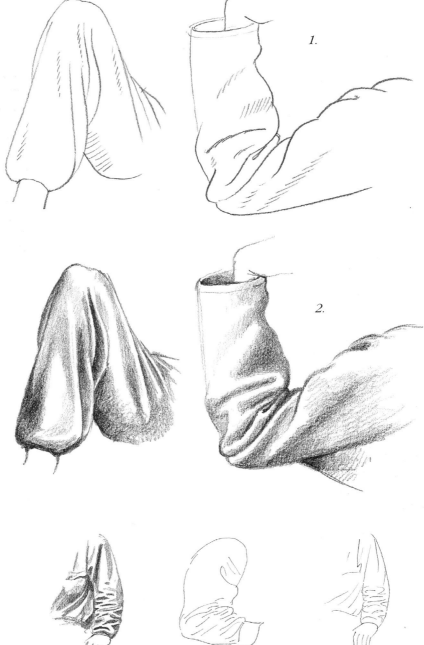

1.

1. Start by very simply putting in the main lines of the creases. Note how on the jacket the folds and creases appear shorter and sharper across the sleeve, whereas on the tracksuit they appear longer and softer down the length of the leg.

2. Shade in where necessary to give the drawing substance.

2.

3. The patterns on these sleeves look almost stylized, partly because the material is a bit stiff.

3.

EXPRESSING MOVEMENT

We can now look at how artists draw figures which express some emotional or sculptural movement. As you get more into drawing, you will begin to notice how other artists to create different effects. There is nothing like doing it yourself to understand how brilliantly some artists have solved the problems associated with producing those effects.

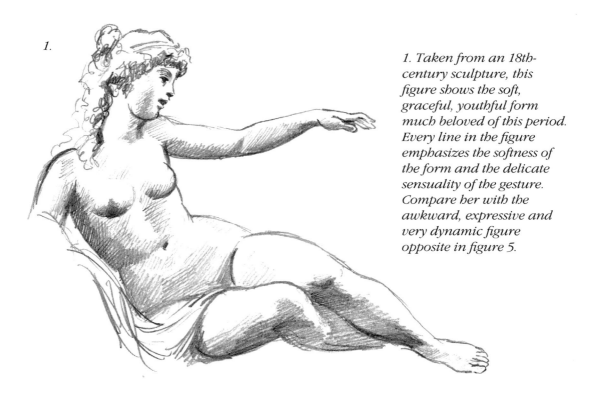

1.

1. Taken from an 18th-century sculpture, this figure shows the soft, graceful, youthful form much beloved of this period. Every line in the figure emphasizes the softness of the form and the delicate sensuality of the gesture. Compare her with the awkward, expressive and very dynamic figure opposite in figure 5.

2. The most expressive aspect of this figure – based on a Gauguin painting of a Tahitian girl – is its monumentality. She appears to be almost carved out of wood, the surface tones clearly changing from one plane to the next in a rather simplified fashion. This has the effect of creating solidity and strength and giving a very rectangular, compact shape.

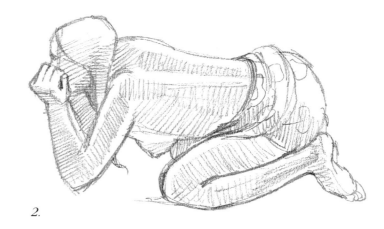

2.

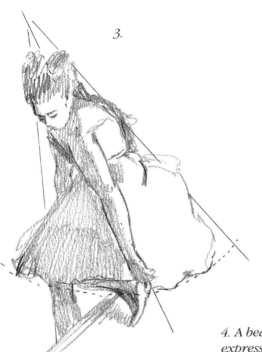

3.

3. A copy of the Impressionist master Degas, who was a brilliant draughtsman. Somehow, he has seen the simplicity of this triangular pyramidal shape of the ballet dancer pulling on her shoe. The shadow emphasizes this by being mainly all on one side, giving a dark triangular shape against a bright triangular shape with a slight fuzzing over near the apex where the shadows on the face and hair are reversed. The shape of the dress hides most of the lower figure but the arm is very clearly shown thrusting through the middle of the triangle. The geometric shaping of figures gives a picture great power and a satisfying stability.

4.

4. A beautiful expression of the classical contra-posto attitude by a young ballerina at the barre. Her shoulder tilts one way and her hips in the opposite direction, throwing the weight onto one leg, the head tilting to compensate. Many artists have used this complex, balanced shape to produce extremely beautiful figures, especially when representing Goddesses or the Three Graces.

5.

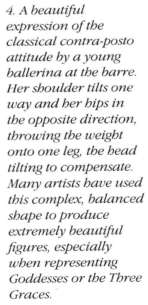

5. This drawing was taken from a photograph of a shopkeeper gossiping on her doorstep and is redolent in gesture of small-town interest in other people's problems. A wry look on the face, the jutting knee and weight pushed back against the folded arm; the rather broader than long, sturdy figure has none of the grace shown by the 18th century subject (figure 1).

EXPRESSION IN ATTITUDES

In all the drawings shown here, the particular arrangements of hands and arms combine with very clear facial expressions to convey the emotional situation very forcibly. When you come to draw people in such attitudes, the techniques you use must match the mood.

1. A man in a relaxed social setting, obviously enjoying a joke or amusing comment. The slightly rough shading helps to underline his jaunty attitude.

1.

2.

2. A young girl cooing over a lamb with sympathy and the love that children often feel for animals. Her head is pressed against the lamb's head, looking down, with mouth slightly open and lips pursed. The soft line used helps to emphasize the mood.

3. An elderly couple enjoying their friendship, heads pressed closely together, the man's chunky hand softly and affectionately draped over the woman's shoulder. The loose line emphasizes the pair's casual, unadorned attitude.

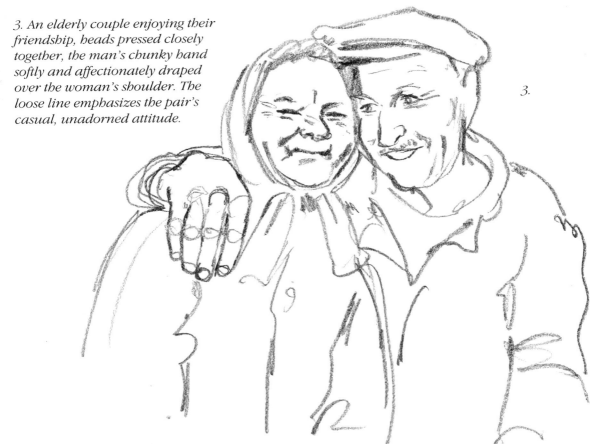

3.

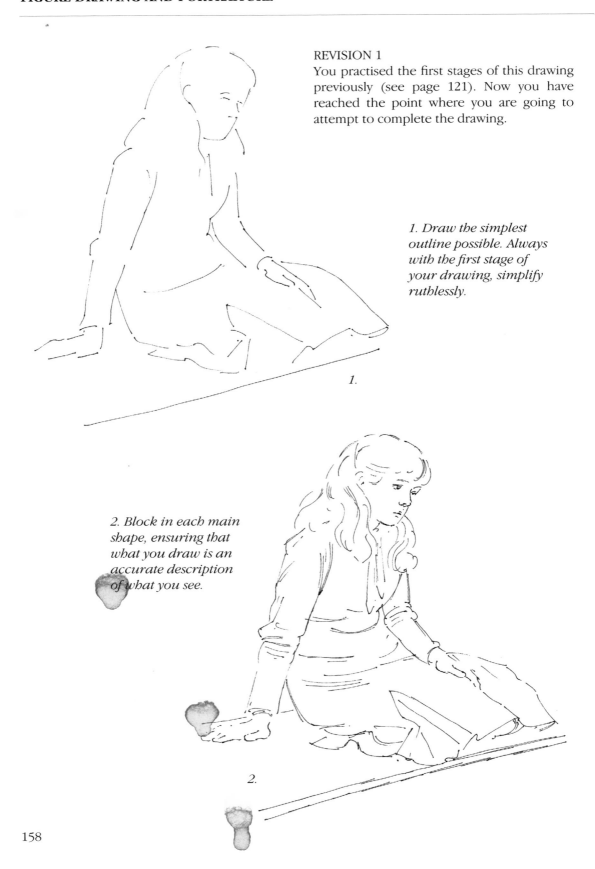

REVISION 1
You practised the first stages of this drawing previously (see page 121). Now you have reached the point where you are going to attempt to complete the drawing.

1. Draw the simplest outline possible. Always with the first stage of your drawing, simplify ruthlessly.

1.

2. Block in each main shape, ensuring that what you draw is an accurate description of what you see.

2.

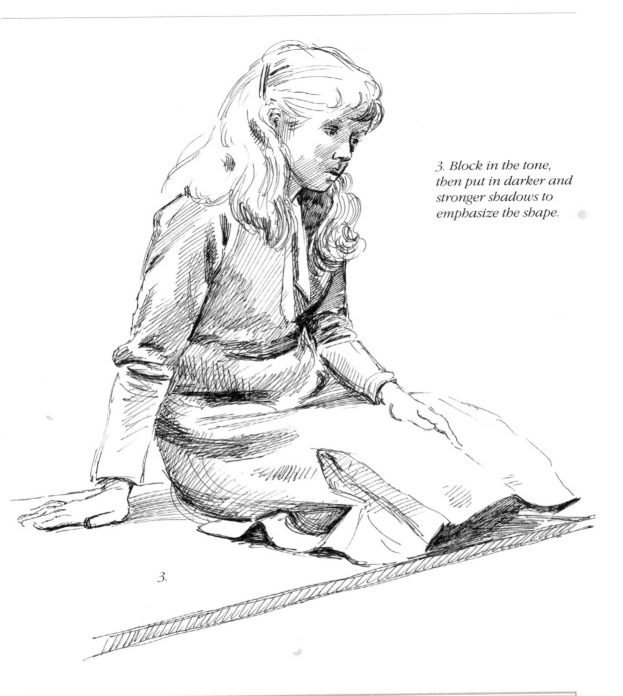

3. Block in the tone, then put in darker and stronger shadows to emphasize the shape.

3.

The drawings you have been studying so far have shown you many ways of drawing the human being. None of this information and guidance is of use unless you carefully and repeatedly practise. The best way is to draw from life. If this is not always available, regular practice using master-drawings will help a great deal. There is no substitute for continuous practice. Without it, you will not improve.

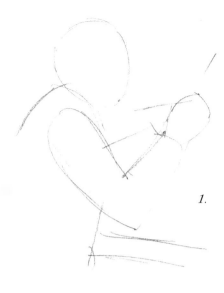

1.

REVISION 2
If necessary, refer back to page
120 to refresh your memory of
the first stages of this portrait.

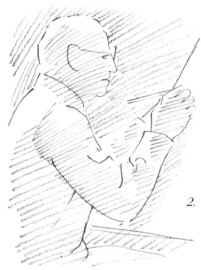

2.

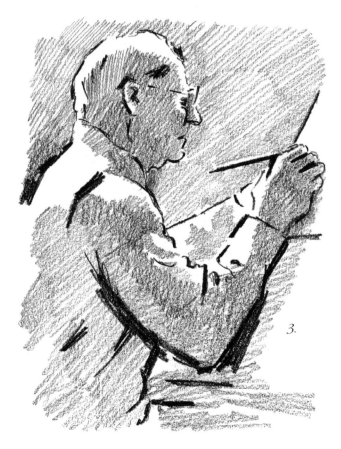

3.

*1. Make a basic outline to define the
area of your drawing.*

*2. Draw in the main shapes, making
sure they resemble your model. Lightly
block in areas of tone.*

*3. Work more subtle variations into
the main tone. Distinguish the more
powerful outlines from the less
powerful. The large areas of tone
contrast with the bright patches left on
the man's head, shoulder and arm
and make them stand out.*

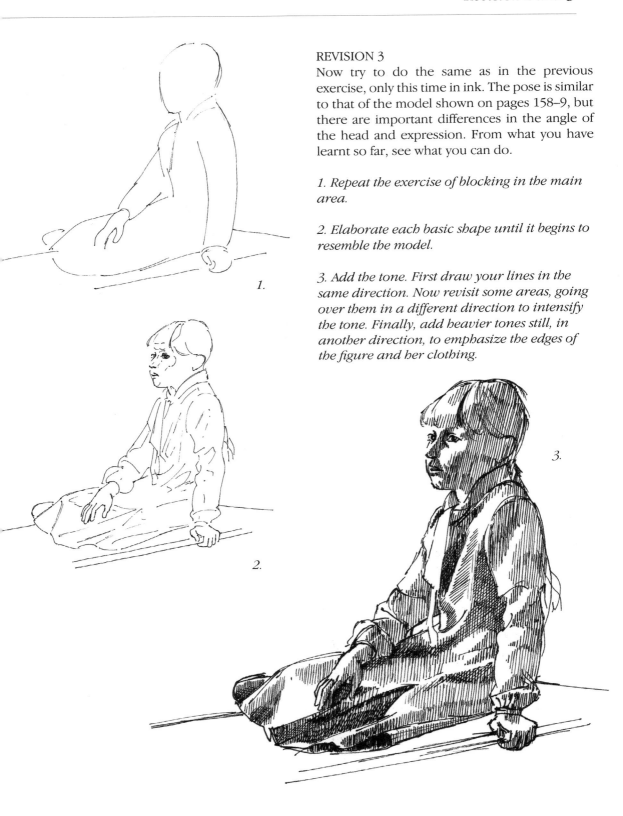

REVISION 3
Now try to do the same as in the previous exercise, only this time in ink. The pose is similar to that of the model shown on pages 158–9, but there are important differences in the angle of the head and expression. From what you have learnt so far, see what you can do.

1. Repeat the exercise of blocking in the main area.

2. Elaborate each basic shape until it begins to resemble the model.

3. Add the tone. First draw your lines in the same direction. Now revisit some areas, going over them in a different direction to intensify the tone. Finally, add heavier tones still, in another direction, to emphasize the edges of the figure and her clothing.

1.

2.

3.

REVISION 4
Capturing the likeness of a subject can be problematical, as can choosing the position from which to draw the face. This position gives some idea of the kind of person you are drawing. Gentler people tend to look down. Aggressive people look up or straight ahead, chin raised. The position for this type of forceful personality would be head on so they are looking straight at the viewer. Some people smile easily, others look darker or cooler. A profile is often the answer if the expression is less confident.

1.

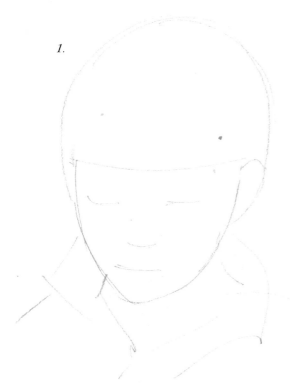

1. Before you start, look at the shape of the head as a whole. Study it; it is essential that you get this right. (If necessary, refer back to page 143 for guidance on drawing this portrait.)
Now draw an outline, marking the area of hair and the position of the eyes, nose and mouth.

2.

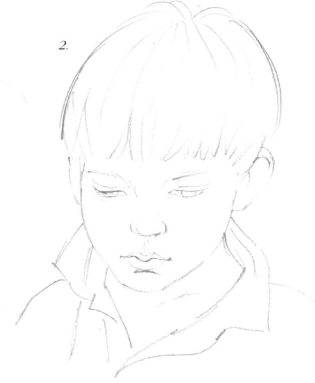

2. Build up the shapes of the ears, eyes, nose, mouth and a few more details such as the hair and neck.

3.

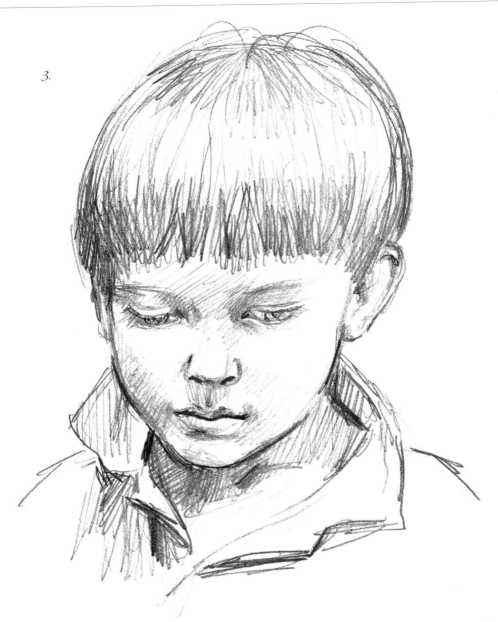

3. In the final drawing, effort has gone into the areas of tone or shadow, the quality of hair and shirt and the tonal variations of the shading around the eyes, nose and mouth in order to define the features. You'll notice that the lines of tone go in various directions. There is no single, 'right' way of doing this. In your own drawings you can try out single direction toning, multi-direction toning, shading around and in line with the contours and, where appropriate, smudging or softening the shading until it becomes a soft grey tone instead of lines. What you do – and what you think works – is simply a matter of what effect you wish to achieve. Softer, smoother tones give a photographic effect, more vigorous lines inject liveliness. Here the slight roughness of shading emphasizes a boyish unconcern with appearances.

REVISION 5
The lighting lends a special quality to this portrait, accentuated by the three-quarter view. Although the light is coming from above, the face is not directly lit, apart from the nose. With this type of view, care has to be taken to align the central line of the head and face and correctly position the features across this line. If the subject had been looking straight at the viewer, the centre line would have been much more obvious. However, that view would not have given the atmosphere of gentleness and peacefulness intended.

1.

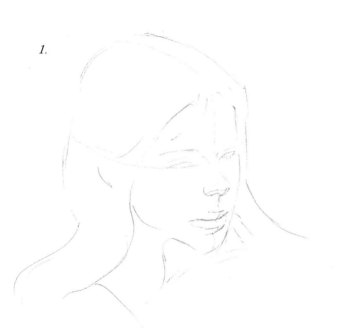

If necessary, refer back to page 142 for guidance on drawing heads at different angles and this portrait in particular.

1. After studying the shape of the head, draw the outline, marking the area of the hair and the position of the eyes, nose and mouth.

2.

2. Add the basic area of shade, this time all in the same direction to keep a smooth, soft look.

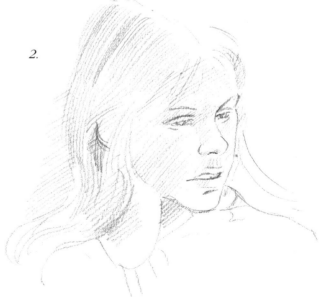

3.

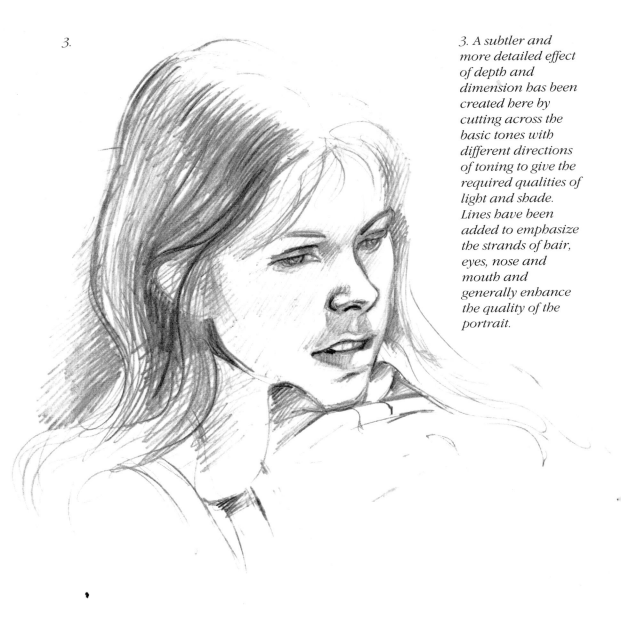

3. A subtler and more detailed effect of depth and dimension has been created here by cutting across the basic tones with different directions of toning to give the required qualities of light and shade. Lines have been added to emphasize the strands of hair, eyes, nose and mouth and generally enhance the quality of the portrait.

It is essential in a portrait to place the features exactly right and then make sure that the basic shapes of mouth, nose and eyes and the outline of the head and jaw are as close to your original as you can get. Don't worry if this doesn't happen the first time, but be mindful of it as an important aim. Always try to reproduce exactly what you see and not what you don't see. Trust your eyes. They are very accurate.

165

REVISION 6

In this portrait you are faced with a very unusual position of the head. The degree of difficulty accentuates the necessity of correctly drawing the outline of the head. If you don't spend time getting this stage right, the result will be unsatisfactory, no matter how beautiful your detailed drawing. Generally, the first few minutes of a drawing determine how good or bad it will be.

Because of the unusual angle don't expect the shapes to be conventional or even what you know. Observation here is the real key, and if you observe keenly there is more chance of a powerful drawing resulting from your efforts.

1.

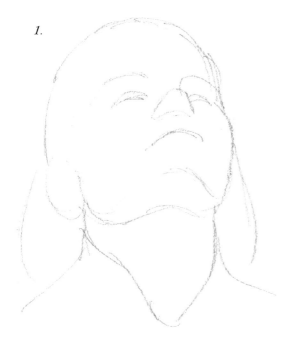

1. As you saw earlier, on page 143, where you first encountered this angle, the key to this drawing is understanding the construction of the shapes. Refresh your memory by referring back now. When you are ready, draw the outline and sketch in the features.

Make sure that the shapes you can see are reproduced in your drawing as precisely as you know how.

2.

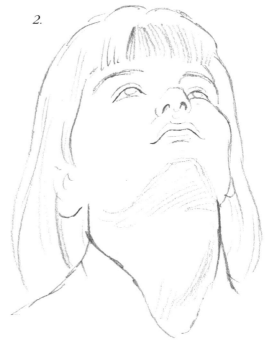

2. Pay special attention to the shape under the jaw and how it combines with the neck to make a large, open shape. The features – eyes, nose and mouth – are all pushed together in a smaller space than is usual, because of the angle.

3.

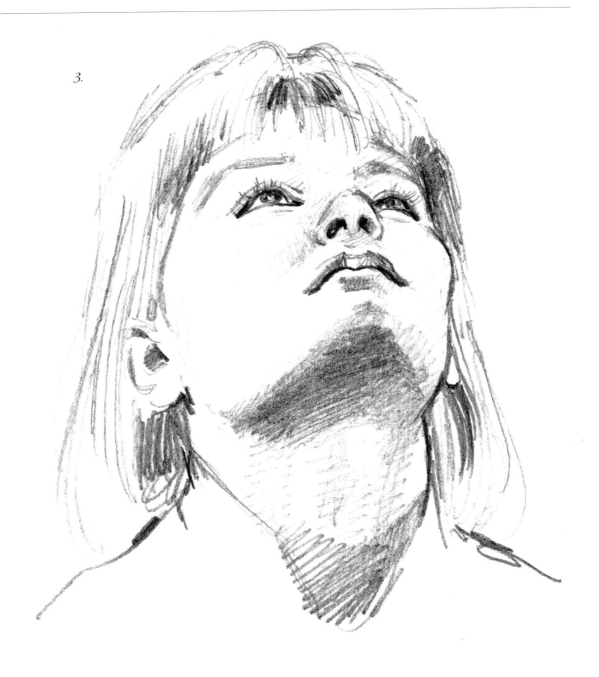

3. Add all the embellishments of light, shade and detail, using emphasis accurately to create both a good line and a convincing portrait.

ARRANGING A SUBJECT

Next we look at ways of arranging the subject of your portrait to get the best effect. To get a truthful portrait your subject must be taken on their own terms, so any props should support the idea of them you want to convey.

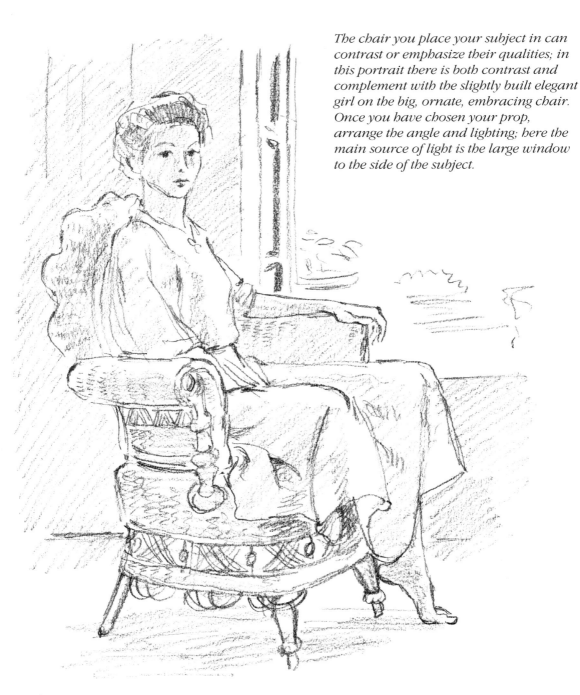

The chair you place your subject in can contrast or emphasize their qualities; in this portrait there is both contrast and complement with the slightly built elegant girl on the big, ornate, embracing chair. Once you have chosen your prop, arrange the angle and lighting; here the main source of light is the large window to the side of the subject.

SPONTANEOUS PORTRAITURE

You would probably have to take photographs – and make many sketches – to capture an active portrait like this. I just happened to have my sketch book with me when I came across this figure and couldn't resist sketching him as he worked. For this to become a real portrait, it would need much more detail, especially of the head.

There is an intentional hint of allegory here, reminding us of Father Time, who is always shown as an elderly man with a scythe. The loosely drawn line gives a feeling of movement to the shape.

PORTRAITURE WITH A DIFFERENCE
Both of the examples shown here are unusual approaches to portraiture and stand almost at opposite ends of the spectrum: the first showing the effect of simplified outline treatment, and the second the visual impact of detail and texture.

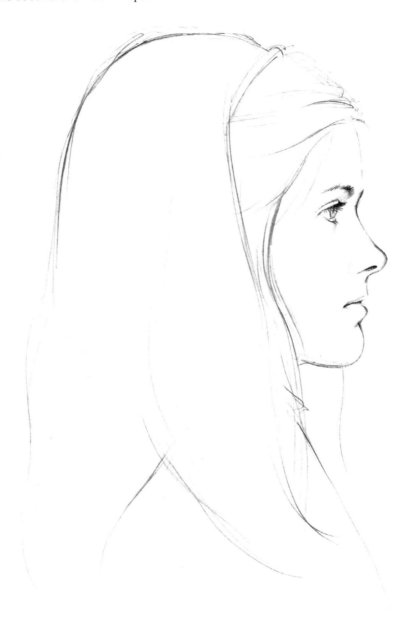

The effect of this drawing derives purely from the outline shape of the basic features and hair. For this approach to work well you have to succeed in getting the profile accurate, in proportion and shape. Although time-consuming, this is not as difficult as it might seem.

The technique of ink drawing was rather useful here to emphasize the dark richness of the young woman's luxuriant head of hair. You'll notice that the lines are not continuous from top to bottom and that white areas have been left between the breaks in the line. The impression, though, is of a mass of long, shiny hair.

Composition

Eventually, with practice, anyone can learn to draw
the basic parts of a picture, but composing or
designing the whole effect is a different matter
altogether. This is the most interesting and rewarding
stage of an artist's work, and also the most difficult.
Both intellectually and emotionally challenging,
composition reveals either an artist's vision or his lack
of it.

Many compositions are produced simply by means of
using geometric principles. The picture is divided into
geometric areas and all the parts conform to a pattern.
This approach might seem to reduce a picture's
creative punch, but it does in fact enhance it, as you
will see from the examples of great works included in
this section. The discipline of geometry is used by
artists to create harmony and balance, and this is what
we shall explore next.

ANALYSIS

Compositionally, Renoir's 'Boating Party' is a masterly grouping of figures in a small space. The scene looks so natural that the eye is almost deceived into believing that the way the figures are grouped is accidental. In fact, it is a very tightly organized piece of work. Notice how the groups are linked within the carefully defined setting – by the awning, the table of food, the balcony – and how one figure in each group links with another, through proximity, gesture or attitude.

Let's look at the various groups in detail.

Group A: In the left foreground is a man standing, leaning against the balcony rail. Sitting by him is a girl talking to her dog and in front of her is a table of bottles, plates, fruit and glasses. It is obviously the end of lunch and people are just sitting around, talking.

Group D

Group B

Group C

Group B: *Just behind these two groupings are a girl, leaning on the balcony, and a man and woman, both seated.*

Group C: *In the right foreground is a threesome of a girl, a man sitting and a man standing who is leaning over the girl, engaging her in conversation.*

Group D: *Behind this trio, two men are talking earnestly, and to the right of them can be seen the heads and shoulders of two men and a young woman in conversation.*

In Seurat's large, open air painting of 'The Bathers', the composition is effectively divided in two: the horizon line with factories along it comes about two-thirds above the base of the picture, and the diagonal of the bank runs almost from the top left of the picture down almost to the bottom right corner. The larger figures are grouped below this diagonal. The picture is drawn as though the viewer is sharing the quiet calm of the day with them, surveying the people sitting on the grass, in the boat on the river and the scene beyond.

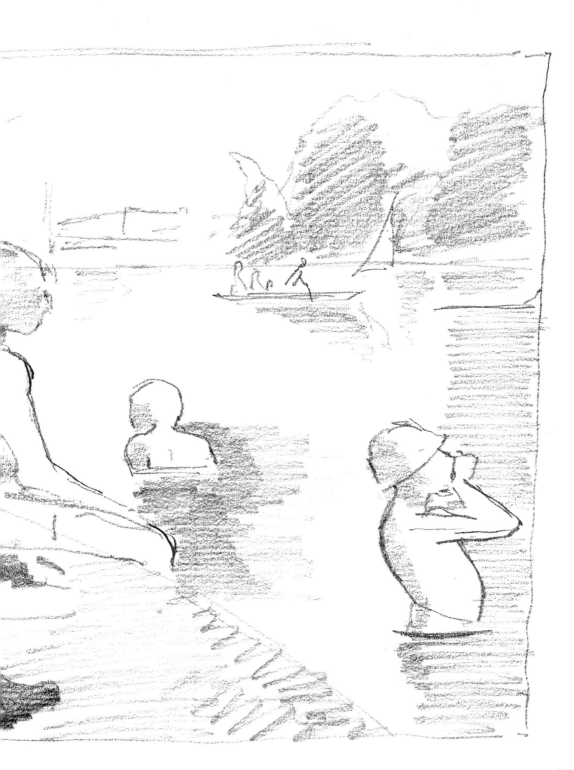

MOVEMENT IN COMPOSITION

These two images share a tremendous energy and dynamism, but the means by which this was achieved by their respective artists – Rubens and Titian – was very different. In the Rubens the drama is compressed, the confusion and struggle made palpable by the physical connection between the figures and the backdrop provided by the prancing horses. In the Titian the scene is much more open with the action spread across the picture plane although also skilfully highlighted within disparate sections.

In this copy of Rubens's painting of the rape of the daughters of Leucippus, the fidgeting of the horses gives context to the human action and lends amazing dynamism to the scene. In the foreground we see two nubile young blondes being lifted up onto the horses in front of the powerful male riders. The two female figures juxtaposed in a writhing symmetry with the two males act as props to this movement. Although there are only two horses and four figures, the baroque movement of these beings creates a powerful dramatic action.

In Titian's painting of Bacchus and Ariadne, there is just as much dynamism as in the Rubens but the effect of the energy is quite different because the scene is set further back in the landscape. The picture is much more open, with the airy space in the left half contrasting with the unruly procession of figures emerging from a grove of dark trees and moving across from the right. In this group are disporting maenads, satyrs and the drunken Silenus, all belonging to the boisterous entourage of Bacchus, god of wine and ecstatic liberation. Both aspects of this god's personality are represented here. Bacchus is centre stage, creating the major drama by flinging himself from his chariot, eyes fixed on the startled Ariadne, newly abandoned by Theseus on the island of Naxos, whom he has come to claim as his bride.

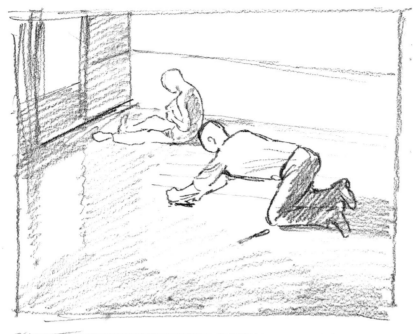

INTERIORS

On these two pages we look at what happens when a viewpoint is changed, and how much the narrative of a picture owes to the positioning of figures within a scene. In each of these pictures there is a strong sense of containment.

First, we compare two versions of Caillebotte's 'The Floorscrapers' and consider what happens to a composition when the viewpoint changes from side on (above) to head on (below). The men in the picture are working in an empty room on the first floor of an apartment in Paris, scraping a floor to renew its surface. In both pictures one window is the sole source of light.

In the top picture the light reflects off the wall in the background, and the bodies of the men are highlighted. In the second version the background wall appears dark and shadowed and the bodies of the men blend in with this. The change of viewpoint changes the whole dynamic of the picture, from one of calm and almost lazy activity to hard, intense industry. The darker tones in the bottom picture accentuate the pace of activity, and the fact that all three are stripped to the waist underlines the elemental feel. The space between the men isolates them within their labour. They do not share the easy companionship of the men in the top picture whose physical proximity emphasizes their 'at oneness' within the task.

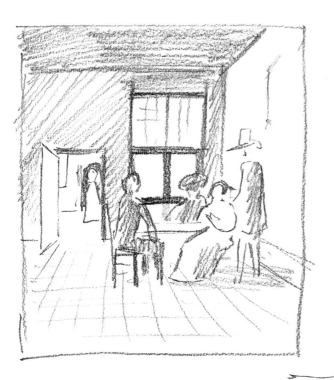

This copy of a Pieter de Hooch is less intimate than the von Menzel below by virtue of the fact that the viewer is kept at some distance from the group sitting in the room. The area above them is dark except for the light coming in through the window at the back. The doorway to the left allows us to see even further into the picture. If you ask a child or an adult unpractised in art to draw a scene, they tend to set the action in distant space, as here.

The advent of the camera and the influence of techniques evident in the work of Japanese print makers encouraged Western artists to cut off large areas of foreground so as to increase dramatic effect and bring the viewer into the scene. This interior by Adolphe von Menzel ('Living Room with the Artist's Sister') is like a cinema still: the viewer is standing the other side of the lit open doorway, looking into the room where someone sits in front of a light. We are confronted by two contrasting images – of an inner world from which we are cut off by the door and the anonymity of that lone figure in the background, and of the girl who is looking expectantly out towards us. We wonder what this girl is waiting for and we wonder about her relationship with that other figure.

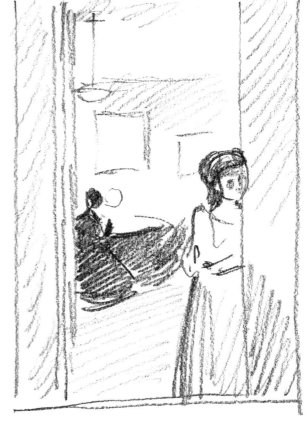

BALANCING A COMPOSITION
Both of these examples show an unusual way of composing a picture. Gustave Caillebotte was as good at composing exterior scenes as interiors. His rainy day on the streets of Paris epitomizes a view of 19th century France as it is imagined by many people. Its composition is similar to that of the Velasquez opposite. In both success is achieved through the use of dramatic contrast.

The left side of this picture is mostly empty, with the distant wedge-shaped block of apartments thrusting towards us. The right half of the picture is packed with three figures under umbrellas, a couple coming towards us and a single figure who is entering the picture from the right edge. The two halves of the picture are neatly divided by the lamp post. The scene is played out between tall buildings which bleed off the side of the picture. As with the other Caillebotte, the viewer is made to feel part of the scene. Like the next picture we are about to look at, the balance is quite brilliant.

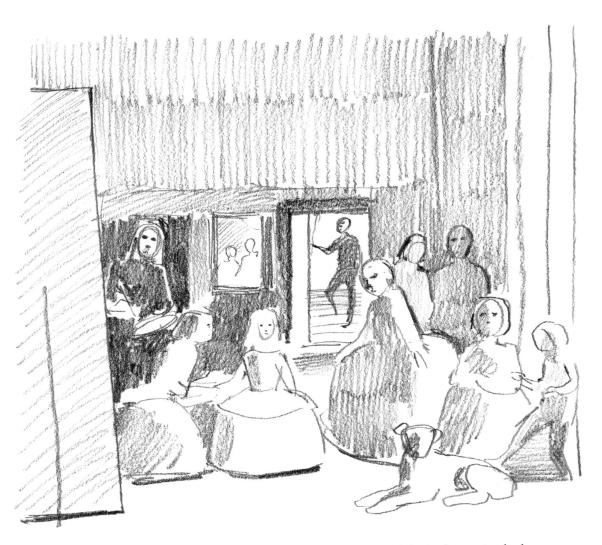

Here the contrast between the dark upper half of the picture and the lit figures in the lower half works brilliantly. Velasquez himself makes an appearance. He stands at the left, palette in hand, looking out at us. In the front of the picture are the Infanta of Spain and her maid. To the right are grouped in depth the members of her entourage, including a dwarf and a dog. At the back of the painting, just off centre, is an open doorway through which we can see a man looking in. To the left of this door is what appears to be a mirror with the reflections of the couple being painted by the artist. Three of the figures in the foreground are gazing at us, as is the artist, so perhaps we are that couple. Psychologically, as well as compositionally, this is a very interesting picture: a case of the viewer being viewed.

EMOTIONAL CONTENT
The emotional rapport between characters can of itself create intensity and interest in a picture. However, it is the compositional elements that convey emotion and these have to be worked out carefully. In the first three pictures you will see how brilliantly emotion can be conveyed by two masters – Manet and Toulouse-Lautrec.

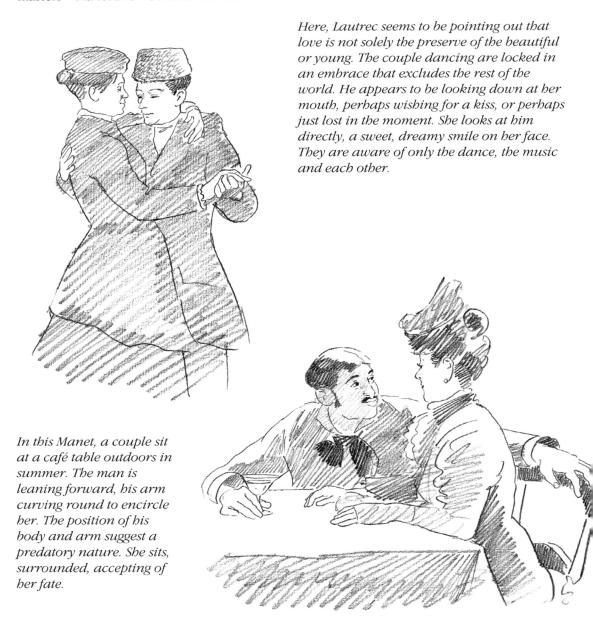

Here, Lautrec seems to be pointing out that love is not solely the preserve of the beautiful or young. The couple dancing are locked in an embrace that excludes the rest of the world. He appears to be looking down at her mouth, perhaps wishing for a kiss, or perhaps just lost in the moment. She looks at him directly, a sweet, dreamy smile on her face. They are aware of only the dance, the music and each other.

In this Manet, a couple sit at a café table outdoors in summer. The man is leaning forward, his arm curving round to encircle her. The position of his body and arm suggest a predatory nature. She sits, surrounded, accepting of her fate.

The amazing thing about this picture of two lovers – another copy of a Lautrec – is that there is so little to see of the characters and yet it speaks volumes. The couple exchange very direct, affectionate looks, their hair dishevelled, the emotional and erotic connection between them almost palpable.

The togetherness of this mother and child is suggested by the way their bodies intertwine. They seem to grow out of the same stem, like a plant. The mother's arms wrapped around the child's legs and body are suggestive of protection and warmth. Both bodies extend out of the picture, bringing them closer to us.

185

VARIATIONS ON A THEME

The use of a basic activity like eating and drinking is a very good way of connecting with the viewer. This situation can be shown in many different ways, and can say many different things. In the Van Gogh the family at table is at a fairly low level of subsistence, their attention concentrated on getting fed as quickly as possible. The Breughel tells us about the earthy enjoyment that can be had from drinking. At the Duc's banquet, restraint is the watchword. We are kept at arm's length, surveyors from afar, in contrast to the Metsu where we are taken into the scene as though we are one of the family. Here the familial connections are made obvious through look and gesture.

Eating and drinking as necessity are clearly shown in Van Gogh's 'Potato Eaters'. The evening meal is a serious business for these gritty peasants. The drawing is full of darkness and shadows, the gloom punctuated by telling shafts of light which catch on tired faces, gnarled hands and what little there is to be consumed.

'The Peasant Dance' by Breugel shows a more cheerful if just as intense eating and drinking scene. The peasants greet each other, talk with their mouths full and embrace with gusto. The characters' enjoyment of the table is well illustrated by the composition, which gives us a close-up of what's going on. Each shape is pushed together and overlaid, much as you would find with a photograph taken at close range. This creates a feeling that we might be watching people we know, perhaps neighbours. We are catching them unawares.

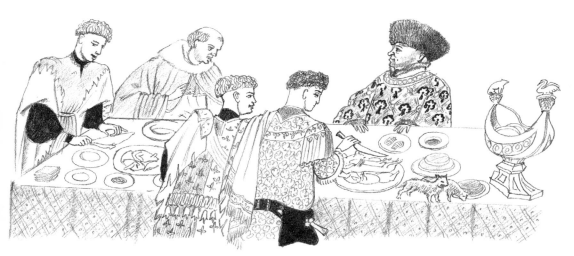

The composition of the Limbourg Brothers' illumination for the 'Tres Riches Heures du Duc de Berry' is formal and courtly, the food and clothing sumptuous. Each of the feasters is aware of his status in society. Only the Bishop and the Duc himself are seated. The lateral spread of the composition lends detachment to the scene. Unlike the other pictures here, we don't know these people.

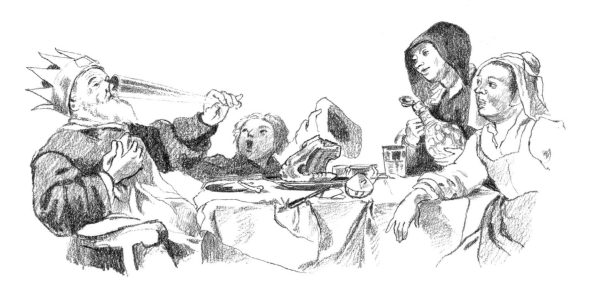

In Gabriel Metsu's fluid composition of the Epiphany feast in a Dutch home, we are onlookers at a relaxed family gathering. An old man drinks a yard of ale, to the amazement of the little boy and the old servant or wife, while the younger woman is disapprovingly unable to believe her eyes.

ACHIEVING UNITY IN SEPARATENESS
In each of these scenes we sense the isolation of people in public places. Despite their close proximity to other figures in the drawing, each of them is isolated within a private realm while being part of the wider world. There is a sort of egalitarianism at play here, with no one figure being more important than another.

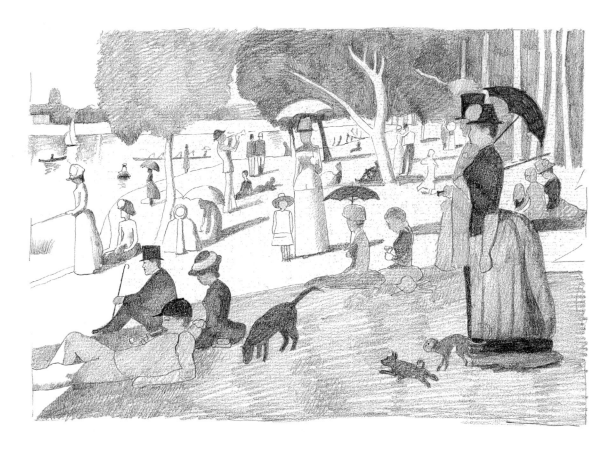

Seurat's picture 'Sunday afternoon on the island of La Grande-Jatte' appears to show a typical park scene with people disporting themselves in a fairly naturalistic way. The figures are simplified and posed, as though frozen in time. The uniform fuzziness of the tree tops, the long shadows across the sunlit grass and the large shadow in the foreground give a formal set of horizontal shapes against which the figures seem to have been placed. Although nobody is actually doing anything to attract our attention, somehow the whole picture has significance. Their positions in relation to one another seem to be accidental, but obviously are not. There is a brilliant posed quality in which everyone is responding in some sense to everyone else.

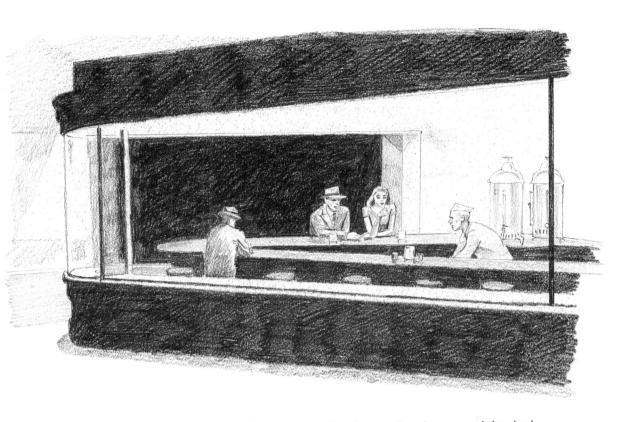

In 'Nighthawks' Edward Hopper uses the bright band of the window frame and the dark horizontal bands above and below to create a strong lateral shape in which he sets four figures. We are cut off from them by the window and they look to be cut off from one another. The scene is redolent of late-night exhaustion.

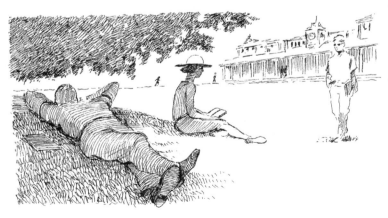

Lateral composition has again been used here, reinforced by the recumbent male placed diagonally across the left of the picture. The tree under which he lies casts a shadow over him and partly over a woman who sits slightly behind him, reading a book. A figure is walking towards the area they occupy but is obviously not coming to meet either of them. Each figure is cut off in some way, by sleep, a book, or thoughts of being somewhere else.

THE GEOMETRY OF COMPOSITION

Artists use geometry to harmonize their compositions. Often merely by dividing the parts of a picture formally into halves, quarters, thirds and so on, and placing figures and objects where these lines divide or intersect, an artist can balance a scene. The pictures shown here are classic examples of the use of geometry. Both Leonardo and della Francesca were great mathematicians and their handling of geometry in their works reflects this facility. If you want to test the effect of the systems they used, go and look at the originals of these drawings (you'll find the Leonardo in the Uffizi in Florence and the della Francesca in the National Gallery, London).

'The Annunciation' by Leonardo is centred on a 'cleft' (the mountain in the background) to which point all the perspective lines converge. (This symbol of the cleft earth is often used in paintings in conjunction with God's incarnation in human form.) The picture is divided vertically into two halves by this point and horizontally by a long, low wall dividing the foreground garden from the background landscape. The angel's head is about central to the left half of the picture and the Virgin's head is about central with the right half of the picture.

The scene seems to be divided vertically into eight units or areas of space: the angel takes up three of them, as does Mary, and two units separate them.

The angel's gaze is directed horizontally straight at the open palm of Mary's left hand, about one third horizontally down from the top of the picture.

All the area on the right behind Mary is manmade. All except the wall behind the angel is open landscape or the natural world.

In della Francesca's 'Baptism of Christ' (opposite) the figure of Christ is placed centrally and his head comes just above the centre point of the picture. The figure is divided into thirds vertically, by a tree trunk and the figure of St. John the Baptist. The horizon hovers along the halfway line in the background. The dove of the Holy Spirit is about one third of the way

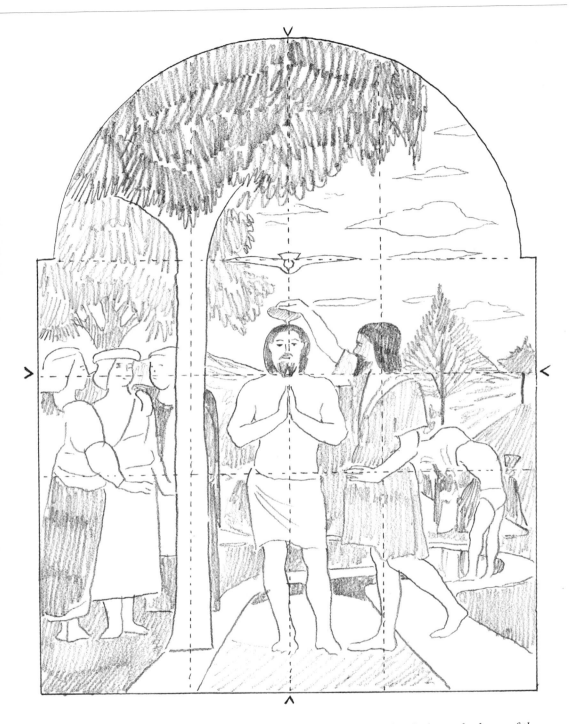

down the picture, centrally over Christ. His navel is about one-third above the base of the picture. The shape of the bird echoes the shape of the clouds and because of this doesn't leap out at us. The angels looking on in the left foreground, and the people getting ready to be baptised in the right middle ground, act as a dynamic balance for each other.

ABSTRACT DESIGN IN COMPOSITION

In the 20th century there was much discussion in artistic circles about the respective merits of naturalistic and abstract art. However figurative a picture, it still needs an understanding of abstract design to make a satisfying composition. In these examples, although the world is portrayed naturalistically, their power derives from the arrangement of one shape against another within the confines of the picture.

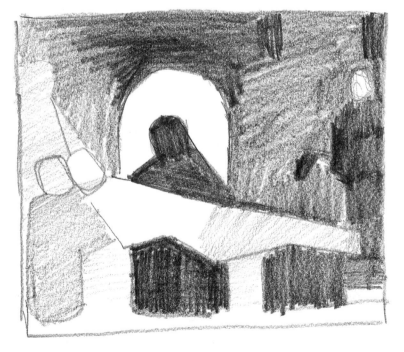

In this 'Pieta' by Pinturicchio, a colleague of Raphael, the dark shape of the mother of Christ supports her son's pale corpse, represented as a strong horizontal shape cutting across the arch which frames the scene. The dark shape of the Virgin and her central position serve to balance the picture. The dark areas above and to the sides contribute to the power of the composition.

You can see these relationships very clearly in the simplified version.

In these two sketches of Veronese's 'Venus with Satyrs and Cupid', a very simple compositional device has been used to give sensual potency to the work. The bare back of Venus is revealed to us as she stretches across the picture plane, sharply lit against the dark, chaotic space in front of her where the moving shapes of the satyrs and Cupid can just about be made out.

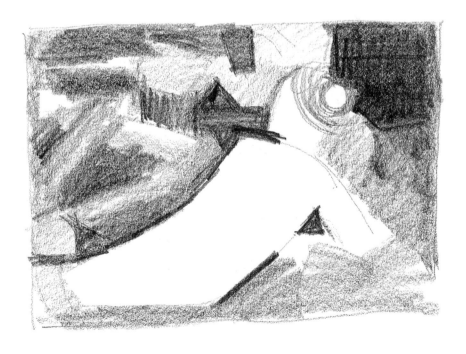

ABSTRACT AND NATURALISTIC
DESIGN IN COMPOSITION
Some pictures, while appearing
to be purely abstract in
conception, are in fact
naturalistic and portray actual
things. These few examples
show how easy it is to move from
a naturalistic to an abstract
approach, and back again. The
abstractionists can teach us
different, but equally valuable,
lessons about composition.

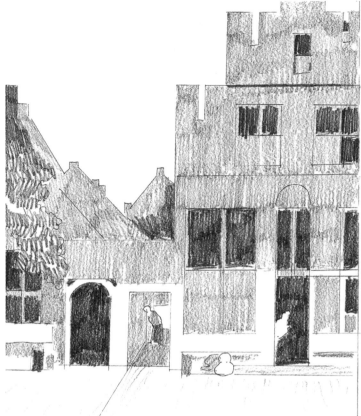

*Vermeer's 'Street in Delft' is a remarkable picture for its time. Cut diagonally in half from
bottom left to top right, the lower half is filled with the façade of a building and most of the
upper half is taken up with sky. The house is built out of a series of rectangles for the windows
and door, enhancing the picture's geometric effect, even though other details suggest a real
house with people.*

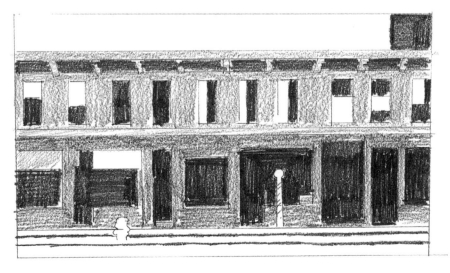

*Edward Hopper's
'Early Sunday
Morning' is another
geometric,
horizontal
composition in
which rectangular
darks and lights
are fitted into its
length. Together
with the angled
sunlight, this is a
very effective
means of
portraying a place
and a time of day.*

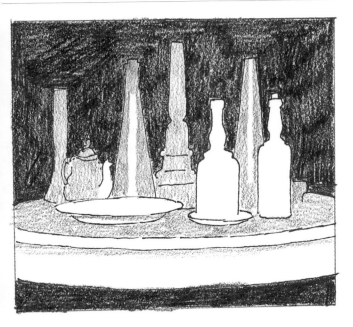

Giorgio Morandi used the same kinds of objects over and over again in his paintings. The effect of muted colours and objects devoid of significant detail was of a sort of soft-focus geometry in which quite ordinary objects gained almost monumental power. The regularity of the arranged shapes and the almost impersonal view of what is being painted somehow gives them even greater visual significance.

Piet Mondrian created a system of balanced but dynamic spaces by using black verticals and horizontal bars across a largely white background, interspersed by blocks of colour.

It is not such a great leap from Vermeer, Hopper and Morandi to pure abstraction. The Russian suprematist artist El Lissitsky used abstract geometric shapes in arrangements that suggest floating movement.

PRACTICE: CREATING A
COMPOSITION

Most artists draw or paint the
elements in their compositions
piecemeal and then fit them
together in the studio. Here I have
deconstructed a Manet by
separating out the individual parts
of his picture and then re-
assembling them as he did. Try
this system yourself. If you have
understood the abstract
composition pages, you should
not find it too difficult to do this
effectively. Manet arranged the
elements shown here to produce
a rather intriguing picture. Let's
discover why it works so well
compositionally.

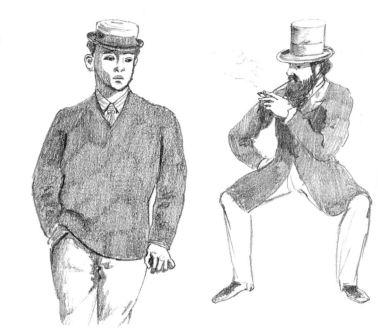

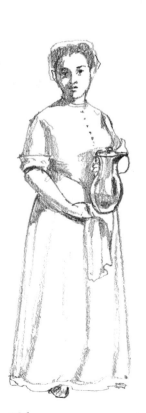

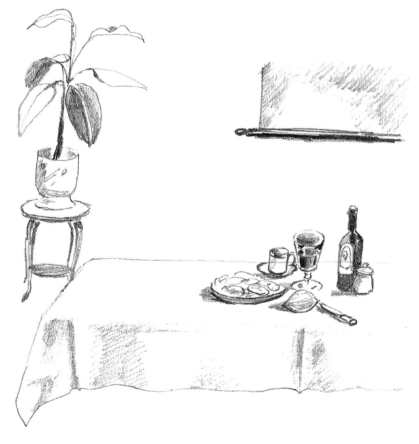

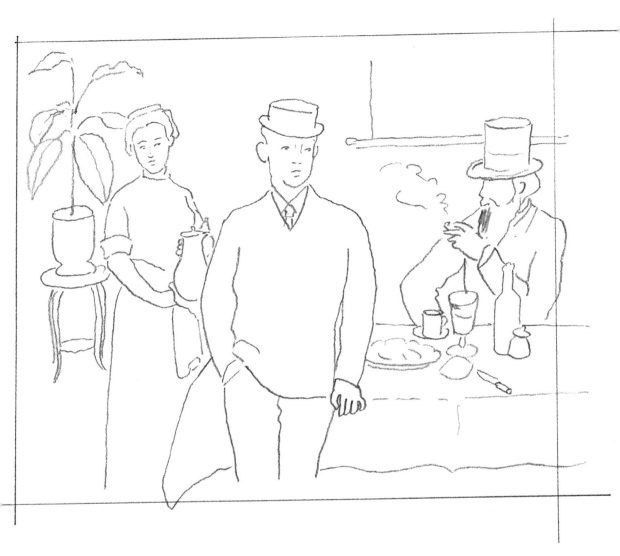

A cursory glance tells us that we are witnessing the end of a meal enjoyed by two men, whether alone or separately we are not sure. Neither is communicating with the other. The woman with the jug has been placed in the background with the pottted plant to the left of her, thus acting as a frame and serving to make her part of the narrative. The older man looks in the direction of the woman, the woman looks questioningly at the younger man and he looks beyond, out of the picture.

When you create a composition have in mind the poses you want to put together, then draw them separately. Afterwards draw in the background, including still-life objects, to make the scene convincing. If you decide that you want an outdoor setting, draw the background first and then decide how you will fit the figures in before you draw them separately. Some artists look for backgrounds to suit the figures they want to draw. The important point is to match the shapes and sizes carefully so that the proportions work.

Techniques

In this section we will consider how certain technical details affect our view of a figure. Line, tone, texture and contrast work together to bring greater feeling, significance or just sheer enjoyment to the way we look at a picture. As you will see from the following examples, the techniques we use change the way figures work. Experimenting with techniques will increase your understanding of how to bring about the effects you want to achieve in your own drawings.

LINE VERSUS TONE
Each of the following drawings has been given different treatment with regard to line and tone. Different effects can result from the balance between these two technical elements.

1. This is primarily a line drawing, showing the outline of the form with only minimal shading to reinforce the shapes. The outline is sharp and definite, and even without the cross-hatching shading it would still make sense.

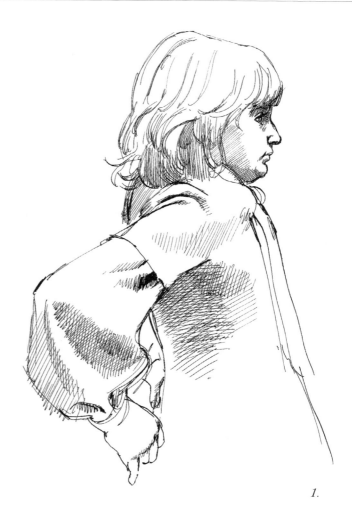

1.

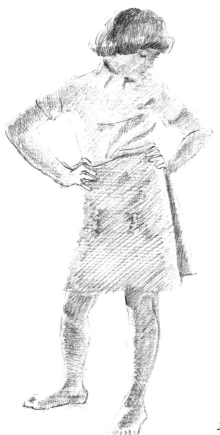

2.

2. In this figure the outside edge is much less sharply defined but the impression of solidity is much greater. Standing with the light coming from behind, this figure was drawn almost without an outline. Blocks of pencil toning of various strengths give the main shape of the figure and only some details are outlined to give emphasis. The small areas of light which creep around the edges of the arms, legs and skirt point up the round solidity of the figure and stop it being just a silhouette.

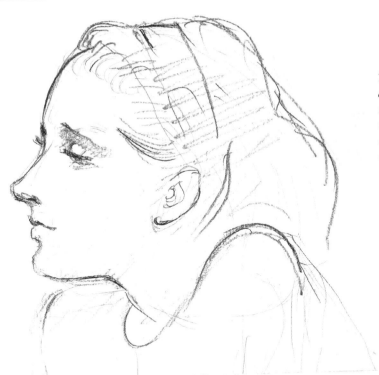

This profile is very loosely drawn with hardly any tonal work and not even a very firm outline. The lines of her head are a lyrical expression of her youthful enjoyment of life.

Contrast this technique with that used in the drawing below, where the head is heavily pencilled in with shadows.

Here the head is heavily pencilled in with shadows and vigorous tonal values. The dark tonal marks underline the atmosphere of brooding and the apprehension evident in his concentrated gaze. He appears to be considering something we cannot see.

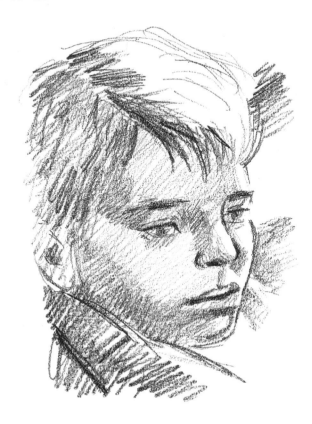

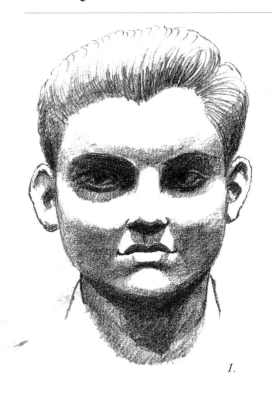

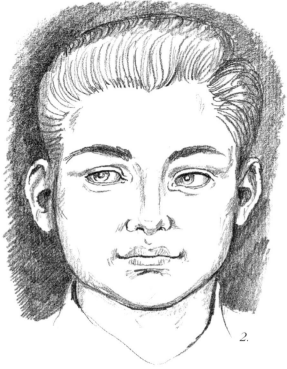

1. Lit from directly above, producing dark shadows around the eyes and under the nose and chin.

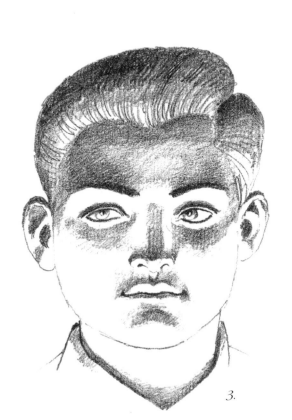

2. Lit from the front, flattening the shape, resulting in loss of depth but there is increased definition of the features.

3. Lit from beneath. Everything is reversed and it is difficult to believe this is the same boy as in the first picture. The shadows are now under the eyes but not the brow, and on top of the nose instead of under it. This lighting technique gives the drawing a decidedly eerie feel.

EXPERIMENTING WITH LIGHT

No matter what you are drawing, the light source is important. Here we look at the effect of different lighting on the same subject. Different lighting teaches a lot about form, so don't be shy of experimenting with it. Try the following options with a subject of your choosing.

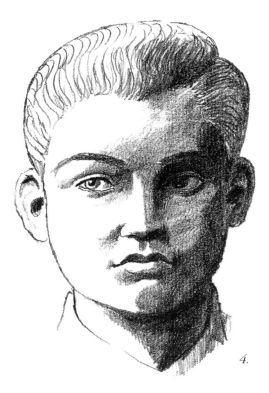

4.

4. Lit directly from the side. Here, half of the face is in shadow and the other half is strongly lit.

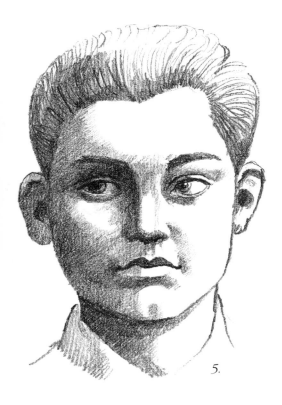

5.

5. Lit from above and to one side. The lighting evident here is fairly standard. The shadows created define the face in a fairly recognizable way.

As this series of images shows, directional lighting can make an immense difference to a face. The same principles apply equally to figures and objects. Experiment for yourself, using a small lamp or candles. Place objects or a subject at various angles and distances from a light source and note the difference this makes. When you have an effect that interests you, try to draw it.

ACTION FOR DRAMA
Drama in art can be conveyed through the action of figures. The quality of the composition depends on the way the figures move across the surface of the picture. In these two examples dramatic action is shown in two different ways: in the Picasso by the distortion of shape and in the Castagno by exaggeration of movement.

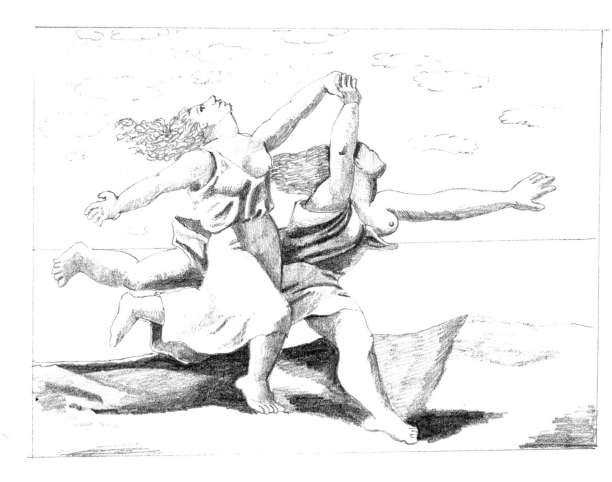

Picasso's figures on a beach are not naturalistically correct. They express the joy of running through the arrangement of the arms – outstretched and linked – and the disjointed leg of the leading figure which stretches out distortedly to suggest the horizontal movement of running.

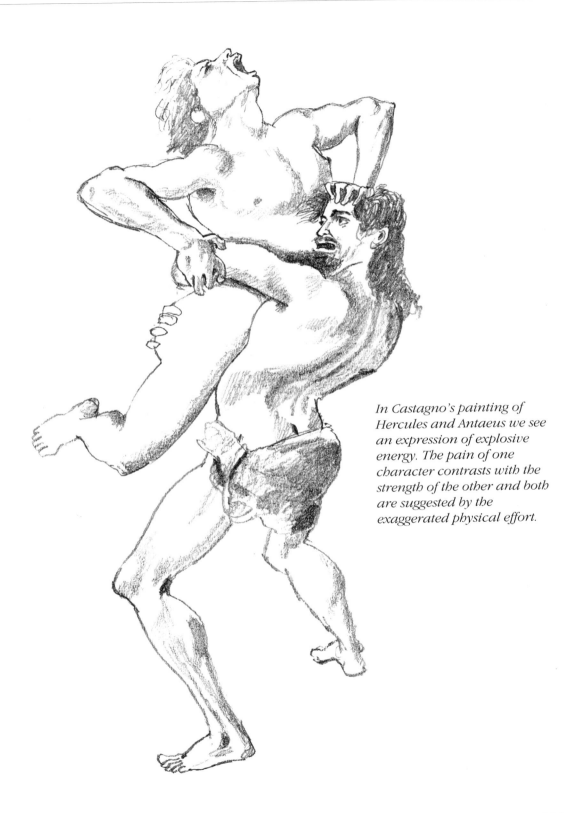

In Castagno's painting of
Hercules and Antaeus we see
an expression of explosive
energy. The pain of one
character contrasts with the
strength of the other and both
are suggested by the
exaggerated physical effort.

THE GENIUS OF SIMPLICITY

We come full circle with these two copies of paintings by Matisse. Both examples are tutorials in great draughtsmanship: keen observation, the simplification of shapes and the absolute supremacy of line over detail.

Copying any of the great masters teaches us that great art can not be reduced to a formula and simply emulated. The observation of life and the attempt to draw honestly what you see, each time, freshly, is the way to produce good drawings.

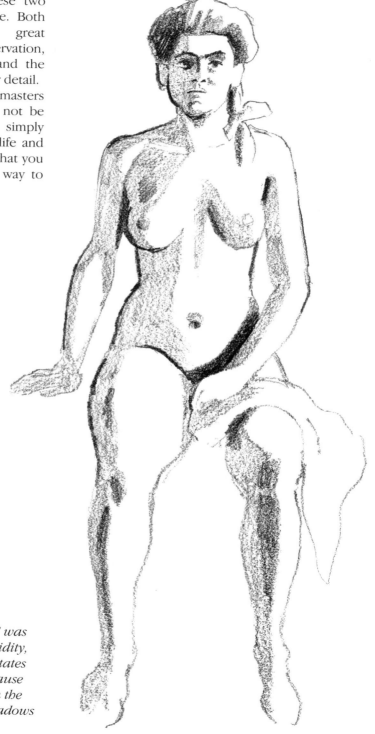

Matisse's original of 'Carmelina' was painted very simply to create solidity, and this pencil drawing of it imitates his solid, chunky technique. Because the figure is lit very strongly from the side, you will notice clear-cut shadows and brightly lit areas.

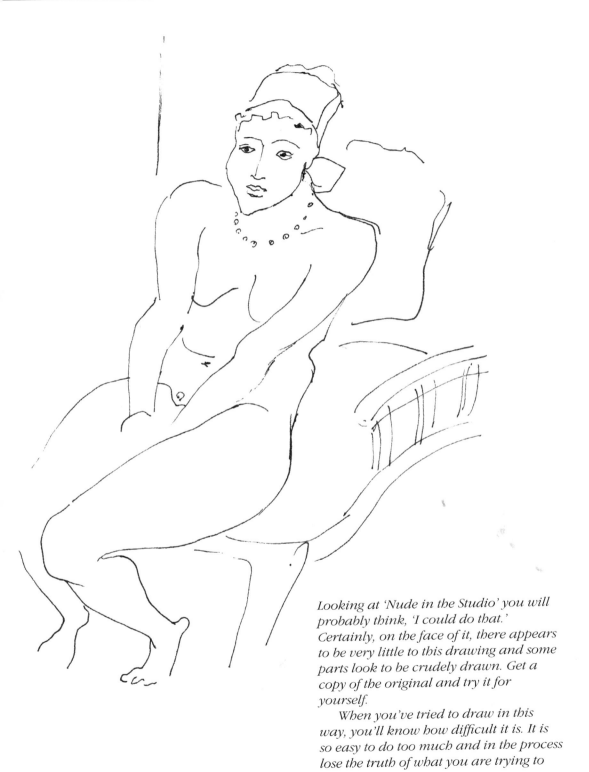

Looking at 'Nude in the Studio' you will probably think, 'I could do that.' Certainly, on the face of it, there appears to be very little to this drawing and some parts look to be crudely drawn. Get a copy of the original and try it for yourself.

When you've tried to draw in this way, you'll know how difficult it is. It is so easy to do too much and in the process lose the truth of what you are trying to portray.

207

AIDS TO BETTER DRAWING

For the newcomer who wants to learn to draw, the pitfalls can sometimes seem insuperable. I see this time and again in the classes I teach, both with adults and young people. Drawing can get tough for a number of reasons and there is no magic wand a teacher can use to wave them away. In actuality the problems are few, and some of them arise out of the student's own misconceptions and anxieties. Here are a few points to remember.

• You get good at what you practice. It is always possible to improve. Talent is useful, but desire, determination and intelligence will get you much further.

• The exercises provided in the First Stages section are essential practices which cannot be repeated too often. All of them have been exhaustively practised by myself, and have proved to be very useful in terms of improving my levels of perception and confidence. No matter where you are starting from, these practices are important. Don't be too proud to re-visit them when you are having problems with your drawing. A good technique gives confidence which is vital if you want to draw well.

• Tackle difficulties one at a time. As soon as you see something that is obviously incorrect, work to put it right. Artists gain confidence from the knowledge that if they can put one problem right, it must be possible to put all the other problems right. By correcting one type of error, you will find that other areas of your work tend to improve as well.

• Try not to get tense or angry when your efforts don't seem to be bearing fruit. Don't concern yourself with the idea of producing 'beautiful drawings'. Just keep correcting. Aim for accuracy, and let the beauty of your work look after itself.

• Look at as many works by other artists as you can. If you have contact with a living artist, study his work and watch him draw if he will allow you to. You can learn very much more quickly like this. If you are serious about becoming an accomplished artist, you will eventually have to find a teacher to work with.

• Don't throw away any of your work immediately. It is always difficult to see a recently completed drawing objectively. A year later you can see exactly how good it is and whether to keep it or not. For the beginner, keeping work is important for another reason. It is tremendously satisfying to see some improvement. Bit by bit, if you persevere, your drawings will improve. You can check this out for yourself by putting aside early drawings and not looking at them for several months until you feel you have done some real work. If you then place one of your early drawings against a current one, I bet you'll see a big difference.

• Finally, a tip for when you decide to try painting and use colour. Remember this: painting is only drawing with colour, and the 'language' you have learnt in this book will still apply.

Once you get into drawing, you will find it adds a whole new quality to your life. After you have been practising for a while, you will actually begin to see the world differently. For an artist, the visual world is full of interest, and what he sees is life-enhancing. Shapes, colours, light, shade, movement – all these elements go into making this world a feast of experience. I hope by this stage you have gained a sense of this richness and that it will carry you forward and encourage you to keep practising and keep experimenting. Good luck.

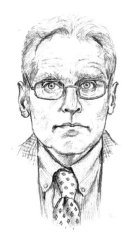